Muntadas On Translation

Muntadas

On Translation

Octavi Rofes

On Translation: Theories, Practices and Attitudes

The series of proposals which since 1995 have gradually given form to Munta-
das' artistic complex *On Translation* can be seen as exercises which put to the
test a certain model of artistic audience, explore its limits and identify its
specificities. In a previous article on the specific case of *On Translation: The
Audience*, I attempted to describe the model of ideal audience which the work
seemed to define. This ideal audience would be characterized by an attitude
which would not be that of an observer who distances him/herself from his/her
surroundings in order to seek out authenticity and aesthetic pleasure beyond
any form of cultural consensus, including language, but neither would the
model of audience coincide with the group which participates in the use of
a shared code as the sole possible instrument of approximation to the work.
The type of audience which *On Translation* seems to define would be situated
between the solitary, rational-autonomous observer who seeks to isolate the
work of art from its surroundings, and the member of an organic community
who seeks in art the recognition of the very signals of collective identity:

**"...a type of audience prepared to confront otherness and committed to decoding
the cultural discourses implicit in the conventions of institutional grammars. And
an audience receptive towards the unexpected, willing to denaturalize acquired
taste and revise it according to new necessities."** Octavi Rofes. "On the Audience: The Translation,"
in Octavi Rofes and Muntadas (eds.). *Muntadas: On Translation: The Audience*. Rotterdam: Witte de With, 1999, p. 38

But, at the same time, *On Translation* has also gradually defined a field of
action and a territory of forms and symbols susceptible to certain types of
manipulations. It is the restricted character of the manipulations, more than
the frontiers of the area on which they operate, which gives coherence to the
whole. Since *On Translation* unfolds over a surface traced by the accumulation
of fragments, displacements and transformations, the goal of this article is
to propose a system of references which will make it possible to identify the
paths along which these fragments move and are transformed. In order to
respect the heterogeneity, provisionality and liminality in which *On Transla-
tion* moves and not to violate it by adopting a single point of view, the tech-
nique of representation adopted for the delimitation, following a suggestion by
Muntadas himself, will be the selection of quotations which – from the fields
of linguistics, semiotics, philosophy, anthropology, sociology, cultural studies
or literary criticism – deal with the practice of translation or use "translation"
in a broader sense as an analogy applicable to other cultural practices. These
quotations must not be viewed as a coherent whole providing an explanatory

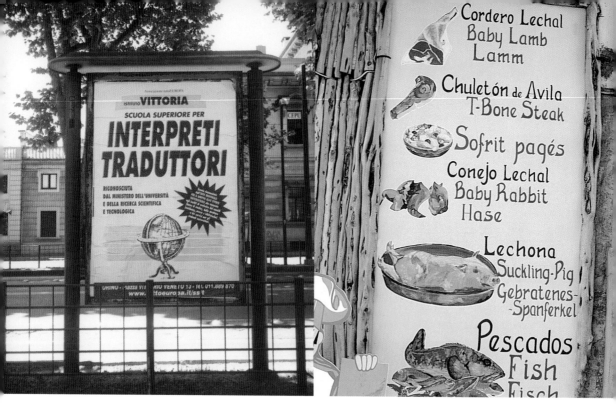

conceptual framework of *On Translation*, and still less as the reconstruction of a theoretical baggage prior to the development of the project which could be considered an efficient cause of it. More than a closed system, it is a series of partial responses to questions posed by *On Translation* and linked by means of a thread fine enough for the quotations to maintain a high degree of autonomy and to give rise to new recombinations. This article, therefore, does not offer a *systematic method* of approach to *On Translation* but the *solution of problems*, in the sense Wittgenstein gave to the practice of translation:

"Translating from one language into another is a mathematical task, and the translation of a lyrical poem, for example, into a foreign language is quite analogous to a mathematical problem. For one may well frame the problem 'How is this joke (e.g.) to be translated (i.e. replaced) by a joke in the other language?' and this problem can be solved; but there was no systematic method of solving it."
Ludwig Wittgenstein. *Zettel*. Oxford: Basil Blackwell, 1981, p. 120

In the most restrictive and at the same time most generalised sense of the practice of translation, it is considered a mechanical process of reproduction of a text in a language different from the original:

"What is generally understood as translation involves the rendering of a source language (SL) text into the target language (TL) so as to ensure that (1) the surface meaning of the two will be approximately similar and (2) the structures of

the SL will be preserved as closely as possible but not so closely that the TL structures will be seriously distorted." Susan Bassnett. *Translation Studies*. London/New York: Routledge, 1991, p. 2

Roman Jakobson adds to this strict sense of translation two closely-related practices, reformulation and transmutation:

"We distinguish three ways of interpreting a verbal sign: (1) translating it to other signs of the same language (2) to another language, or (3) to any other non-verbal system of symbols. These three types of translation can be designated differently:

1. Intralinguistic translation, or rewording, is an interpretation of verbal signs by means of other signs of the same language.

2. Interlinguistic translation, or translation proper, is an interpretation of verbal signs by means of any other language.

3. Intersemiotic translation, or transmutation, is an interpretation of verbal signs by means of the signs of a non-verbal system.

Roman Jakobson. "On the linguistic aspects of translation", in Roman Jakobson. *Essays on General Linguistics*. Barcelona: Ariel, 1984, p. 68-69

This classification of Jakobson's would not include a fourth possibility: the translation of signs of a non-verbal system to signs of another non-verbal system, a form of translation which Ludskanov calls "semiotic transformation":

"Semiotic transformations (Ts) are the replacements of the signs encoding a message by signs of another code, preserving (so far as possible in the face of entropy) invariant information with respect to a given system of reference."

A. Ludskanov. "A Semiotic Approach to the Theory of Translation," *Language Sciences*, 35, 1975, p. 5-8

In a broader sense, then, we understand equally as "translation" both reformulation on one hand and transmutation and transformation on the other.[1] Umberto Eco has distinguished four forms of interpretation of semiotic transformations: hypothesis, hypocodified abduction, creative abduction and meta-abduction. In hypothesis or hypercodified abduction, the interpretation is produced by the automatic application of a code,[2] while in the case of hypocodified abduction the rule of the interpretation is selected from a series of probable rules pending subsequent verification.[3] Creative abduction,[4] in contrast, entails the creation of a new law and necessitates a meta-abduction:

"Meta-abduction consists in deciding whether the possible universe drawn by the first-level abductions is the same universe of our experience. In hyper- or hypocodified abductions, this meta-level of inference is not indispensable, since we

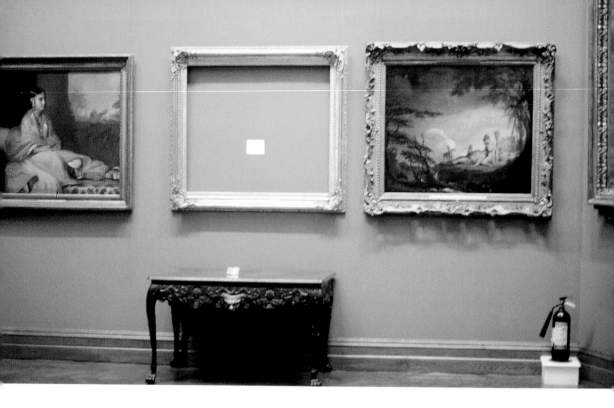

obtain the law on the basis of a baggage of experience of actual worlds which are already controlled. In other words, we are authorized by the knowledge of the common world to think that the law has already been recognised as valid (and the question is simply to decide whether it is the right law for explaining those results). In creative abductions we do not have this type of certainty. We tend to make guesses not only about the nature of the result (its cause), but also about the nature of the encyclopaedia (in such a way that, if the new law is verified, our discovery leads to a change of paradigm)." Umberto Eco, *The Limits of Interpretation*. Bloomington. Indiana University Press, 1990.

In the same way as the scope of translation is broadened, extending from the relationship between texts to the relationship between systems of signs, the range of problems posed by the theory of translation also expands. George Steiner has shown that although the classic texts of translation theory centred on resolving the demands and particularities of a specific text with an empirical orientation, from the 19th century onwards, the nature of translation adopts a philosophical category and approaches hermeneutic investigation by entering into the analysis of the meaning of "understanding" a discourse. From the second half of the 20th century onwards, translation theory came into contact with the development of formal logic, structural linguistics and information theory, and later with generative-transformational grammars, a convergence which fuelled research into machine translation. This broaden-

ing of the scope of the problems and of the span of the influences continues to characterize translation theory, according to Steiner:

"Even more than in the 1950s, the study of the theory and practice of translation has become a point of contact between established and newly evolving disciplines. It provides a synapse for work in psychology, anthropology, sociology, and in intermediary fields like ethnolinguistics and sociolinguistics. A publication such as *Anthropological Linguistics* or a collection of articles on the *Psycho-Biology of Language* are cases in point. The adage, familiar to Novalis and Humboldt, that all communication is translation, has taken on a more technical, philosophically grounded force." George Steiner. *After Babel: Aspects of Language and Translation*. Oxford. Oxford University Press, 1975, p. 250

This greater ambition in tackling the problems related with translation and the capacity for establishing synapses between different disciplines have meant that the prestige of translation, and therefore the status of the translator, have progressively risen, so that it is no longer considered a subsidiary and second-rate practice. This can be confirmed by studying the images used by translators themselves in describing their work:

"So, for example, Theo Hermans' study of the metaphors used by Dutch, French and English translators in the Renaissance has yielded an extensive range of ideas about translation – the translator is variously seen as following in the footsteps of the original author, borrowing garments, reflecting light, even searching for jewels in a casket. By the eighteenth century, dominant metaphors are of the translation as a mirror or as a portrait, the depicted or artificial held up against the real, whilst in the nineteenth century the dominant metaphors involve property and class relations. It is worth noting that in the 1980s a number of women working in the field began to discuss translation in figurative terms involving infidelity, unfaithfulness and reformed marriage." Susan Bassnett. *Translation Studies*, op. cit., p. 2

In this respect, it is interesting to trace the degree of creativity granted to the translator. In 1861, for example, Dante Gabriel Rossetti considered translation as a synonym of subordination to the original and a repression of creativity:

"...he avail himself of any special grace of his own idiom and epoch, if only his will belonged to him; often would some cadence serve him but for his author's structure – some structure but for his author's cadence." Dante Gabriel Rossetti. *Poems and Translations, 1850-1870*. London: Oxford University Press, 1968, p. 176

For Roman Jakobson, in contrast, the fact that full translatability is impossible makes translation a practice with a powerful creative component:

"The only remaining possibility is creative transposition: either intralinguistic transposition from one poetic form to another poetic form or interlinguistic transposition from one language to another language, or, finally, intersemiotic transposition from one system of signs to another system of signs, for example, from the art of the word to music, dance, the cinema or painting." Roman Jakobson. "On the linguistic aspects of translation", in Roman Jakobson. *Essays of general linguistics.* Barcelona: Ariel, 1984 (bilingual)

If translation theory cannot establish a series of rules which will guarantee and permit the evaluation of the "perfect translation," it is because the practice of translation has ceased to be seen as a technical activity and is now understood as a complex process of decodification and recodification, whose influence and responsibility goes beyond the strictly linguistic field, once it is accepted, as André Lefevere says, that translation is one of the most obvious forms of production and manipulation of images:

"It can be potentially subversive and it can be potentially conservative. It can tell us about the self-image of a culture at a given time, and the changes that self-image undergoes. It can tell us about the strength of a poetics and/or an ideology at a certain time, simply by showing us the extent to which they were interiorized by people writing translations at that time [...]. Translation can tell us a lot about the power of images and the ways in which images are made, about the ways in which authority manipulates images and employs experts to sanction that manipulation and to justify the trust of an audience, which is why the study of trans-

lation can teach us a few things not just about the world of literature, but also about the world we live in." André Lefevere. "Translation: Its Genealogy in the West," in Susan Bassnett and André Lefevere. *Translation, History and Culture*. London: Cassell, 1990

We find one example of the increasing complexity acquired by metaphors on translation in *On the Towers of Babel*, where Jacques Derrida evokes virginity and the marriage contract to establish the relationship between the text and the task of the translator:

"If one can risk a proposition in appearance so absurd, the text will be even more virgin after the passage of the translator, and the hymen, sign of virginity, more jealous of itself after the other hymen, the contract signed and the marriage consummated. Symbolic completeness will not have taken place to its very end and yet the promise of marriage will have come about – and this is the task of the translator, in what makes it very pointed as well as irreplaceable." Jacques Derrida. "On the Towers of Babel," in Joseph F. Graham (ed.). *Difference in Translation*. Ithaca/London: Cornell University Press, 1985, p. 192.)

The broadening of the spectrum of problems tackled by translation theory, which has evolved, following Lefevere's formula, from teaching us a few things about the world of literature to also teaching us a few things about the world we live in, is seen in the type of questions Dirk Delabastita poses when he considers the application of translation theory to the mass communication media in general and to cinematographic dubbing in particular:

"The linguistic organization of the target culture: what varieties, registers, styles does the target language have at its disposal, and how do they relate to each other? How do written and spoken language relate to each other? Which attitudes are adopted towards neighbouring or 'exotic' languages (openness versus purism)? Which foreign language teaching policy has been adopted? [...] What degree of openness does the target culture display towards other cultures? Does it entertain relations of dominance, subordination, competition – or any relations at all? Does the target culture constitute a stable system or does it find itself in a period of rapid change?" Dirk Delabastita. "Translation and the Mass Media," in Susan Bassnett and André Lefevere. *Translation, History and Culture*. London: Cassell, 1990

In the same way that, as we have seen, translation theory approaches problems which transcend what are strictly the worlds of linguistics and literature to move into the territory of the social sciences, we also see in the social sciences a growing interest in the practice of translation understood as a metaphor of the role of intellectuals in postmodern society. Gerd Bauman has defined the intellectuals of modernity as "legislators" legitimized by a

higher level of knowledge which enables them to issue judgments and dictates addressed to establishing a universal, ordered system based on certainty. Postmodernity, in contrast, represents the substitution of a single system of knowledge by an unlimited number of models of order which are validated according to their local specificity. The model of intellectual comes to be that of the interpreter who translates principles and facilitates communication between different communities of meaning without imposing hierarchical structures between them.

"Interpretation between systems of knowledge is recognized, therefore, as the task of experts armed with specialist knowledge, but also endowed, for one reason or another, with a unique capacity to lift themselves above the communication networks within which respective systems are located without losing touch with that 'inside' of systems where knowledge is had unproblematically and enjoys an 'evident' sense. Interpretation must make the interpreted knowledge sensible to those who are not 'inside'; but having no extraterritorial references to appeal to, it has to resort to the 'inside' itself as its only resource."
Zygmunt Bauman. *Intimations of Postmodernity.* London: Routledge, 1992, p. 22

Exploring further the metaphor of the intellectual as translator, Ulf Hannerz has defined his/her functions as a builder of the bridges of comprehensibility in complex societies:

"It is the business of intellectuals to carry on traffic between different levels and fields of meaning within a culture; to translate between abstract and concrete, to make the implicit explicit and the certain questionable, to move ideas between levels of consciousness, to connect ideas which superficially have little in common, to juxtapose ideas which usually thrive on separateness, to seize on inconsistency, and to establish channels between different modes of giving meanings external shape. (...) The thinking of the real intellectual (that is, the ideal intellectual) seems not fully domesticated. If the intelligentsia at times lean toward involution, the intellectuals with their disregard for conventional boundaries and constraining structures may indeed be forever liminoid – that relative of the liminal which Victor Turner described as not returning the world to where it was before, but rather going on and on, more likely undermining the prevailing order and sacred." Ulf Hannerz. *Cultural Complexity: Studies in the Social Organization of Meaning*. New York: Columbia University Press, 1992, p. 166

It is precisely among the "liminoid intellectuals" to whom Hannerz refers where the metaphor of translation has taken root most powerfully. Donna Haraway, for example, from the feminist revision of scientific discourse, uses the metaphor of translation to define a new type of science which replaces the single point of view of Cartesian rationalism, the "conquering gaze from nowhere," with "situated knowledges" which are conscious of occupying a specific position of power:

"Feminism loves another science: the sciences and politics of interpretation, translation, stuttering, and the partly understood. Feminism is about the sciences of the multiple subject with (at least) double vision. Feminism is about a critical vision consequent upon a critical positioning in inhomogeneous gendered social space. Translation is always interpretative, critical, and partial. Here is a ground for conversation, rationality, and objectivity – which is power-sensitive, not pluralist, 'conversation.' [...] There is no single feminist standpoint because our maps require too many dimensions for that metaphor to ground our visions. But the feminist standpoint theorists' goal of an epistemology and politics of engaged, accountable positioning remains eminently potent." Donna Haraway. "The Persistence of Vision," in Nicholas Mirzoeff (ed.). *The Visual Culture Reader*. London/New York: Routledge, 1998, p. 197

Also from a critical view of scientific discourse, Bruno Latour has defined modernity by the fact of keeping strictly separated the practices which lead to "purification," which create distinct and comparable zones of knowledge, those "translation practices" which produce hybrid territories lying between nature and culture:

NOW OPEN — THE GOOD SAMARITAN INN
HOLY PLACE
CAFETERIA SOUVENIRS
BEDOUIN-TENT CAMEL TOILETS
FREE ADMISSION

נפתח מחדש
אתר שומרוני הטוב
מזכרות מזנון שרותים
כניסה חופשית

"(...) the word 'modern' designates two entirely different groups of practices which, to remain effective, must remain distinct, but which have recently ceased to be so. The first group of practices creates, by 'translation,' mixtures between entirely new genres of beings, hybrids of nature and culture. The second creates, by 'purification,' two entirely distinct ontological zones, that of humans on one hand, that of non-humans on the other. Without the first group, the practices of purification would be vacuous or futile. Without the second, the work of translation would be slowed down, limited or even prohibited. The first group corresponds to what I have called networks, the second to what I have called criticism."

Bruno Latour. *Nous n'avons jamais été modernes*, translated as *We have never been modern*, transl. Catherine Porter. Cambridge, Mass.: Harvard University Press, 1993

For Latour, only anthropology has dealt simultaneously with these two groups of practices, and only when the object of study has been premodern societies where the anthropologist acts at the same time as a rational critic and a mediator between cultures. It is precisely anthropology, and specifically British social anthropology, which has often used the notion of 'cultural translation' as a programmatic metaphor; in this line, in 1954 Godfrey Lienhardt described the central task of anthropology as:

"The problem of describing to others how members of a remote tribe think then begins to appear largely as one of translation, of making the coherence primitive thought has in the languages it really lives in, as clear as possible in our own."

Godfrey Lienhardt. "Modes of Thought," in E. E. Evans-Pritchard et al. *The Institutions of Primitive Society.* Oxford: Basil Black-well, 1954, p. 97

Talal Asad has observed that in fact the idea of "cultural translation" is based on a relationship of "inequality of languages." As a consequence of the fact that the languages of the societies studied by anthropologists are often "weaker" than the language used by the anthropologists, these are often subjected to transformations and manipulations, an influence which the translated language cannot exert over the language of the translator. The result of the "cultural translation" is presented as the "real" implicit meaning of what the "translated" people have said, regardless of whether or not it corresponds to what they believe they said.

"'Cultural translation' must accommodate itself to a different language not only in the sense of English as opposed to Dinka, or English as opposed to Kabbashi Arabic, but also in the sense of a British, middle class, academic game as opposed to the modes of life of the 'tribal' Sudan. The stiffness of a powerful established structure of life, with its own discursive games, its own 'strong' languages, is what among other things finally determines the effectiveness of the translation. The translation is addressed to a very specific audience, which is waiting to read about another mode of life and to manipulate the text it reads according to established rules, not to learn to live a new mode of life." Talal Asad. "The Concept of Cultural Translation," in James Clifford and George E. Marcus. *Writing Cultures: The Poetics and Politics of Ethnography.* Berkeley: University of California Press, 1986, p. 159

For Talal Asad, the definition of the possibilities and limits of "cultural translation" must be made from the analysis of the asymmetric tendencies and pressures between languages of dominating and dominated societies. The alternative to the perpetuation of the inequality of languages would revolve around a cultural translation addressed to transforming the "strong" languages, and, by extension, the forms of knowledge and styles of life of the translators. In this case, the image of the translator is taken from Walter Benjamin, for whom:

"Translation is so far removed from being the sterile equation of two dead languages that of all literary forms it is the one charged with the special mission of watching over the maturing process of the original language and the birth pangs of its own." Walter Benjamin. "The Task of the Translator," in Octavi Rofes and Muntadas (eds.) *Muntadas: On Translation: The Audience,* op. cit., 1999, p. 42

学习为革命　　读书为劳动

Both Benjamin and Asad find in Rudolf Pannwitz a forceful declaration which makes translation the motor of transformation of the translator's own language to bring it closer to the intentions of the translated text:

"Our translations, even the best ones, proceed from a wrong premise. They want to turn Hindi, Greek, English into German instead of turning German into Hindi, Greek, English. Our translators have a far greater reverence for the usage of their own language than for the spirit of the foreign works. The basic error of the translator is that he preserves the state in which his own language happens to be instead of allowing his language to be powerfully affected by the foreign tongue. Particularly when translating from a language very remote from his own he must go back to the primal elements of language itself and penetrate to the point where work, image, and tone converge. He must expand and deepen his language by means of the foreign language." Rudolf Pannwitz, quoted in Walter Benjamin. "The Task of the Translator," in Octavi Rofes and Muntadas (eds.). *Muntadas: On Translation: The Audience*, op. cit., p. 51

We find a similar point of view, and likewise rooted in Benjamin's article, in the definitions of "cultural translation" which, in the context of literary studies from the postcolonial viewpoint, are proposed by authors like Homi Bhabha or Iain Chambers:

"Cultural translation desacralizes the transparent assumptions of cultural supremacy, and in that very act demands a contextual specificity, a historical differen-

tiation within minority positions." Homi K. Bhabha. *The Location of Culture*. London / New York: Routledge, 1994, p. 228

"For the nomadic experience of language, wandering without a fixed home, dwelling at the crossroads of the world, bearing our sense of being and difference, is no longer the expression of a unique tradition or history, even if it pretends to carry a single name. Thought wanders. It migrates, requires translation. Here reason runs the risk of opening out on to the world, of finding itself in a passage b without a reassuring foundation or finality: a passage open to the changing skies of existence and terrestrial illumination." Iain Chambers. *Migrancy Culture, Identity*. London/New York: Routledge, 1994, p. 4

The figure of the translator has gained in visibility at a moment when the increased circulation of information, the overlapping of habitats of meaning, the complex interconnections between cultures and the superimposition of creolization processes are becoming especially evident and problematic. In this respect, Scott Lash and John Urry have emphasised how even money has entered into a process of symbolic devaluation, becoming a sign floating in an economic framework which they have characterized as *Casino Capitalism*:[5]

"Money is thus an exceptionally important sign interconnecting with countless other signs removed from real or material processes. Money functions as a detached signifier, part of the sign-system of postmodern societies. It is moreover the exchange of such signs which it is argued serve to construct postmodern identities. It is these signs and their exchanges which increasingly constitute some people's reality in the so-called First World (...) Both money and the world are constituted as signs or images. Money is the world going round faster and faster – a pure simulacrum electronically displayed on the computer screen." Scott Lash and John Urry. *Economies of Signs and Space*. London: Sage, 1994

Finally, the metaphor of translation has also been linked to the artistic practices which develop around what Néstor García Canclini has called "hybrid cultures":

"I find it attractive to treat hybridisation as a term of translation between cross-breeding, syncretism, fusion and the other expressions used to designate particular mixtures. Perhaps the decisive question is not to agree on which of those concepts is more widely-embracing and fertile, but how to continue constructing theoretical principles and methodological procedures which will help us to make this world more translatable, or for it to be cohabitable in the midst of its differences, and at the same time to accept that everyone both wins and loses in the hybridising process. [...] The first condition for distinguishing the opportunities

and the limits of hybridisation is not to turn art and culture into resources for the magical realism of universal comprehension. It is rather a matter of placing them in the unstable, conflictive field of translation and 'treason'. Néstor García Canclini. *Culturas Híbridas: Estrategias para entrar y salir de la modernidad. Buenos Aires: Paidós, 2001, p. 29-31*

The artist as translator will therefore be the one who, without subscribing to universalist or essentialist intentions which have characterized the artistic discourse of modernity, orients his/her work to constructing channels which will provide different communities of taste and meaning with access to zones of intellectual contact and new spaces and practices of sociability. At the same time, the effectiveness of the work of art as translation will have to be measured by its capacity to make evident the filters, conventions and power relations which tend to homogenize cultural productions, and to facilitate transparency by providing elements for understanding specific phenomena without reducing them to stereotypes or deactivating their destabilizing potential.

Notes

1. It is in this broadened sense of "translation" in which we have to situate *On Translation*.

2. In *On Translation* we find different examples of hypercodified abduction in which the task of interpretation consists in recognising a phenomenon given as an *token* of a specific *type*. *On Translation: The Adapter*, *On Translation: The Audience: The Picture Collection*, *On Translation: The Website*, *On Translation: The Edition*, *On Translation: The Bookstore* or *On Translation: The Monuments* present series of tokens which must be related with a type which is not always clearly defined, thus placing in evidence the operation of the codes and systems of classification at work.

3. Also in *On Translation* we find examples whose interpretation necessitates a choice between different equiprobable codes; the uncertainty at the moment of choosing the appropriate rule of interpretation reveals the influence of the context in which the phenomenon takes place, as in the case of *On Translation: The Audience* and *On Translation: La imatge*.

4. Examples of creative abduction with meta-abduction are *On Translation: Culorea*, *On Translation: El aplauso*, *On Translation: La mesa de negociación* and *On Translation: Petit et Grand*. In all of them, the creation of a new law which brings together distant phenomena originates from the distanced observation of cultural environments in which the observer is not a participant.

5. Both *On Translation: The Bank* and *On Translation: The Internet Project* are meaningful as demonstrations of the devaluating effects of the circulation of signs and messages through international channels.

Mary Anne Staniszewski

An Interpretation/ Translation of Muntadas' Projects

On Translation

To live is to consume,[1] or so it seems since the consolidation of global capitalism and communication networks during the last half-century. But this focus on economics can be expanded to the production of meaning. In what has been called a transnational, technological "networked society,"[2] to live is to translate.

Such an all-encompassing view of culture as translation marks Muntadas' *On Translation* – an on-going series of installations, interventions, web sites, public projects, objects, videotapes, lectures, publications, exhibition materials, collaborations, and texts. This trans-media, transnational, site-specific enterprise exists in myriad languages, on the Net and in locations that have included New York, Madrid, Helsinki, Budapest, Santa Fe de Bogotá, Paris, Turin, São Paolo, Arad, Rotterdam, Kassel and Atlanta. Examining what the artist describes as "cultural translation as a contemporary phenomenon,"[3] this project has not only dealt with the translation of languages, but of global treaties, political conferences, currencies, maps, knowledge categories, colors, telecommunications, computer technologies, and exhibitions. To see culture as a translation highlights the historical, interactive, dynamic, site-specific, and interpretative quality of meaning.[4] Such a perspective on art and everyday life characterizes Muntadas' entire oeuvre.

The Political Unconscious and Cultural Producers

For some thirty years, Muntadas has investigated a vast variety of subjects in order to reveal aesthetic, cultural, and social conditions that are marginalized, overlooked, or invisible – what has been called the "political unconscious."[5] This type of investigation is the foundation of his extremely diverse œuvre that includes a variety of strategies and media. By producing a spectrum of enterprises to engage their related issues and to transform their particular contexts, Muntadas is one of a number of artists who clarifies and defines what could be called a "cultural producer."[6] Artists, writers, intellectuals, and really anyone in any field who works with a critical awareness of the institutional and ideological limits of their endeavors function as cultural producers. In this case, Muntadas' exploration of translation crystallizes the inter-related issues of identity, culture, language, nationalism, internationalism, the mass media, and information and communication technologies. Very particular versions of these phenomena distinguish the modern era[7] and, in some instances, they have gained predominance since the mid-twentieth century.

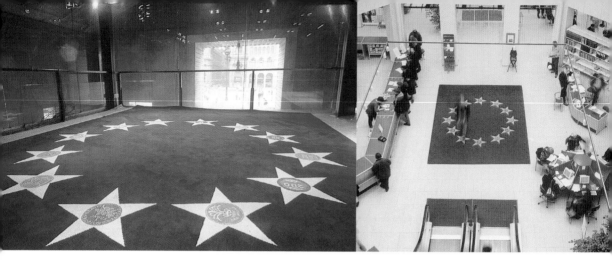

Modernity and its Frameworks

The late 18th century and early 19th century demark a shift in "the order of things" in Western culture. The well-known phrase is a translation of the original French title of Michel Foucault's book examining these modern recon-figurations.[8] Consciousness of modern nationalism and its counterpoint, inter-nationalism, developed in the late 18th century with the liberal, democratic revolutions. Cultural identity and nationhood then became linked to a common language, as was the case in France.[9] After the revolution in the United States, there was even an attempt to create a different version of English to secure the new national identity.[10] Not unrelatedly, inventions that have enhanced inter-nationalism – the development of information and communication technologies – share this historical berth. One of the foundations of global communications networks can be traced to the optical telegraph, which was devised for use during the French Revolution.[11] By 1844 Samuel Morse had perfected the electric telegraph and created the universal language of dots and dashes, Morse code.

Among the specifically modern manifestations investigated by Munta-das are fine art, the museum, the mass media, nationalism, and interna-tionalism. In his *CEE Project*, which was begun in 1988, the artist addresses the latter two issues by the re-presenting symbols of the European Union.[12] Muntadas produced a four-by-six meter carpet with the image of the European flag: twelve golden stars on a blue ground. The carpet/flag has been placed on the floor of twelve public spaces in the European Union, including a design museum in Ghent, an opera house in Thessaloniki, a library in Copenhagen, a city hall in Calais, a school in Frankfurt.[13] Revealingly, there was no controver-sial reaction to putting this flag on the floor, as most likely would be the case if the woven image had been, for instance, a French, Spanish or USA flag. In the art museum, the public walked around it as if it were an artifact, at library they walked on it as if a rug. Muntadas has remarked these different "readings" of this flag/carpet taught him much about cultural translation and the power of a context to transform an audience's interpretation. These responses also

confirmed the artist's perception that Europeans are detached from the EU, see it primarily as a "commercial" entity, and have no nationalistic identification with such a symbol.[14] A visual allusion to this was the one detail where Muntadas departed from the official flag: In the center of each star was embroidered an image of one of the then twelve EU nations' coins.

Throughout his career, Muntadas has examined "archetypes" of modernity by creating complex and often on-going projects that are re-presented in myriad sites. In addition to *On Translation* and the *CEE Project*, which were begun in 1995 and 1988 respectively, *Exposición*, installed in 1985 and in 1987, are such an examples, as are, *Between the Frames*, initiated in 1983, and *The File Room*, started in 1994. These projects have been constructed to make visible social conventions and frameworks within which meaning and value are created. The artist's working method is characterized by selecting a very generalized social structure, and then investigating permutations of the idea in meticulous detail. Muntadas then reinterprets – or translates – these projects at a variety of international sites. In the past several years, the artist has featured this process by actually challenging curators to reinterpret his installations, as is the case for the presentation of *On Translation* at the Museu d'Art Contemporani de Barcelona. For this exhibition, which includes most of the components of *On Translation* to date, Muntadas has asked the museum director, curator and coordinator to address the previous installations and situations of *On Translation*. He has requested that they install "not a recreation," "not a documentation," but "an interpretation" in order to "maximize the consequences of the idea of translation."[15]

After the first installations of *Between the Frames: The Forum*, Muntadas began selecting individuals to act as curatorial "translators" of the piece. At the Witte de Witte in Rotterdam, Muntadas invited an Art History professor, Wouter de Nooy, to interpret and create the installation for the exhibition.[16] At the Musée d'art contemporain in Montreal, he invited a sociologist, Guy Bellavance. For the Berkeley Museum of Art, he asked a philosopher, John Rapko, to do this; for the Forum d'art Contemporain in Luxembourg, he chose an economist, Robert Frankle. In keeping with Muntadas' working methods, this strategy magnifies what would otherwise be an overlooked feature of a social convention. By directing diverse professionals to be curatorial interpreters, Muntadas renders visible the fact that each presentation and installation modifies the work, which is something most visitors to an exhibition – and too many curators – ignore.

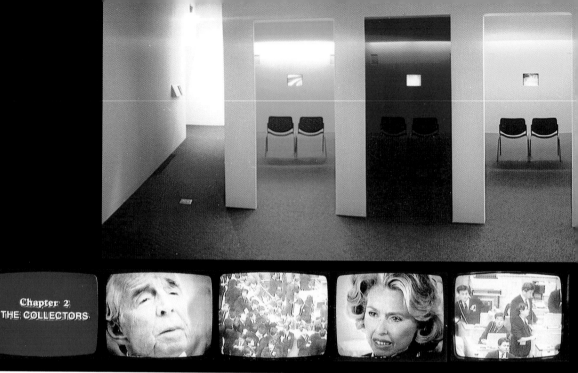

Between the Frames

Between the Frames – a video and installation project which includes four-and-one-half hours of video interviews of individuals who work within or contribute to the art world – is a representation of the art system. But this project is something more than a mere portrait of the people and institutions of the art world. *Between the Frames* makes visible the institutional, theoretical, and ideological configurations within which aesthetic meaning and value are produced: what could be called the contemporary art apparatus.

The videotapes, which were edited from some 160 hours of tape recorded from 1983 to 1991,[17] are divided into eight chapters: "The Dealers", "The Collectors", "The Gallery", "The Museum", "The Docents", "The Critics", "The Media", and "Epilogue" (composed of artist interviews). These chapters can be shown individually or together as screenings, on television or in one of the many installations, such as those at the Rotterdam, Berkeley, Montreal and Luxembourg sites. To distinguish the videos and screenings from the exhibitions, Muntadas titles the latter, *Between the Frames: The Forum*, the first of which was held at the Musée d'art contemporain in Bordeaux where the chapters were installed throughout the museum. Each chapter consisted of a video monitor and chairs placed with an area lit by a trapezoid of colored light. And each

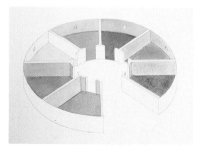

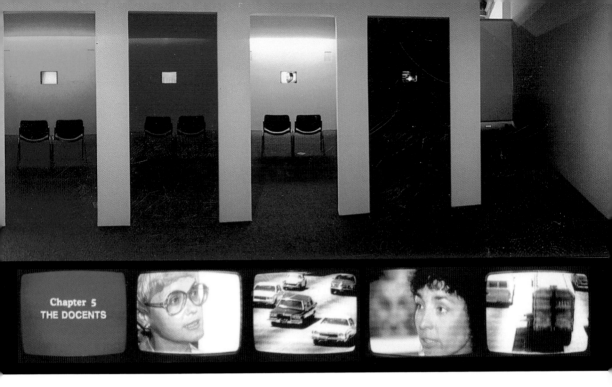

Chapter 5
THE DOCENTS

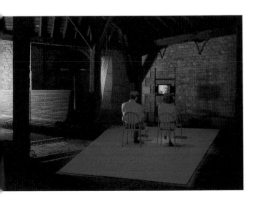

was placed within a different area of the museum corresponding to its subject. "The Critics", for example, were in the library; "The Docents", in the education department. For the second installation of the piece at the Wexner Center in 1994, a circular pavilion was built, with a central circular area that was empty and with the chapters forming galleries radiating from this center. Muntadas self-consciously conceived *Between the Frames* at the Wexner Center as a contained structure within the "deconstructed building" designed by Peter Eisenman. Whereas at Bordeaux's "very constructed building" with traditional galleries, library and bookstore, he chose to "explode the piece" and "scatter" it throughout the institution.[18]

Key to understanding Muntadas's formulation of *Between the Frames* is the fact that the individuals interviewed in the tapes – with the exception of the Germans and Japanese who speak in English – use their native languages: Catalan, English, French, Italian, Portuguese, and Spanish. Text translations were offered in exhibition publications in the languages of the site. If Muntadas had treated the tapes in the conventional manner and had them translated or had added subtitles to match the language of the location's population, this would have made the issues of cultural and linguistic differences

inaudible. It would have produced what the artist has described in another context as a "decaffeinated experience."[19] This multiple language soundscape and installation which mirrors such diversity, allows the visitor to circulate "between the frames" to metaphorically hear and glimpse parameters of a social system, the art world.

Another essential aspect of this piece is the focus on the periphery, the marginal, the frames that engender the discourses within which art is produced. Missing from this portrait of the art world is what might traditionally be the centerpiece of an exhibition and the entire aesthetic enterprise: the work of art.

Exposición / Exhibition

Muntadas's concern for the boundaries that define and limit a social territory took its most literal form in his installation, *Exposición*, presented in Madrid in 1985, and translated as *Exhibition* in New York in 1987.[20] Similar to *Between the Frames* where the centerpiece – the work of art is missing – in *Exhibition* there were no paintings, no sculptures, no videotapes, just frames, three video monitors, a slide projector, a film projector in Madrid, and a light box in New York. There were no ambient lights. Nine *tableaux* comprised the show: "The Print Series", "The Drawing Series", "The Photo Series", "The Triptych", "The 19th-Century Frame", "The Slide Projection", "The Video Installation", "The Billboard", "The Film Projection in Madrid", and "The Light Box Display" in New York. Each was lit according to standard practices associated with the type of work usually presented within each kind of frame, or in the case of the video monitor, for example, the screen was blank and just tuned on. The "Photo Series" frames had a low intensity illumination used to protect light-sensitive photographs. The triptych, which could be perceived as evoking the scale and grander of "heroic abstraction," was displayed centrally signifying a higher rank in the hierarchy of value and power when compared with the smaller The "Drawing Series", which were mounted on the wall near the desk area. By accentuating light – traditionally associated with idealist and metaphysical aspects of fine art – Muntadas paradoxically rendered the historical and material conditions of the modern gallery. Illuminated in this installation was what the viewer does not ordinarily "see": the social conventions that shape aesthetic worth, the "political unconscious" of an art exhibition. This is what

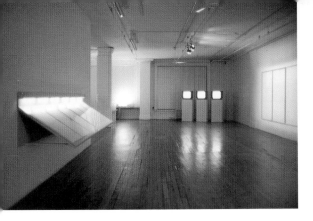

Marcel Duchamp did with that other framing device, the pedestal. By placing an object of everyday life, a urinal, on a pedestal, Duchamp revealed in this gesture the cultural contingency of aesthetic – and by implication – all meaning and value.

Installation as Ideology

The boundaries and frames of any social entity is the realm where ideological limitations reside. Often overlooked is the fact that these ideological dimensions of exhibitions, galleries, and museums are manifest in another framing device: installations.[21] What has become the standard method – hanging works of art isolated on neutral-colored walls at a height for an ideal viewer – is a recent convention and a representation in it own right. Most viewers to an exhibition do not see this framework that emphasizes not only the autonomy of the artwork, but that of the spectator. Not unrelatedly, these types of displays can enhance a viewer's sense of an idealized, ahistorical independence and even free will – characteristics associated with the mythology of the modern humanist subject.

Displaying works isolated and in neutral-colored interiors became a convention from the 1920s to the late 1960s, and by 1970 much of the diversity of institutional display practices that had characterized the early years of modern art museums diminished.[22] During the late 1960s and early 1970s was also when artists' relation to installation practices – and the political dimensions of the institutions and locations where they situated their work – changed. Although the avant-gardes had developed a variety of display practices throughout the first half of the twentieth century,[23] the late 1960s and early 1970s marked the years when artists' installations became commonplace. This was when conceptual, site-specific, inter-media and installation-based art proliferated. With landmark exhibitions such as the 1969 *Live in Your Head: When Attitudes Become Form* 1969 at the Berne Kunsthalle[24] and the 1970 *Information* at the Museum of Modern Art, [25] curators did not so much select specific pieces, but invited artists to create works for that particular exhibition. Each time such work was presented, it would be re-interpreted to suit the particular site and audiences. These were the years when Muntadas began exhibiting.

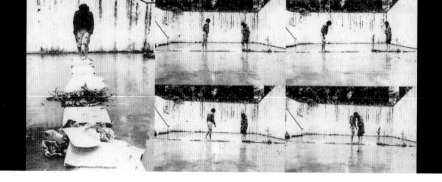

Early Projects

In the 1960s, Muntadas was producing primarily paintings. In 1971, however, he wrote a "declaration of intention" to do work that was less passive and more participatory and he stopped painting.[26] This was the beginning of Muntadas's interest in having viewers interact with his work. The "declaration" can also be understood as the origins of his current use of the statement "Warning: Perception requires involvement" for the posters and public projects of the *On Translation* series. In 1971, Muntadas also began doing actions – what he described as "sensorial experiences" – exploring smell, touch and taste that were documented first in super-8 film and then videotape. These actions were events where the artist, individuals he selected to participate, as well as gallery visitors manipulated constructions; tasted, smelled, and touched food; rubbed things on their bodies; and, in general, interacted with objects, substances, and sensory situations.[27] Many of these actions were done in private and then the documentation became a public manifestation. Muntadas often conceives of this private and public dynamic as "the micro" and "the macro," which is a polarity found in much of his work.[28] In *Experiencia colectiva n° 3 (olfato, gusto, tacto)*, which took place near Barcelona in 1971, Muntadas invited thirteen people, with eyes and ears covered, to touch, taste, and smell assorted materials (such as leaves, plastic, fruit, vegetables, wood, metal, grease), the walls, and each other, if they chose to do so.[29] An important aspect of the piece was that the thirteen people were of different nationalities, ages, professions and each was videotaped for their reactions to the experience.[30] Muntadas' careful selection of socially diverse collaborators in this early action/installation serves as evidence of the artist's persistent concern for issues of cultural translation.

Recalling some of these events thirty years later, Muntadas stated that conceptual practices were new to Spain in the early 1970s and he reviewed the way the Spanish artist community did not have "first-hand" experience of the international shows during the final years of the authoritarian Franco regime.[31] "My generation was totally isolated. The last international thing was pop and with a strong emphasis on abstract painting... There was no tradition for this type of work." When gallery visitors were invited to interact with these materials and environments, "they practically destroyed part of the exhibition... For some of the things to be manipulated – structures made of wood and a series

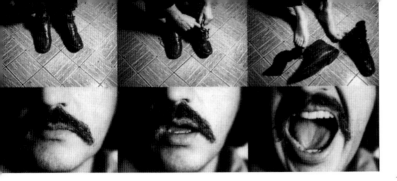

plastic bags hanging with different textures inside of them – a kind of vandalism occurred... I created a box-like room on a patio of Galería Vandres covered with foam on the inside walls and the floor. But some visitors became confused... there were strange violent reactions. Some of the work was destroyed. I think this is related to the repressive situation"... In Spain, at that time, "everything was very directed. It was not a participatory situation, which was related to it not being a democratic situation... All of these were proposals for the visitors and there was no tradition to participate in a country where you couldn't vote." A super-8 film Muntadas produced in 1972 is an eloquent reaction to the Spanish political and cultural context. In the film, Muntadas floats the newspaper La Vanguardia's front-page close-up of Francisco Franco in the beautiful aqua water of a pool, and then the image "drowns."[32]

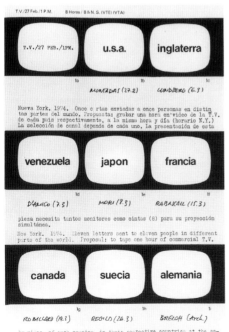

From 1973 to 1975, Muntadas was a member of Grup de Treball [Work Group], an interdisciplinary collective of artists, writers, musicians, and filmmakers formed to address political and social issues by making use of the public forum – what the artist describes as "an open window" – the art context could offer in an otherwise "closed" society.[33] "A lot of this work had to do with the end of Franco period: solidarity with prisoners, manifestos with workers, photo-text pieces, activism."[34] The last presentation by Grup de Treball was at the Biennale de Paris in 1975, the year of Franco's death.

It was within this personal and political context of the sometimes aggressive public reactions to his actions/installations and the collaborations with Grup de Treball that Muntadas shifted in 1973 from video taping himself and individuals interacting with substances and sensorial situations to a broader conceptual framework of the individual interacting with social environments. His Markets, Streets, and Stations was a

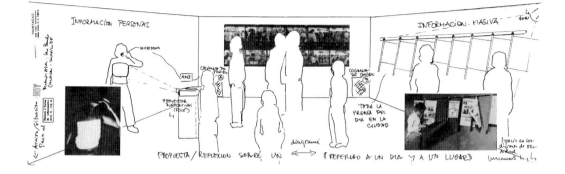

series of tapes recording people in public places in Mexico, Morocco, Portugal, Spain, and the United States. That same year, he produced another project that foregrounded issues of cultural translation that were implicit in *Markets, Streets, and Stations*. For *TV/27 Feb/1 PM*, he asked eight artists to videotape one hour of commercial television broadcast in his or her country on February 27th, at 1 PM. Exhibited at the Automation House in New York City, the installation consisted of eight monitors playing the one-hour broadcasts from Canada, England, France, Japan, Germany, Switzerland, the United States and Venezuela simultaneously.

By 1975, Muntadas had expanded his thematic interest in international and cultural site-specificity to include such concerns on a structural level by actually presenting a work in different locations. *HOY: Proyecto a través de Latinoamérica* was an action/installation that took place in Buenos Aires, São Paulo, Caracas, and Mexico City from November 1975 to February 1976.[35] Muntadas stood on one side of a darkened room with only his chest illuminated and with the sound of his breathing magnified by a microphone. On the opposite wall was large publication rack displaying local newspapers. The only thing that changed in each site was the publications and the type of gallery – in Mexico the event took place in a university gallery for example, and in Caracas at a modern art museum.

What Muntadas witnessed as he stood there in the dark could be interpreted as a tutorial in cultural translation. He remembers extremely different audience reactions.[36] In Buenos Aires, the visitors treated it as a "performance piece," and seemed to just "try to understand the work." In São Paulo, the viewers were "very attracted to the person, they put their hands on my chest, tried to breath at the same time as me," and they ignored the newspapers. In Caracas, "they reacted as if it were a cocktail party or an opening. People kept talking and socializing and didn't pay much attention to the work." In Mexico, they "were attracted to the media. Someone lit it on fire. I saw newspaper

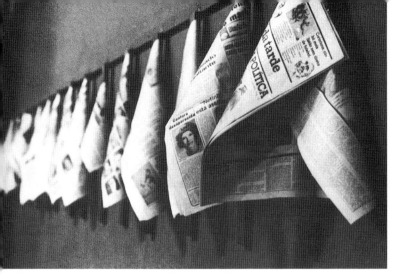

burning, then another person grabbed a fire extinguisher, it wasn't working, and then someone got a bucket of water and threw it on the fire... It was amazing. They were reacting totally to the media and this was very, very different from the other audiences' reactions to the same thing... Of course, all of this is a reduced, subjective interpretation... My interpretation."

Muntadas is part of a generation of artists that made the transition from a predominance of image and object making to a more expanded spectrum of options that includes performative, interactive, multimedia, site-specific, "time-specific"[37] creations that would morph and transform with each presentation. Considering Muntadas' career – comprising scores of projects, installed in sometimes a dozen sites – it is not coincidental that he has now chosen to foreground "translation," which could be said to be a foundation of his entire body of work.

TVE: Primer Intento

However much Muntadas's work may seem to be characterized by social rather than the personal concerns, any creative endeavor is, in a sense, a self-portrait of its maker. The origins of another major piece of his, *The File Room*, lay in the artist's personal experience, and it actually contains an autobiographical reference.[38] For several years Muntadas worked on a videotape dealing with the history of Spanish television. He was given access to the archives of Spain's only network at the time, TVE. Entitled *TVE: Primer Intento*, Muntadas described this video as a "memory piece..." "I remembered Spanish television from when I was a kid. It was part of my past and my native countries' background... It was a work dealing with forty years of Spanish history... It was made for a specific context and audience, the Spanish audience."[39] But when completed in 1989, the TVE would not broadcast the tape and would not explain why they would not show it. As is the case for many such broadcasts, Muntadas had initially signed a contract that gave TVE broadcast rights and

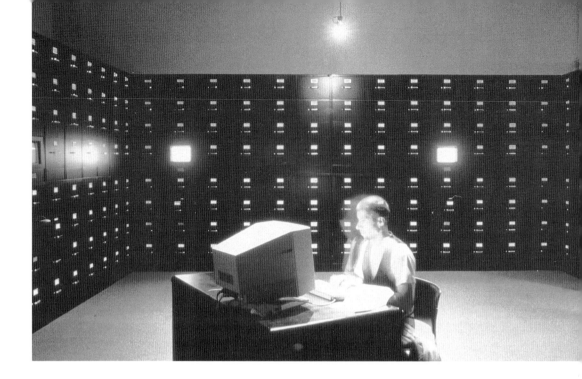

the artist rights for cultural presentations and screenings. But this contractual
situation prevented the tape from ever being broadcast. It was at this point
that Muntadas began thinking about doing a piece about censorship.

The File Room
The File Room installed in 1994 at the Randolph Street Gallery in Chicago[40]
and simultaneously on the World Wide Web, [41] is a public, open-ended, socio-
logical venture that was conceived due to the artist's personal experience
with censorship. Now considered one the classic early works created for the
Internet, *The File Room* is an archive for cases of censorship to which anyone
can contribute. Muntadas's *TVE: Primer Intento* was one of the first cases
posted on the site.[42] *TVE: Primer Intento* is an especially appropriate point of
origin for *The File Room* due to the fact that it was compiled from the archives
of the Spanish television network. Similar to so much of Muntadas work,
The File Room functions on "micro" and "macro" levels. The artist admitted
that producing *The File Room* was "an exorcism" of his frustrating experience
with censorship. Muntadas also described it as a reaction to the political and
cultural controversies in the United States, with such cases as those of Robert
Mapplethorpe and Andrea Serrano, in addition to the public debate about the
Internet and freedom of speech in the public domain.[43]

 The initial physical installation consisted of a gallery filled with 138
black metal file cabinets, holding 522 drawers. Seven computer monitors
were installed in the file cabinets and in the center of the room was a desk

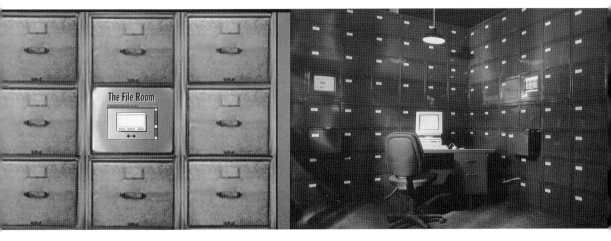

with another computer where visitors could view the site and add censorship cases. All the terminals were linked to *The File Room* web site, which is now at www.thefileroom.org/. A significant aspect of the initial installation was the visitors' access to the Internet at a time when a relatively small percentage of the U.S. population was on line. The gallery, with black-metal-file-cabinet walls and lit by the light of computer monitors, can be seen to evoke associations with oppressive institutional memory and authority. Muntadas's interest in censorship is related to an essential aspect of his work. Censorship is a crude, blatant realization of social restraints. Such repression when public, forced, and obvious is censorship, when internal, automatic, and unconscious, it is ideology. And as the artist also commented, censorship is a "negative form of translation."[44]

Although arranged according to four categories – dates, locations, grounds for censorship, and medium – not all the listings in the categories are alphabetized. Entering the web site, there is a statement that "the project does not presume the role of a library, an encyclopedia, or even a copy editor, in the traditional sense...but instead proposes alternative methods for information collection, processing and distribution, to stimulate dialogue and debate around issues of censorship and archiving." This type of database for *The File Room's* is apt, for it mirrors the simultaneously organized yet chaotic, public yet personal character of the Internet. This is one of the elements that makes *The File Room* such an effective piece. That it's theme is censorship is appropriate considering the mythologies and realities of the Net, which has

been seen both as a vehicle for individual freedom of expression and an instrument for commercial and governmental control. *The File Room* serves as a lens, clarifying issues related to paradigms of the modern era, such as individual liberty, freedom of speech, internationalism, the mass media, and information and communication technologies.

The Translator

The peripheral or invisible element, which has characterizes so much of Muntadas's work, took human form in 1994. At a month-long workshop proposed by Muntadas in San Sebastian, twenty-five artists, writers, activists, art historians, anthropologists, and sociologists from different countries gathered to investigate urban interventions.[45] Muntadas followed the discussion in the three languages of the workshop: Spanish, French and English. Many of the participants were, on the other hand, not fluent in all three languages and used headphones to hear translations. During the discussions Muntadas began to notice that the participants were smiling at odd moments and there seemed to be "some misunderstanding."[46] When he put on the headphones, he realized that the translator, Juan Mari Mendizabal, "was doing an interpretation," adding commentary to aid in his work. This small moment – when Muntadas saw the potential power of this marginalized activity – was what lead him to begin to directly and self-consciously investigate an issue that had been implicit in all of his work. And with this description of the origins of *On Translation*, this essay will end.

HIRI-INTERBENTZIOAK tailerra bukatzeaa, interesgarria iruditu zitzaidan hilabete osgan zehar interpretari lanetan jardun zuen Juan Mari Mendizabali bere lankidetza eskatzea orrialde hauek moldatzeko, hizkuntzak/ek saio guztietan sortutako hausnarketa eta eztabaidetan garrantzia handia izan baitzuen.

Hona hemen saio haietan zehar idatzi genituen hitzak, edo egun haietatik gogoratzen ditugunak.

Al finalizar **INTERVENCIONES URBANAS** me pareció interesante pedirle a Juan Mari Mendizabal, traductor a lo largo de todo el mes, la colaboración para decidir estas páginas, dada la importancia del lenguaje (s) a nivel de reflexión y discusión durante todas las sesiones.

Estas son las palabras que anotamos o recordamos, a lo largo de esas sesiones.

Having finished the **URBAN INTERVENTIONS** workshop, I thought it interesting to ask Juan Mari Mendizabal, who had been working as a translator throughout that month, to cooperate in laying out these pages, since language (s) had played a major role during the process of reflection and discussions that took place all through the sessions.

These are the words that we wrote down at the time, or remember from the sessions.

MUNTADAS. New York, november 1994.

monumento	site
antimonumento	construcción
intervención	city planning
indoors	device
outdoors	neighborhood
permanente	community
efímero	nomad
utilidad	homeless
specific	portugués
función	alemán
institución	japonés
sponsor	change
commanditaire	état d'urgence
alternativa	racismo
interference	utopía
turismo	media
activismo	network
terrorismo	frame
surveillance	proyecto
control	materiales
private space	escala
suburbia	imagen
espacio protegido	colaboración
appropriation	público
gentrification	populismo
misérabilisme	realización
deplacement	mass media
quartiers desafectés	manipulación
deal with	concern
crítica	permisos
nuance	euskara
espacio público	ras-le-bol
projection	traducción

Notes

1. To give one obvious example, this is one way to interpret Guy Debord's assessment of post-WW II culture, see *Society of the Spectacle*. Detroit: Black and Red, 1983. A book I know only in an English translation of the original French: Guy Debord, *La Société du spectacle*. Paris, Buchet/Chastel, 1967.

2. See Manuel Castells', *The Rise of the Network Society*. Cambridge, Massachusetts: Blackwell Publishers, 1996. Uncannily, as I was writing this essay and making reference to Castells' work in relation to Muntadas', the two were having a public discussion in Spain on issues of translation, globalization and the Internet. I was informed of the following discussion after I had written this text: Antoni Muntadas and Manuel Castells, "Cultura i societat del coneixement: present i prespectives de future," which took place in the context of *Cultura xxi: Nova Economia? Nova Societat?, Institut de Cultura: Debats Culturals Palau de La Virreina*, Barcelona, April 10, 2002.

3. Author interview with the artist, February 23, 2002.

4. Examining the etymology of "translation" reveals its earliest documented meanings from the 14th century include: "transference; removal, or conveyance from one person, place or condition to another," and "to change in form, appearance or substance, to transmute," as well as the meaning "...turning from one language into another." See *The Oxford English Dictionary*, second edition, prepared by J. A. Simpson and E. S. C. Weiner, vol. 18. Oxford: Claredon Press, 1989, 109-110.
Such etymological origins evoke the historical, interactive, transformational, and broad cultural associations that are in keeping with Muntadas' project.

5. Fredric Jameson's *The Political Unconscious: Narrative as a socially symbolic art*. Ithaca, New York: Cornell University Press, 1981, influenced my concept of this term. When reviewing Jameson's description of "political unconscious" for these notes, I discovered that he not only defines this in terms of "the repressed" and "the ideological" (which is what I chose to remember) but he also states on the first page that "texts come before us as the always-already-read; we apprehend them through sedimented layers of previous interpretations," see pages 20, 12, and 9 respectively. I had forgotten that Jameson's definition of "political unconscious" also includes an emphasis on interpretation, or what Muntadas would describe as translation.

6. I also define this term in the "Introduction" of my forthcoming book, *The Lens of Culture: Art, Money, Politics, Activism, The Internet, and Everyday Life*. In my first book, *Believing of Seeing: Creating the Culture of Art* (New York: Penguin, USA, 1995), which was written primarily in the late 1980s, I used the term "artist producer," but in the 1990s found I had changed the term to the more broad-based cultural producer.
"Cultural producer" is the term I choose to use to describe an engaged contributor to society, which is similar to many other such terms, such as cultural worker. Cornel West refers to "cultural worker" in his essay "The New Cultural Politics of Difference" in *Out There: Marginalization and Contemporary Culture*, ed. Russell Ferguson, Martha Gever, Tinh T. Mihn-ha, and Cornel West. Cambridge, Massachusetts: The MIT Press and the New Museum, 1990, 19-36.

7. By modernity, I am referring to the past two hundred years, and the period when the modern, liberal, democratic, capitalist state consolidated. Other configurations of the modern era include art for art sake and the museum.

8. The original phrase in French is "Les mots et les choses," See Michel Foucault, *Les mots et les choses; une archéologie des sciences humaines*. Paris: Gallimard, 1966, and Michel Foucault, *The Order of Things: An Archeology of the Human Sciences, The order of things: an archaeology of the human sciences*, translated from the French, *Mots et les choses*. London: Tavistock Publications, 1970 (first US publication, New York: Pantheon Books, 1971).

9. Jill Lepore, for example, discussed the way a single French dialect came to be favored by printers and that became the national standard in France in her lecture based on her book *A is for American* on February 26, 2002 at the US Library of Congress, which was broadcast on the US television channel, C-span 2. See Jill Lepore, *A is for American: Letters and other Characters in the Newly United States*. New York : Alfred A. Knopf, 2002.

10. After the revolution, many desired the development of a US language. Among such proponents was Noah Webster who was supported by such figures as Benjamin Franklin. Webster became a proponent of a US version of English, with spellings different from the mother tongue. Such an attempt failed and only a small number of Webster's US spellings survive, such as "favor" instead of the British "favour." Despite this failure he did leave a linguistic legacy, *Webster's*, the standard US dictionary. See Lepore lecture (note 9).

Language may contribute to a sense of nationhood, but the US exemplifies the fact that there are, of course, other elements the engender cultural differences and defined cultural identities. This is the complex and potentially infinite terrain that Muntadas explores in *On Translation*.

11. "A Short History of Telecommunications, "www.francetelecom.com/vanglais/apropos/grp-histt.htm (May 10, 2002).

12. Constituted in 1950, The European Union has gained prominence during the past decade, with such enhancements as the adoption to the Euro as the standard currency:
"The process of European integration was launched on 9 May 1950 when France officially proposed to create 'the first concrete foundation of a European federation." Six countries (Belgium, Germany, France, Italy, Luxembourg and the Netherlands) joined from the very beginning. Today, after four waves of accessions. 1973: Denmark, Ireland and the United Kingdom; 1981: Greece; 1986: Spain and Portugal; 1995: Austria, Finland and Sweden, the European Union has fifteen Member States and is preparing for the accession of thirteen eastern and southern European countries." See *Europa*, the official European Union web site, http://europa.eu.int/abc-en.htm. May 12, 2002.
Adoption of Euro was completed and national banknotes and coins were withdrawn from use on February 28, 2002; see http://europa.eu.int/euro/html/rubrique-cadre5.html?pag=calendrier5.html|lang=5|chap=10

13. The sites were as follows: Museum voor Sierkunst, Ghent, Belgium; Theatro Etairejas Makedonikon Spoudon, Thessaloniki, Greece; Kobenhaus Hovenbildiothek, Copenhagen, Denmark; Mairie de Calais, Calais, France; and Staaliche Hochschule für Bildende Kunst, Franfurt, Germany.
For a survey of the installations to 1999, see "Work" in *Muntadas: Media, Architecture, Installations*, a CD ROM, or Interom (CD with link to Internet) directed by Ann Marie Duguet and Muntadas, an archive series. Paris: Centre Georges Pompidou, number 1, 1999 www.univ-paris.fr/aharchive.

14. Interview with the artist, May 11, 2002.

15. Interview with the artist, May 11, 2002.

16. Muntadas asked each of his "translators" to display their notes for their process next to Muntadas's original notes, so that the viewers to the exhibition could compare and better understand these interpretations.

17. The entire video archive will eventually be available for viewing at a public cultural institution.

18. Interview with the artist, April 29, 2002.

19. Josephine Bosma "A De-cafeinated Experience (of Net.Art): Interview with Antonio Muntadas," *Telepolis: Magazin der Netzkultur*, July 12, 1999, www.heise.de/tp/english/inhalt/sa/6552/1.html, April 27, 2002.

20. *Exposición* was installed at the Galería Fernando Vijande, Madrid, from September 23 to October 19, 1985. *Exhibition* was installed at Exit Art, New York, from May 1 to 31, 1987.

21. This is the argument of my book, *The Power of Display: A History of Exhibition Installations at the Museum of Modern Art*. Cambridge, Massachusetts: The MIT Press, 1998.

22. See the author's *The Power of Display* (note 20) for this history.

23. For texts that deal with this history see, for example, the author's *The Power of Display* (note 20), as well as Bruce Altshuler's *The Avant-garde in Exhibition: New Art in the 20th Century*. New York: Harry N. Abrams, 1994, and Lewis Kacher's *Displaying the Marvelous: Marcel Duchamp, Salvador Dali, and Surrealist Exhibition Installations* (Cambridge, Massachusetts: The MIT Press, 2001).

24. The exhibition was held from March 26 to April 27, 1969. See Harald Szeeman, *Live in Your Head: When Attitudes Become Form: Works-Concepts-Processes-Situations-Information; Wenn Attituden Form Werden: Werke-Koncepte-Prozesse-Situationen-Information; Quand les attitudes deviennent forme: Œuvres-concepts-processus-situations-information; Quando le attitudini diventano forma: opere-concetti-processi-situazioni-infomacione*, London: Kunsthalle, Berne, 1969.

25. *Information* was held from July 2 to September 10, 1970. See Kynaston L. McShine, *Information* (New York: Museum of Modern Art, 1970).

26. This statement did not have a title, and Muntadas refers to it as a "declaration of intention." The following is an excerpt: "Situation on April 1st, 1971, The painting itself achieves its end. Particular and general reasons make me firmly believe so... The passiveness of the painting as object – the necessity of participation on the part of the

public... Painting as a consumption element (after the ice box, TV set, car...) Necessity of art to accomplish education labor – active...." *Muntadas*, Galería Vandres, 1971, n.p.

27. These "Experiencias Subsensoriales" took place primarily in Galería Vandres, Madrid in 1971.
Muntadas also began working in the United States in 1971 as well and commented in regard to his producing actions and documenting them in super-8 film and video: "When I arrived in New York, I was surprise to see so many people working in the same direction." Interview with the artist, May 11, 2002.

28. Interview with the artist, May 20, 2002.

29. *Muntadas: Media, Architecture, Installations* (note 13).

30. A forty-minute video was produced, *Experiencia colectiva n° 3 (olfato, gusto, tacto)*, 1971.

31. The statements by the artist cited in this paragraph are taken from a May, 20, 2002 interview.
Francisco Franco ruled Spain from 1939 until his death in 1975.

32. For a clip of this, see *Muntadas: Media, Architecture, Installations* (note 13).

33. The statements by the artist cited in this paragraph are taken from May 11 and May 20, 2002 interviews.
For some documentation of this group's activities, see *Global Conceptualism: Points of Origin, 1950s-1980s*, project directors, Luis Camnitzer, Jane Farver, and Rachael Weiss (New York: Queens Museum of Art, 1999), 174 and 248.

34. Most of the members continued creating individual work in addition to the Grup de Treball projects, as was the case with Muntadas. Interview with the artist, May 11, 2002.

35. *HOY: Proyecto a través de Latinoamérica* – the artist always publishes this title in Spanish, it should not be translated into other languages – was presented at the following sites: CAYC Centro de Arte y Comunicación, Buenos Aires, Argentina, November 14, 1975; Museu de Arte Contemporânea da Universidade de São Paulo, Brazil, December 13, 1975; Museo de arte Contemporáneo, Caracas, Venezuela, January 25, 1976; and Museo de Artes y Ciencias de la Universidad, México City, Mexico, February 27, 1976.
Muntadas consciously tries to use titles that are in different languages to contextualize the work, interview with the artist, May 20, 2002.

36. The statements by the artist cited in this paragraph are taken from a May 11, 2002 interview.

37. "Time-specific" is Muntadas' term, which he described as work produced as "a time-specific reaction," often related to "activist and political work," where there is an "urgency" in terms of issues that people need to address. He considers the Grup de Treball projects time-specific work. Interview with the artist, May 20, 2002.

38. Although this autobiographical aspect has been present throughout Muntadas's work, it was only in 1996 with his video installation *The Nap/La Siesta/Dutje* produced for the Filmuseum in Amsterdam that he addressed this issue directly. In the tape the subtitles state: "all works of art are always autobiographical."
The work which is discussed in this section and is "autobiographically" referenced in *The File Room*, TVE: *Primo Intento*, foreshadows Muntadas' explicit acknowledgement of the autobiographical element of his working process in 1996.

39. Interview with the artist. February 23, 2002.

40. The Installation at the Randolph Street Gallery in Chicago ran from May 21 to September 4, 1994. The gallery was in Chicago's Cultural Center, which was the city's public library before it became a municipal exhibition facility.
The File Room has since been installed in other venues.

41. See www.thefileroom.org/

42. The case of *TVE: Primer Intento* can be found in the following areas of *The File Room*: Date: 1985 - 1995; Location: Europe; Subject: Political/Economic/Social Opinion; Medium: Television, Film/Video, see *The File Room* (note 40).

43. Interview with artist, May 20, 2002.

44. Confirmation of previous discussion, email to author, May 13, 2002.

45. The workshop was titled "Urban Interventions" and was held at Arteleku: Forum de las Artes, San Sebastián in July 1994, see *Hiri-Interbentzioak: Projektuak eta Hitzaldiak; Intervenciones urbanas: proyectos y Comunicaciones; Urban Interventions: Projects and Lectures*, Arteleku, San Sebastián, 1994.

46. The statements by the artist cited in this paragraph are from April 29, 2002 interview.

Javier Arnaldo

Translate this Page

With the evolution of computational linguistics, automatic translation pro-
grammes have now become customary tools. All Net surfers occasionally use a
translation device which is activated by clicking on the button saying "trans-
late this page." The language fabricated by computer translation programmes
has great defects, but it retains many features of the original text. And if
computer systems existed for writing automatically about Muntadas' series
On Translation, I would rush to use them and would then take notes on the
discourse appearing on the computer screen. As this is impossible, we have to
think of more modest pleasures, like clicking on *On Translation* to learn about
its literal meaning [in Spanish, in this case]: *acerca de la traducción, sobre la
traducción, sobre la transmisión, a propósito de la traducción*, etc. These or
other translations will appear, depending on the initial configuration. And
with the title it gives me it already translates for me something of the content,
which has to do with the mechanics of equivalences in acts of communication.
Translation could also be translated as *reflejo* (reflection), or *espejo* (mirror),
which in the series *On Translation* always figures as a more or less asymmetric
reflection of an original interpreter.

1. Everything is Full of Echoes

In communication, as in musical counterpoint, signs and their reflections link
together in a continuous process of *translating*. A good example of translation-
reflection is what sometimes happens with whistling. I am thinking here of the
following passage in Julio Cortázar's most famous novel, *Rayuela*:

**"It's incredible how loudly I whistle," Oliveira thought, amazed. From the ground
floor, where there was a brothel with three women and an errand girl, someone
was parodying him with a pitiful counter-whistle, a mixture of boiling turkey-hen
and toothless hissing."**

Echoed sounds, whatever their quality and condition, are symbolic manifesta-
tions of original sounds. The echo replaces the ego in acoustic communication,
and embodies it, with a change of consonant, because now it is shared ego. We
easily place ourselves in the order that connects the terms *private* and *public*,
which has so occupied Muntadas in his realizations. I am thinking, for exam-
ple, of the album of photographs *Ladies & Gentlemen*, which contains dozens
of photos of doors of men's and women's toilets taken all over the world. The
public urinal is undoubtedly a place that marks the border between public and
private. The ladies/gentlemen classification has the same universal validity

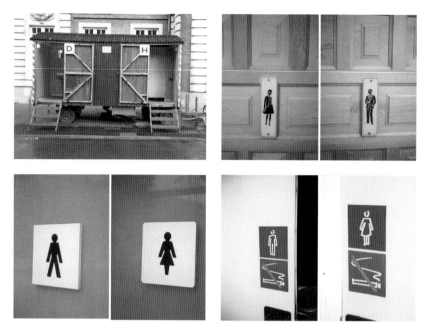

as the division of the day into morning, afternoon and night, and so we accept
it. But there are also personalized spaces; and the album demonstrates this
by reproducing dozens of different signs used to indicate these lavatories. And
now, to close the door on this rather undignified matter and to turn it around,
I will recall one of those works that talk about the private and the public, and
whose title indicates that we are talking about translations: *On Translation: The
Bookstore*. In the words of its author, this group of photographs "is an itiner-
ary through a generic bookstore."[1] The photographs focus on the signs used to
classify the sections of large bookstores: "Psychology," "History," "Literature,"
"True Crime," "Local Interest," and so on. These and other categories order the
public display of the books and establish fixed patterns for the bookseller, from
his/her subjective standpoint, to fill those concepts with meaning and translate
what he/she sells into a recognisable object. Muntadas succeeds in demonstrat-
ing the convention common to the private and the public, the subjective and
the objective, the ego and the echo. He himself has given the name "transitive
dichotomies"[2] to the motifs that interest him: the standard measure becomes
specific and vice versa. Everything is translated obligatorily to the standard
measure. Muntadas' work forces us to reflect on those articulated orders that
constitute filters of interpretation. With breathtaking simplicity and expositive
clarity he suggests the suspicious complexity of what is simple.
 At least twenty of the projects Muntadas has carried out since 1995
are grouped under the name *On Translation*. The first exponent of the series
was the, shall we say, diorama called *On Translation: The Pavilion*, which he
installed in Helsinki in 1995, and the most recent is *On Translation: La imatge*,

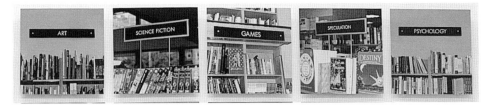

which he is presenting this year, 2002, in Barcelona. Each and every one of those works deals with the theme of the echo, of the reflection, but also has the singularity of making that echo return the sound to its producer. We are accustomed to echoes not coming back to us or passing unnoticed, but this advantage makes us ignorant. The aim of this series of works is just the contrary, namely to show, like the ancient philosophers, that everything is full of echoes, and that we would do well to listen to them. *Jovis omnia plena*, wrote the poet Virgil. All of use those new calculators that include a converter from pesetas to euros. All of us use the converter whenever we do not know how much a particular amount of the European currency costs. Concerning this translation, so common and habitual among us, from an old currency to a brand-new one, it could be said that on each occasion our interest moves with that of the echo, but we fail to free ourselves from the ignorance that we are in the midst of a beautiful metaphor for the world: life and its changes celebrated by our portable converters bear numerical symbols, like time and fortune.

In 1997 Muntadas presented in New York a kind of *collage* entitled *On Translation: The Bank*. It was not a *collage* in the strict sense, that is, papers stuck together, but a computer-created image composed of a combination of signs, a money exchange chart, national flags, an hourglass icon and a thousand-dollar bill. In the middle of the picture, the following printed question: "How long will it take for a $1000 to disappear through a series of foreign exchanges?" What is presented here is a chain of echoes, a reiterated translation of the money through all of the national currencies, until the loss of monetary value reveals the energy of the translation, but reserving an emblematic place for the original sound, the $1000 bill, which becomes harder and harder to recognise in its successive echoes. The picture leans over the precipice of the echoed sounds of a majestic original, whose value is just as soon great as negligible, but whose icon shines out imperiously, untouched, flying above all of the national flags. The bank is the agent subject in the translation of the money, the transformer of the value as is appropriate, the intermediary in planetary communication, the depository of legal currencies and the ambassador of the dollar in all the countries of the world. The interpretation chart, which is the currency exchange table, establishes the asymmetries of the reflections, the irregularity of the equivalences, the vanishing of the echoed sounds, the idiosyncratic, indefatigable voice of money.

On Translation: The Bank presents translation embodied in the money market. The restless quotations of the currencies and banking interests pro-

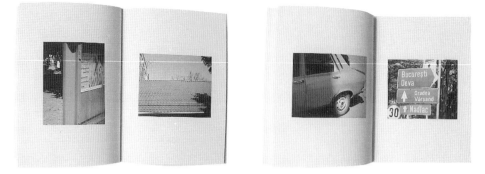

duce a slimming effect on the translated material. But the translation is not a synonym of ruin, nor even of loss of value; some are ruined while others get rich. The translation functions as the nexus of an asymmetric relationship between parts.

2. Work in Progress

As I said, that and other works form part of a series entitled *On Transla-tion*. But this is a way of speaking. In reality it is a very open, wide-ranging, ongoing project, in which very different contributions converge but with the common denominator of the formula of communication which is enounced with the word "translation". The works are markedly diverse, in terms not only of the media they use and their versatility and dimensions but also of the acceptions that dominate the word "translation" in each case. Among the realizations that make up the series there are albums of photographs and photographic interventions, video installations, publications, installations of elements of furniture, Internet projects, images like *On Translation: The Bank* and even a video-conference, which took place on 7 May 1996 in the audi-torium of the Art and Technology Foundation of Madrid, transmitted from Atlanta, at that moment the host city of the Olympic Games. This pioneering action was superimposed on the project which, of all those of the series, has the greatest complexity of media, the installation *On Translation: The Games*, presented in Atlanta that same year within the framework of the Olympic Arts Festival.

All of that plurality of manners and means in which the pieces of the mosaic *On Translation* are formalized is determined by the context in which the projects have developed and by the materials and conceptions which form their starting point. But above all it reflects how they form part of a work in prog-ress, of an investigation which demands a diversification of tests and trials, of a project measured with a large number of experiments, of an orientation, in a nutshell, of the discourse which passes through successive registers. That diversity of means, so evident and justified, requires no further demonstra-tion, but what is more elusive is the matter of the range of meanings of the word "translation": a common ingredient in all of the dishes, but each one with a different flavour.

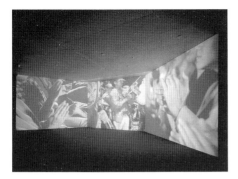

The same thing that occurs with the projects we were discussing within the series, within the ensemble of Muntadas' work *On Translation*, evolves like a chapter of a more wide-ranging essay, closely linked to the contents of others, and all of them in interlocution with the public and private reality in which we situate ourselves. And I would say that other works, other films, other photographic series by the same author could be embraced under the same heading of *translating*, since the search I have mentioned does not have a starting date in Muntadas' realizations. What he has done is to focus his attention more on a phenomenon which has its place among the codes of the illusionist impulse of the civilization to which those artistic creations call out.

In the photographic series *On Translation: Culoarea*, translation is identified with the transposition of one colour of the Romanian national flag to different settings of the city of Arad in which the camera discovers them. What is understood here as "translation" is closely related to the phenomenon of the labelling of power as a guide for the interpretation of reality. It is an artistic analysis which shows how a formula of interpretation of the setting acts on the understanding of collective life. Translation appears in many of Muntadas' works as the agglutinant of all of the communicative acts that convert life into a topological spectacle. The video installation *On Translation: El aplauso*, which he displayed in Bogotá in 1999 in the halls of the Luis Ángel Arango Library, treats applause as a gesture into which all events are translated. Applause is the sonic interpreter of the harshest of realities, and leads it towards the territory of normality. Applause constitutes an unequal translation, creates a powerful asymmetry with regard to what is translated, but it is the privileged agent of consensus, of conventions and of a topological structuring of the social contract.

In *On Translation: The Games* the theme of translation was addressed explicitly, as it was in *On Translation: The Pavilion*, the first two exponents of the series of which we have spoken. I say "explicitly" because the role of the professionals of simultaneous translation is a central motif in both pieces. The glass pavilion of Helsinki acted, in a way, as a simile of an enormous translation cabin represented by the 1975 conference on European security and cooperation, that is, an event destined to have an effect on the international convention. The principal component of the installation *On Translation: The*

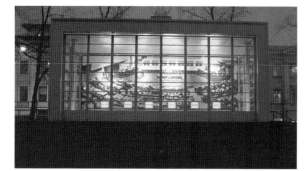
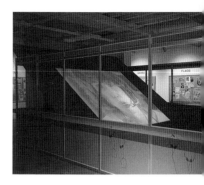

Pavilion is an oversized translation cabin; so large that it can accommodate the projection of a video showing interviews with various professionals of simultaneous translation, who are not heard in their original language but via the voice of an interpreter into Vietnamese – the alternative being to put on headphones and listen to the inverse translation into English of that Vietnamese version. The gigantic cabin was placed in the centre of the hall, as a kind of emblem of the convention represented by the Olympic Games. The installation was completed by four wall clocks showing the time in Atlanta, Athens, Barcelona and Sydney, and a series of sixteen panels delimiting the translation cabin with an order that was also topological. Each panel showed graphic materials and bore a sign saying "Games," "Flags," "Systems," "Signs," and so on. There is one more element in the sonic material of that installation: the *Anthem of Anthems*, a medley of national anthems composed by Muntadas and Víctor Nubla, which was heard at intervals among the strenuous translations into Vietnamese.

Vietnamese, a minority language at any Olympic Games, serves as a counterpoint to standard English. The *Anthem of Anthems* adorns the discourse translated into this metaphor in which the subtle and discreet agent of any treatise, which is the interpreter, is identified parodically with the true agglutinant of the convention. What we witness is an act which reflects the Olympics, or, so to speak, all of the Olympic experiences possible in an agreement. We witness a polyphonic event in which good relations are traded, standard referents are respected and translation works for convergence. The ritual of translation is projected as harmonic order, even as an aspirant to a world order, if it were not for the many dysfunctions of the media lie staged by this *On Translation: The Games*.

3. Mould and Casting

Even in Muntadas' works that use a relatively large number of media, the anti-rhetorical sense of his work is appreciated. An austere clarity and a distant, analytical appearance gives his realizations the aseptic character which, from the expositive point of view, permit their insertion into reality with no apparent discordances, which is particularly important when he makes interventions in public spaces. There is no emphasis on what is called the "artisticity" of

the work, nor is it considered important, and neither do the stylistic resources figure among the most eye-catching features of these works, whose intention lies in revealing and questioning. If they create controversy, it is because they strive their hardest to represent reality, not thanks to their rhetorical qualities. But it is clear that the debate they establish with reality stems from the condemnation of the rhetorical resources of reality and its metaphysical lie. The confidence in the technological society, in the benefits of a strongly mediatized culture and, to put it another way, in the protection of welfare through *translations*, is an object of dispute in many of Muntadas' works, which parodically re-enact the sublimation and metaphysical projection of that object which forms the depository of a formal confidence. The formalization and intentional rhetorical articulation of that reality or cultural consensus becomes the object of a patent pretence. To put it another way, the rhetorical resources of Muntadas' projects always start from the reality which they echo, but are not generated by creation itself.

I would like to say more on this point. It is not easy to establish the comparison between a multimedia author and a sculptor dedicated to modelling, but this is what I propose to do. One of the techniques most closely related to modelling is casting, which always requires the modelling of an original which serves to prepare the mould. The word "casting" is suggestive, because it indicates a complete assimilation of the form created in the previous process. The comparison I mentioned is apt here because in Muntadas there is no original which is different from reality. The question he poses himself in his work concerns the mould of mediatic reality, and its casting is the object.

In this respect it is interesting to consider the constants that are maintained in the series *On Translation*, since the *translating* could be easily identified with a mould of the reality recreated. And, indeed, *On Translation* is displaying a stylistic resource which, to the same degree as it tends to degrade the information, constitutes the basic flow of the mediatic frenzy and the element which arbitrates the aesthetic sublimation of politics and culture.

What we find in these realizations are metaphors of metaphors. The key to every aesthetic artefact resides in the principle of relationship, of which the metaphor is a fundamental manifestation. In architecture, for example, theoreticians since ancient times have held up the principle of proportion as the key to a good building. A similar case is what has been said regarding composition and colour in painting, and relationship is also what governs the harmonic support of any musical composition. The relationship between the parts is

Ein Mitteilungssystem macht das bessere Verständnis zwischen Völkern möglich. Aber das Problem ist, welche Sprache sollen wir verwenden.

외사전달시스템은 민족들간의 보다 나은 이해를 가능케 한다. 그러나 문제는 우리가 어떤 언어를 사용해야 하는 가이다.

the condition of any aesthetic order. In editing a film there is no possibility whatsoever of narration, not even of creating sense, without linkage, which generates relationships or associations between the scenes that are joined end to end to make up the film. Only thanks to linkage can the cinematographic illusion exist. We can find whatever other metaphorical formulas in the film we like, but none of them could evolve without the prior relationship of linkage between elements.

In poetry, the relationship between words coincides even more plainly, if this is possible, with the metaphorical image. "Like an hourglass / music falls into music," says a poem by Alejandra Pizarnik. "My memory opens and closes / like a door in the wind," says another text of her *Complete Poetry*. And Gonzalo de Berceo wrote: "They found his tongue as fresh and well / as the inside of a beautiful apple." This selection could be extended to a full-length anthology, but what I am saying does not require such profuse demonstration. The rhetorical relationship we call a simile or metaphor creates the poetic illusion. It would be difficult to identify simile with *translation*, since this concept entails an evident conformity with the conventions determined by equivalences. The metaphors we think of when we allude to the grammar of poetic creation are always new, introduced in order to name and discover things with language, except in the not infrequent cases of the use of manipulated images. These are created productive relationships, not the type of relationship between equivalent terms which is proper to translations.

What Muntadas' realizations convey to us is that "translation" – "transferral" – is the aesthetic agent of communication, the linkage that produces the illusion of harmony in the mediatic convention. In *On Translation: The Internet Project*, which he presented on the Documenta X website in 1997, a sentence in English was successively translated into 23 languages. *Translation*, a sign of the confluence facilitated by telecommunications, deployed all of its powers of relationship – but this *On Translation: The Internet Project* acted as an asymmetric mirror of the charms of translation and showed how it was used to mark out the path of illegibility and linguistic degradation. *On Translation: The Internet Project* was the killjoy at the floral games of telecommunications.

The works of *On Translation* are obviously not based on generating and inventing similes, but, as we have said, on discovering them in mediatic reality, exploration and staging. Muntadas exhumes "translation" as a privileged formula of relationship between elements in the social contract and as a subtle agent which converts the mediatic consensus into aesthetic artefact.

The series *On Translation* adapts to the aesthetic mould which it discovers in the reality it recreates and parodies. Translation, like the monetary transaction of *On Translation: The Bank*, the interest-based interpretation of maps in *On Translation: La mesa de negociación*, the transferral of signifiers with political intention in *On Translation: Culoarea*, are stylistic resources of the formula of civilization we invest ourselves with.

But the action of *translating* also covers a fascinating avalanche of meanings, especially when the object of study is the rod of civilization. The same action which presents itself as a harmonising medium is condemned as a miserly filter or as an epiphenomenon of an effective incommunication. It can also occur that this *translating* – which above I described as the echo of an original sound – produces an effect which signifies a shift towards the declassing of that virtuous original. The effect is that of the experience of perversion of the virtuous, frequently achieved in Muntadas' works. *On Translation: The Image*, his latest realization, offers an unequivocal example. The museum, the workshop in which artistic images are legitimized for civilization, converted into aesthetic paradigms and politically exploited, gets straight to the point and, in order to provide its translation mechanism with content, adopts nothing more or less than the photo of its own board of trustees, the new aesthetic authority. It is not the first time, by any means, that a portrait has been made of a board of directors, a corporation or a similar body. But it would be better to say that *On Translation: La imatge* does not portray a board but merely allows its mechanism of translation to be heard, even in diverse media. For the first time, museological concord is represented as the consequence of an exemplary functioning of the governing bodies of the institution, whose trademark deserves to be displayed. If you feel something is missing, translate this page.

Notes
1. *Muntadas*. Pamplona: Galería Moisés Pérez Albéniz, 2002.
2. *Pubblico-privato*. Turin: Galleria di San Filippo, 2001, p. 23.

José Lebrero Stals

From the Museum to Museums

In the first conversations that launched the project of which this publication is part, Muntadas threw down a gauntlet to MACBA. He proposed to give up the idea of just showing a group of his works and to engage in a task of another kind: to study them, and then to exhibit, not the works, but the results of that interpretation. The invitation forced us to address a crucial issue that helps to understand the essential intentions of the result, which we have entitled *On Translation: Museum*. The issue is to find out to what extent the curator's competence allows him to apply that radical idea that puts artistic practice on the same footing as the notion of liberated work to his own activity. The artist exceptionally gives the curator a free hand to interpret his work in exhibition format. Apparently, all the works in the *On Translation* series done by Muntadas since 1995 were available to be translated into any medium of expression; to be manipulated, therefore. The author offers the mediator, the manager, the intellectual interlocutor a unique opportunity to free himself from the usual conditioning factors inherent to his conventional work, in other words: to bring together works and install them properly in an exhibition room. Here it seemed that for once Ludwig Wittgenstein's claim that "art begins just where what cannot be seen can be shown" could be put into practice by the curator, and not the first author. Muntadas is an expert in creating situations, a militant in defending the idea that the work of art is not an isolated event and that there are inevitable relations between art and society, between artistic institutions and power. That is one of the qualities of his work: knowing how to use the aesthetic motivation to activate ethical discussion among his interlocutors. On other occasions, he had already sought the cooperation of experts in other disciplines, sociologists, philosophers or town planners, asking them for exhibition solutions for some of his works. The interesting part of *On Translation: Museum* is that in some way the direct beneficiary of the artist's will to share part of the authorial responsibility for the discourse is the curator, the representative of the contemporary art centre, an entity, at all events, more specialised in speculating with works than freely interpreting their contents.

And so, did I have to respond to the idea by making use of a supposed freedom granted now by the artist himself? Should I play at the fiction of becoming a suspect, occasional artist? When I began to draft a work plan, it soon became clear that the idea of process had to guide the implementation of the project in terms of methodology. Without detracting from the importance of the need to obtain an effective device, which is what the receiver judges in the end, what seemed fundamental from the outset until the final

result was to periodically review the events and circumstances that would crop up along the way, so that what started out as a dialogue between artist and curator would become an orchestration of voices, bringing fresh nuances, interpretations and materials that would enhance the new human situation we were trying to reach. A fresh formulation of the way of working, and therefore of producing and mediating, was essential. In that sense, if the artist had offered a more committed participation by the curator, instead of hogging some kind of full authorship, that curator set out to extend the process framework and the circle of participants as far as possible. The idea consisted of getting the world's point of view to impose itself on his personal vision, to commit an intellectual fallacy in some way in order to feel only partly responsible for the action and try to limit his own participation. Now that the project has been made public, it can be stated that that part of the task is complete, since the number of people who have translated On Translation so far, taking part in important decision making to obtain the interpretative results described later on, is more than ten. It was clear that this work methodology, consisting of delegating responsibilities – which is not the same as evading one's own –, would generate communication problems, confuse competences and lead to ambiguous situations in which authorship, who does what, would enter a crisis. The kind of society we live in authorises and promotes, in terms of productivity and profit, individualised authorship for everything which, by tacit agreement, is supposed to be socially profitable in some way. To call that premise into question, to doubt whether someone in particular must assume that absolute authorship, to mistrust consensus as a goal, is to attack the very bases of the system. However, the gradual appearance of non-governmental entities and organisations in the public sphere which are capable of pointing to and putting pressure on those who decide for the rest, whether in terms of company profits or the so-called common good, supply suggestive models of inspiration for those who are currently exploring alternative roads for cultural practices.

The fact is that the artist's daring offer leads one to think about fundamental questions which, though they are by no means new, do seem to need successive renegotiations of possible answers, or at least appropriate reactions to the strategic conditions that define the historical moment at which they arise. One of them is basic: who holds the power of discourse? As everyone knows, there is a history of the relation of dialectical opposition between artist and museum. Whilst the members of the classic avant-

gardes of the 20th century believed that it was necessary to steal the voice of cultural power from the museum, the radicals of the cultural revolution of 1968 chose to look for alternative representation spaces and unusual supports beyond the physical and symbolic space which culturally has been that legitimating entity. Before the last quarter of the last century, the artistic mediation professionals – critics, curators or promoters – had never had such a central role as they gradually acquired, one which at times seemed to have silenced the voices of the artists themselves. Two tools which have played an important part in that respect have been the exhibition and the collection. Putting on exhibitions and accumulating heritage, that type of professional has apparently managed to take over the controls of the locomotive of art history from the person who had been its main driver, the academic historian. In that sense, *On Translation: Museum* aims to provide data for a look at a new epochal equation, another way of tackling the question. The moment and the circumstances help: an artist like Muntadas who, over the last three decades has devoted part of his energy to critically investigating the museum as an institution, offers the curator a virtually free hand to use his work. He does so at an interesting moment, when the figure of the "star curator" is clearly in decline and when the museum institution itself is exploring alternative models of mediation and public service.

One of the functions of the work of a museum curator is to put on exhibitions. How to translate works that are not always designed for a museum? With the project *On Translation: Museum* it has been necessary to systematically review what the boundaries of the social practice of the museum institution are and where they are to be found. When a problematic but very seductive way of working, such as the practices related to the theory known as "relational aesthetics," is at its height on the international art scene, when everywhere we see exhibitions in which the now old practice of exhibiting art works is questioned – even violently –, it is no surprise that questions like this arise: What could be an effective role for a mediator/curator who aims with his work to respond constructively to the present condition of contemporary art? Where do his competences begin and end? Who defines those boundaries: the artist, the museum management, the political entities that promote it, the public? What are his duties to the artist and his work and, at the same time, to an audience which is more plural and atomised than ever? What relevant task is reserved, at the beginning of the century, for the museum of contemporary art, when it is obvious that conserving is not enough, that investigating is almost

never possible and that showing has become a perverse game at the service of opaque agendas and objectives? In what "museum" formats is the canonising contribution of the maker of exhibitions, his function as catalyst, put to the test? Is it possible to carry out a self-criticism of that figure from inside the system itself, or is that very kind of publicly promoted and subsidised supposedly radical activism no longer capable of playing any role other than of a symbol or metaphor without a future, beyond speculation by and for the professionals of politics and the culture business or the experts who give the art system its name?

Naturally, *On Translation: Museum* cannot be an answer to all those questions and does not try to be. That is why, even with an aspiration to offer new materials for future discussions on the matter, it leaves open the difficult question of deciding what the most appropriate use of the museum today might be. Moreover, aware that it is dragging a contradiction in its wake, it reveals to what extent the museum often functions as a tool which, though a critical one, never quite attacks the cultural order it is confronting and in which it remains immersed, obliged by its need for self-affirmation. The first concerns Muntadas aroused in us about the function and ways of cultural mediation and action of the centre, about public perception of that centre, led us to think about this: a museum is not just architecture, economy and heritage. As a social institution it is also organisation and management of human capital, people who take decisions, who classify and select, who when they include symbols in a particular cultural context – Barcelona in this case – simultaneously exclude a host of other possibilities, of other ways of doing. And so now – five years after making a first timid contact with Muntadas to see what form a possible collaboration with the museum might take, not merely a conventional exhibition – it seems almost inevitable that, after numerous periods of cooling off and warming up the cooperative temperature, the project *On Translation: Museum*, in its present formal and human condition, can only take place at the Museu d'Art Contemporani de Barcelona, a centre where for the time being it is possible to try to avoid monumentality and encourage emancipation by providing the visitors with the means to make their own task of thinking easier.

Certain "historical" coincidences confirm that, if you like, though they may be no more than random incidents. The *On Translation* series began physically with the exhibition *On Translation: The Pavilion*, a specific work by Muntadas presented in Helsinki in 1995, the year MACBA, empty, briefly opened its

doors to the public for the first time. This contemporary art museum is the first in Spain to create a website and try to set up a stable art programme on line. One of the projects proposed by the team from Universitat Pompeu Fabra who directed that pioneering initiative, which came to nothing in the end, was an idea of Muntadas' which was later to become *On Translation: The Internet Project*, a work on Internet commissioned for Documenta 10 in Kassel. Moreover, the installation *On Translation: The Games* (1996), which Muntadas is reconstructing for the first time, was his contribution to the cultural programme that went with the Olympic Games in Atlanta. As everyone knows, the Olympic Games in Barcelona in 1992 made it possible to construct an old local aspiration: a museum of contemporary art.

Launched from 1995 in Helsinki, the *On Translation* series has evolved so far in association with various cultural structures in different parts of the world. It is a set of works, installations and projects in which the artists tackle the concept of translation from a cultural perspective, related to interpretation and transcription. Each of the concepts in the series explores specific aspects of different contexts and events; to do so, Muntadas adapts the medium, the type of process and the form of presentation. That is why it is impossible to try to understand the twenty-seven projects and handle them as artistic artefacts in an attempt to bring them together as a collection in an exhibition room. *On Translation* is an unfinished, open series, governed by a reflection on the role of translation in contemporary society and the degree to which it particularly affects its social rites, its economic negotiations and its communication devices. "We live in a translated world," is a phrase from Muntadas himself.

First of all we understand that it is a mistake to treat the whole as a series of conventional art objects. Muntadas has used all kinds of supports to do the works and has tackled specific notions related to the idea of translation such as the audience, telecommunications, and competitive games, while also asking questions on subjects such as identity in artistic practice and the idea of social value, the possibilities of representation and curatorial interpretation, the transcription or conservation of the heritage. His criticism discloses the functioning of the system itself which socially helps the public to have access to its propositions. To stress the nature of process and the internal links and relations between the different *On Translations*, as we have said before, was to be one of the premises of *On Translation: Museum*, MACBA's response to the artist's offer.

It seemed necessary to look for an exhibition structure that did not correspond to the exhibition format of works in a conventional room and to try to emphasise the non-artistic nature of that interpretation. Where to locate the curatorial device? We have opted for using a landmark space, but one of transit, between the physical exterior of the museum, the city, and the exhibition rooms, the usual final destination of the audience who come to institutions of this kind. Once the place, the MACBA atrium, had been located another fundamental decision was taken: to turn the artist-curator binomial into a three-way dialogue. To do so we brought onto the team a designer who lives in the city and is as familiar with the artist's work as with the space where we are working. The aim of that movement was to add positions, to combine two different viewpoints: that of the designer, Enric Franch, and our own, to agree on a solution, a translation which was not known *a priori*. However, we also understood that this device, the product of the three-cornered dialogue which would be installed in the atrium of the museum, was not enough. "Interpreting" using only one of the various information tools and mechanisms available to the museum was not sufficient. Why not boost the other communication resources available at the institution to find a higher degree of complexity in the final translation? Now we could try asking other departments for help with transcribing *On Translation* to other complementary supports. Their generous response has enabled us to work with six different media, thus obtaining six expressions of the same thing – exhibition, specific project, website, publication, cultural activity, *On Translation: Museum* –, which points out the differences existing between different translation filters in a single context.

As we recalled earlier, this museum is composed basically of four juxtaposed modes of museum practice, of possible and differentiated interpretation of the work as cultural expression. That peculiarity provides four possible forms of access to the contents in question: the exhibition of works, as a specific project or a hybrid device, the publication, the website and the cultural activities. We wanted to help activate them all. That is why *On Translation* can be approached with different degrees of intensity and involvement, physically – inside the institution and in different parts of the city of Barcelona –, on Internet, with this publication and by taking part in the workshop which is being organised as an activity. Our intention is to reconstruct situations instead of reproducing works, to describe possible scenarios for debate on different levels, and not simply to reconstruct the history of *On Translation* more or less originally.

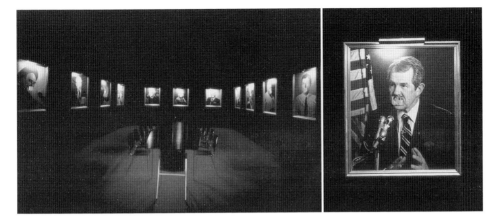

With that curatorial vision, the aim is to harmonise the presentation of artistic ideas with a collection of testimonial documents and a repertory of audience situations. The architecture of the project produced by MACBA, *On Translation: Museum*, consists of the following elements:

The exhibition. A retrospective, it is presented in one of the conventional museum rooms, and brings together a combination of works which belong to the series and others which do not. In the first category we have included *On Translation: The Games* (1996), *On Translation: The Applause* (1999-2002), *On Translation: La mesa de negociación* (1998-2002), a new triptych of the *On Translation: The Audience* group for the city of Barcelona (2002), *On Translation: The Bookstore* (2002) and an element of the specific work *On Translation: La imatge*, also new, to which we will refer to below. Though not part of the group and done before 1996, the other works provide explicit evidence that the concerns expressed by the artist in *On Translation* are matters he has studied throughout his career, and for that reason we believe that in the exhibition they will help understand the values his work contains as a critical intellectual position. In that sense, and as an approach to the question of institutional criticism and analysis of cultural reception and interpretation, we have included a version adapted for MACBA of *Exposición/Exhibition* (1985-1987), an installation that had only been shown before on two occasions (Madrid and New York). The installation *The Board Room* (1987) recreates the institutional and corporate typology of the space and is representative of Muntadas' interest in revealing the operation of the mechanisms that govern the mythology of power and the mystique of social leadership in the contemporary world. Next to the Baroque atmosphere of this installation is the empty space of *City Museum* (1991). One of the main intentions of this installation is to recall the value acquired by architecture as spectacle, an expression of power and a factor in the tourist business. In a room with no works in it, the visitors can look, through discreet holes bored in the walls, at scenes of the open spaces in cosmopolitan cities, turned into immense recreational parks by consumerism. This interest in col-

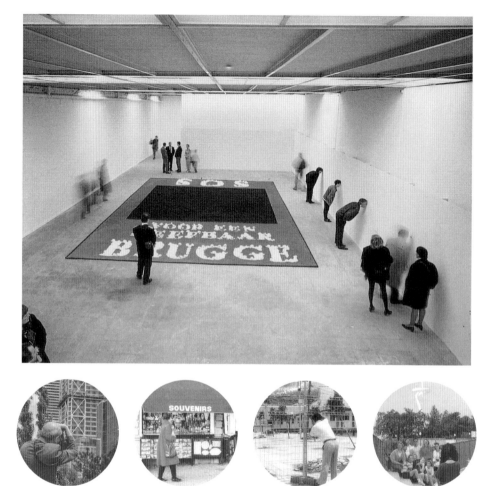

lective spaces and in investigating the way in which the media shape individual experience of what belongs to the community is one of the aspects dealt with in the five versions existing so far of *The Last Ten Minutes* (1976-1977), a confrontation, on three television monitors side by side, of the last ten minutes of the television programmes in three cities – here the version with Washington, Kassel and Moscow – selected quite deliberately by Muntadas. The clip is followed by a sequence of shots taken in the urban context of the country of origin of the images. The selection is completed with a double slide projection of *Transmission/Reception* (1974-2002) here in an updated version produced specially for the city of Barcelona, for which Muntadas has been assisted by the photographer Margaret Galbraith. The two series of slides projected on opposite walls contrast stills from the usual television programmes with images of

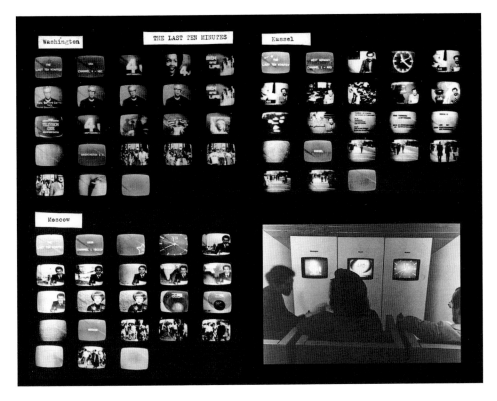

places with people watching television in bars and private homes. The section "The Exhibition", in museum format, aims to reflect the artist's interest in analysing four central notions which are present throughout his work: architecture, the media, the city and the museum.

The specific project. With the title *On Translation: La imatge*, it has been conceived and produced for this occasion and it is the most recent work in the series to be presented in public. It consists of an image designed specially by the artist to be distributed in the city centre, using a similar tactic to advertising campaigns, though what is being launched is a concept and not a product. The visual referent used is a photograph taken at a managerial meeting, in which a number of unrecognisable people appear around a large office table in a meeting room. Based on architectural blueprints, it has been manipulated and transformed by Muntadas to get rid of any value as a photograph or drawing and transformed, as he says himself, into a kind of X-ray of the photograph, in order to emphasise generic gestures which, like all his other meetings, refer to position, behaviour, stereotype and status. The nuances disappear, recognisable people become anonymous. We realise that this is a place for discussion and decision making, but intrigue and fiction are created, which automati-

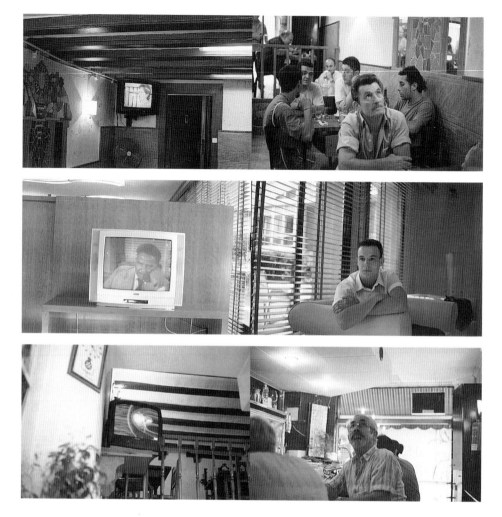

cally triggers speculation and rumour. Designed to be visible and accessible on different supports and in different places, this work has been concocted to become a kind of anonymous visual rumour. From November 2002 and until the end of the show in February 2003, *On Translation: La imatge* will spread its tentacles around the city of Barcelona, with no indication of the author or the sponsoring entity. The seven supports chosen to distribute it during the period of the project are: postcards, posters, advertising hoardings, panels in metro and railway stations, adhesive labels, ceramic plates and T-shirts. The communication circuits where this image is introduced supposedly have different functions, though they end up coinciding and complementing one another. In the art and design object shops, in the advertising media, on public transport and in the press images are promoted for the purpose of selling objects and

mental images. From the merchandising point of view, Muntadas' *La imatge* ends in itself: it is not advertising anything other than its presence and what it might conjure up in anyone looking at it. The same image, as part of the exhibition, is painted as a mural on the glass circular gallery which is the entrance to the MACBA rooms. With this work, the artist aims to investigate our different ways of perceiving the same thing in an open space in the city or the restricted space of a cultural institution. Why is the image read another way according to the medium and the context, according to the ritual of the museum as art and according to commercial logic as a popular expression?

The Web site. As the MACBA has its own Web site, the Internet was seen as another possible platform that could be used. The result is a page designed by Ricardo Iglesias as part of the on-line projects space on the www.macba.es site, which offers another interpretation of the series. The purpose of the page is to present part of the available documentary resources supplied by the artist in different formats, materials and structures. Iglesias' intention is not to create an "artistic" Web site with Muntadas' works and ideas but to get closer to them while looking for a way to pass them from one environment to another, in other words, to translate their specificity to the conditions on the Web.

The publication. Produced jointly by MACBA and Editorial Actar, this volume is in no way an exhibition catalogue, a more or less illustrated book, but the result of team work, which aims to be a documentary printed published translation. Although many of the documentary materials that have also been included in *On Translation: Museum* have been used in it, the large number of written contributions, the particular mode of publishing production and design of the book make it an independent interpretation of *On Translation*.

The workshop. One of the particular features of the MACBA programming in recent years has been the pluralist concept of the public and hence of the possible uses to which the museum can be put, thereby requiring us to see the activity of the museum as more than purely mounting exhibitions and to boost the spaces given over to debate as part of the various programmes of activities, which include seminars and workshops. In this respect, it seemed appropriate to us that the project in question should have a possible translation and public expression on the specific circuit that has generated activities of this type. The result of this is the *On Translation: Public Space Workshop*. From Les

Percourse

Projects, lineal or aleatory acces

1

Information about
the projects

2

Entrance

*Glòries to the Besòs, Urban Change and Public Spaces in the Metropolis of Barce-
lona*, co-directed by Muntadas and Ramón Parramón and run in collaboration
with the Master's Degree in Design and the Public Space taught at the Elisava,
Escola Superior de Disseny. The workshop aims to create a forum for discus-
sion and to generate proposals on the state of urban development in the city
of Barcelona, which is internationally renowned for its urban model, which has
been promoted since the 1980s and which now continues in the coastal area of
the Besòs and the extension of Avinguda Diagonal to the sea, looking ahead
to the holding in 2004 of the Forum of Cultures, an event which for some is
directly related to the latest potential urban and property development within
the city's boundaries. In this way, a project that was originally intended as an
exhibition is transformed into a contribution to the public debate on the future
of the city.

Museum. This proposed interpretation of the existing twenty-seven *On Trans-
lation* projects has two fundamental objectives: to highlight the fact that any
translation generates and demands the creation of a text; and to emphasise
the importance of the concept of process in artistic work. In Enric Franch's
design of the different modules or points of encounter with each of the works
that make up the structure he has conceived, Franch has opted to vertically
emphasise the presentation of the interpretation texts – panels displaying
words written by Valentín Roma, a lecturer in the history of contemporary art,
and quotations by Muntadas himself – while horizontally presenting the wide
diversity of materials selected by working with the artist's archives – tables
containing audio-visual information.

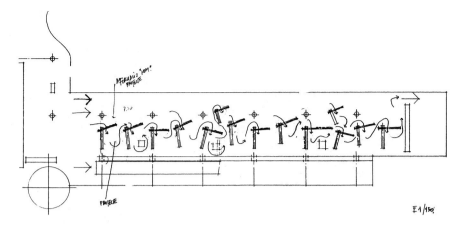

E 1/150

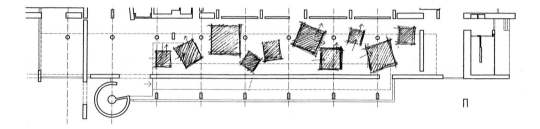

The visitor is offered the oppor-
tunity to approach – using a method
very similar to those applied in cultural
anthropology – each of the various proj-
ects without the need to approach any
of the others. The graphic and written
documents, the objects and audio-visual
material have been arranged systemati-
cally. Only that which the work may have
directly originated, produced or evalu-
ated has been included. The audio-visual
material is arranged in a number of parts
which, between them, aim to offer people who consult them the opportunity
to experiment with a particular narrative of their own based on everything
that is displayed. The audio-visual material also provides information on the
process and involvement in the contexts of *On Translation* and to make some of
the mechanisms used to produce it transparent. In order to encourage visi-
tor participation, it is planned that while the exhibition is on, a series of open
encounters in this space will be held, the aim of which will be to evaluate the
successful aspects and any shortcomings. With regard to each work, particular
emphasis will be placed on:

1. Title of the work, city and year of production. This information is highlighted in the shape of a headline standing out from the file with the aim of emphasising the topographical character of *On Translation* and the intercontinental circuit on which the artist has structured the series.

2. A text divided into three sections which fulfils different functions. To describe what the work in question consisted of as clearly as possible; to supply details of the event that directly gave rise to it; to place the contents in a cultural context; to point out aspects related to its formalisation; to hear the voice of the artist himself on the subject expressed. That cluster of intentions helps to indicate the great variety of supports and formal solutions the artist is capable of proposing from an extremely flexible personal repertory with a great capacity to accommodate particular circumstances. Moreover, the idea is to point out Muntadas' way of reacting to the places and institutional and personal interlocutors he works with, which shows the particular sensitivity of this work to the vicissitudes of the historical time in which it evolves.

3. A selection of images, documents and objects that illustrate and enrich the contents of the informative sections mentioned above. These materials come basically from the personal archive of the artist. Using it supposes an intention to point out his interest in the documentary issue in culture, his critical relation with the notion of collection and his way of interrelating works by means of a thread which does not depend on chance or merely aesthetic decisions. Photographs of the installations, reproductions of the works, working diagrams and graphics, letters, invitations to openings, press cuttings, drawings, story boards, illustrations of the situations where some of the projects took place, sketches and lists of materials make up an open compendium of visual and graphic material.

4. The collection of testimonies of the *On Translation* works. Baptised "leftovers" during the fruitful process of discussions with Enric Franch, these elements make up the repertory chosen to include testimonies that were not strictly text or two-dimensional illustration in *On Translation: Museum*. The aim is to make it easier to approach the contents in space and, almost like an archaeological fragment of the project in question, enhance the visitor's physical experience. Part of its function is to equip the feeling of a linear route

around this area with audiovisual complexity, to give it body. When it was decided not to include autonomous works in this part of the project, since it is a curatorial interpretation exempt from direct mediations, new questions arose: What decides what is and is not a work of art in the semiotic framework of the museum? Does the fact of presenting something considered a "work" as a functionally archaeological object in a set of informative elements detract from its aesthetic value or artistic function? For the file for *On Translation: Culoarea*, for example, a copy of the book that made up Muntadas' "work" is included as a leftover. Is this booklet with photos taken by the artist a work, and therefore something which, to remain consistent with the rules laid down for our job, should not be included in *On Translation: Museum*? Or is a work of art produced as a printed edition to make it easier to distribute its content also a book and therefore an object that is no longer simultaneously a work of art?

A result of the exploration of the mechanisms which produce the physical and mental image of the museum, *On Translation: Museum* underlines Muntadas' observation that in contemporary society all communication is translation and therefore there is never complete objectivity of information. When we were invited to take part in the business and thus be able to place ourselves out-side the bounds of the usual procedure, it soon became evident that the offer concealed an implicit trap: is the invitation not the artist's excuse to put the institution to the test? Or a sophisticated way of confronting it with the values that daily guarantee it the efficiency society requires of it? Is the museum the mirror of what artists do or vice versa? To ask about the competences of the museum in that way means questioning its management, critically exploring the mechanisms that govern the law that determines its survival as a machine for the public canonisation of art or a piece in the administrative and political jigsaw through which the powers that be seek consensus. The reaction here aims to apply a horizontal decision-making model instead of a clearly vertical control system, thus reformulating the classic curatorial model.

We must add that the final presentation system for this part of the project is conditioned both by the budgetary limitations and the succes-sive conceptual crises and subsequent formal redrafting the work team lived through throughout the gestation process. The initial solution agreed upon was a system of separate modules that were spread around the atrium of the museum, filling the space. This however was rejected and an alternative of a large exhibition model was proposed, consisting of a large plywood frame left

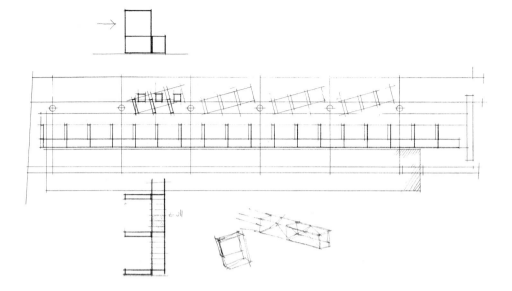

bare on the outside but painted inside. It was to measure 40 metres long,
4 metres wide inside and 3 metres high, thereby enabling two people to move
around side by side inside. Visitors would have been able to consult the concep-
tual details of the 27 projects displayed on the internal walls of this tunnel or
passageway. However, the final form decided upon for *On Translation: Museum*
is a series of units linked chronologically in the atrium and grouped visually
and conceptually in the manner of a three-dimensional archive by means of
the word, reading and the subsequent comment, stressing the temporality of
each work and its relationship with the context in which it was presented. The
information "and/or" interpretation of the facts and places provided by the
written panels is scattered vertically throughout the space, crisscrossing with
the horizontal presentation of the mixture of working materials found, gener-
ated, recycled or manipulated by the artist and which bear forthright witness
to the importance of the notion of process in the type of work he generally
produces. The first solution of independent modules for each *On Translation*
was discarded when it was decided to incorporate the exhibition section into
the project; as we said earlier, it is presented in the exhibition rooms next to
the atrium. The incorporation of an exhibition of works by Muntadas into the
project obliged us to look for a way of clearly showing the difference between
the artist's works and the interpretative concept we are concerned with. The
artistic artefacts – the works in the exhibition – brought about an unexpected
competition that forced us to find alternative devices. Among those options
we toyed with the possibility of digitalising all the available information and
bringing it together in a single information centre set up in the atrium so that
the visitors would have access to the project by watching a screening or print-
ing the parts they wanted. That option, however, came into direct competition

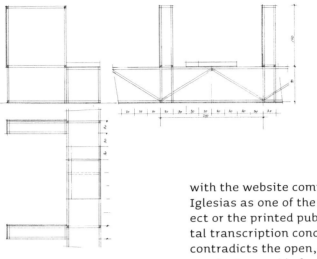

with the website commissioned from Ricardo Iglesias as one of the six elements of the project or the printed publication. Moreover, digital transcription concentrated in a projection contradicts the open, participatory character we aim to provide for the public. The possibility of setting up a multiple system of screenings and audio-visual consultation points was finally rejected for financial reasons. The ultimate solution, a large open linear structure, seeks to reduce the rhetorical factor in the proposal as much as possible and limits the number of visual elements to those which are indispensable in order to reinforce the idea that translation inevitably generates a new text.

As an experiment and an observatory of its own activity, *On Translation: Museum* gives curatorial practice a chance to review in depth concepts we are constantly juggling with in the exercise of cultural mediation, such as the production, the exhibition genre, the exhibition format, the project or the work process. That makes it necessary to rethink notions like space, presentation, context, audience or distribution. The possible contribution of this curatorial interpretation of Muntadas' work will be decided in the end by those who make use of it as receivers of one or more of the six parts that make up the project. As a visitor to the exhibition, a reader of this publication, an Internet surfer, a participant in the workshop or someone who may feel sympathy with that anonymous image Muntadas has sent to circulate around the city, the next interpretation is of course his or hers.

List of works in the exhibition: **1.** *Emissió / Recepció*, 1974 - 2002. / **2.** *Exposició*, 2002 / **3.** *The Last Ten Minutes* (2nd. version: Washington, Kassel, Moscú), 1977 / **4.** *The Board Room*, 1987 / **5.** *City Museum*, 1992 / **6.** *On Translation: The Games*, 1996 / **7.** *On Translation: The Audience*, 1998 - 2002 / **8.** *On Translation: El aplauso*, 1999 / **9.** *On Translation: La mesa de negociación*, 1998 / **10.** *On Translation: The Bookstore*, 2002 / **11.** *On Translation: La imatge*, 2002

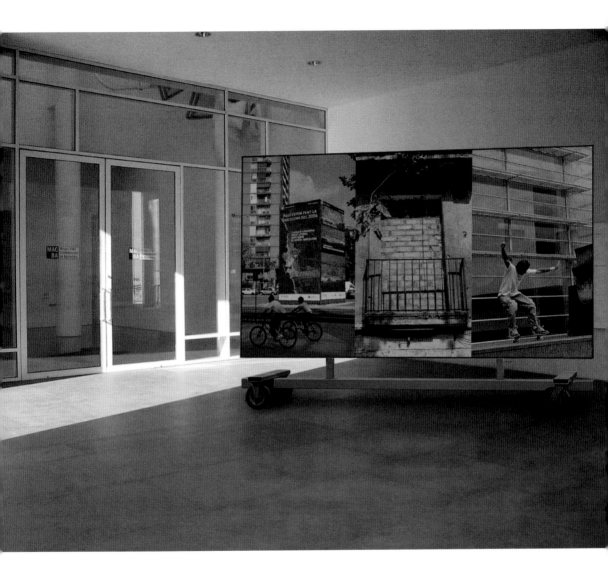

The graphic documentation of each of the *On Translation* projects presented here is accompanied by quotations by the artist, a description of the work, an explanation of the event that it was a part of and an analysis of its contextual situation. Also, a collection of writings has been compiled in which one or more people who collaborated with Muntadas on each proposal look back at the experience and specific aspects related to its development.

On Translation is a series of works exploring issues of transcription, interpretation and translation.

From language to codes

From silence to technology

From subjectivity
 to objetivity

From agreement to wars

From private to public

From semiology
 to cryptography

The role of the translation/ translators as a visible/ invisible fact

Muntadas, 1995

The Pavilion

 1995

Helsinki, Finland
11 February – 26 April 1995

Direction, production and collaboration:
Tuula Arkio, Maria Hirvi, Maaretta Jaukkuri,
Jukka Korkeila

• This installation/intervention was inside a glass pavilion in Helsinki city centre generally used for musical shows. The work, constructed like a diorama, could be seen from outside the building and consisted of an illuminated mural with a large scale black and white photograph of a meeting of the Conference on Security and Cooperation in Europe (CSCE), first held in 1975 in the Finlandia Hall, a building designed by the architect Alvar Aalto. Beneath that large photographic panel, a number of tables were lined up with television monitors on them. The screens displayed the word "translation" written in the six official languages of the CSCE. A series of dictionaries propped up the sawn-off legs of some of the tables and scattered around the floor were posters with the names of the countries taking part in the 1975 conference.

• • The group exhibition *Ars 95*, organised by the Helsinki Museum of Contemporary Art and presented at different venues in the city, was devoted on this occasion to an analysis of the notions of public and private and an exploration of the operation of the structures of political power. Starting from that context, Muntadas had delved into the recent past of the Finnish capital and extracted a historic event whose media representation and public transcendence made it possible to refer in some way to the 'invisible mechanisms' that affect any process of communication and information.

• • • The strategic geographical location of Finland in the European political context, the great renown of its architecture and design, its linguistic peculiarities and the importance of translation in the Finnish context are some of the elements that make up the stereotyped image of the country. In *On Translation: The Pavilion* all those aspects came together through a historic icon that not only reflects local memory but constitutes a staging of the true role of translation and diplomatic agreements.

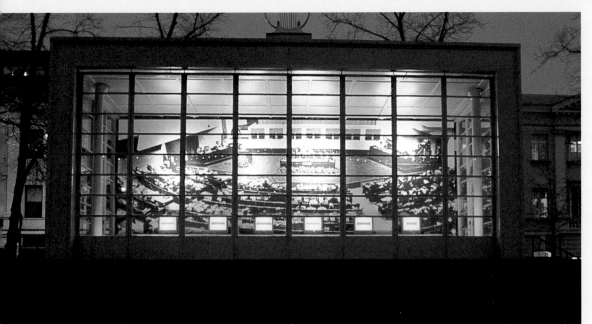

The first instalment of a long-term project under the generic title of On Translation and very broadly related to various forms of transcription, codification, translation, ciphering and so forth from one language to another.

Muntadas, project notes

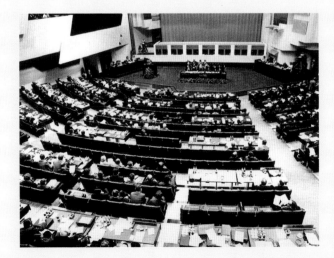

On Translation: The Pavilion Maaretta Jaukkuri

In an interview held in 1995, on occasion of the presentation of *On Translation: The Pavilion*, Muntadas said translation is a vast area incorporating not only languages but also different media, different technologies, oral and verbal languages, and how all these are transcribed or transcipted into/onto each other. He commented on the responsibility of the translator, who is a kind of invisible actor even though crucial in the process. The Conference on Security and Co-operation in Europe held in 1975 had been a celebrated and a highly political occasion, during which the discussions dealt with issues such as human rights, freedom of expresson etc. Muntadas talked about this conference as a fact and as a metaphor – it took place then and there, with all those translators trying to convey what the politicians wished to say to one another, as well as to the people in their home countries and to the international scene in this unique forum, and all this – what was said and what was interpreted and translated – affected the lives of countries and citizens. In the 1995 interview Muntadas said that "it was the language that affected [them], in the same way as art affects people's lives." What is left untranslated – the gap or

the surplus – is the enigma that stays and which needs constant revisiting, re-translating, re-interpreting. Recognising this is of crucial importance today, as we are witnessing processes of cultural encounters which are taking place at such an unprecedented speed in today's world. The enigma, the gap, hides in itself things that cannot – not at least as yet – be translated as they do not translate. Muntadas talks about the work having to be open in the way Umberto Eco has defined this. According to Eco, an open work contains different levels of possible interpretations and the question is more about the ways in which these levels are connected. This openness in the work also offers a possibility of returning to it, in a way a chance to fill "gaps" left in previous translations/interpretations. The openness also demands a degree of abstractness or conceptualisation, allowing several readings. This is as well the moment that offers the viewer a possibility of free interpretation, as the complexity of the work does not yield any simple "solution" and the perception is dependent on the activity of the viewer. The artefact, the work that in this case was installed in the pavilion, "stays passive," as Muntadas comments, while the viewer

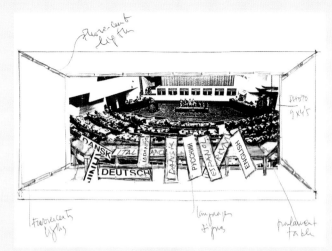

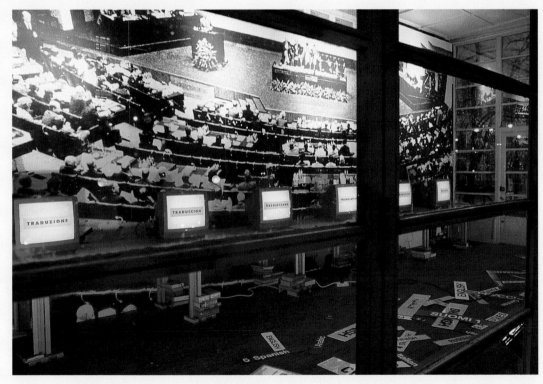

spins his/her story from the threads of
information and experiences that he
gathers from it which resonate with his
knowledge and life-experience.

This work was not in a protected space,
with its specific conditions for rheto-
ric and critique, as Muntadas defines
museums and gallery spaces, but in the
street where people come across the
work and have to contextualize it in their
own way. The pavilion site offered a good
situation for open access. The work was
illuminated in the darkness of the winter
night and invited passers-by to study its
contents. The Security and Co-operation
conference is a famous event in Finland,
so at least the older passers-by knew
well the occasion two decades ago that
the work referred to. And, true enough,
the translators were much in the spot-

light at the time of the conference, as
there were so many of them and every-
body seemed to grasp their important
role in the process. The transparency of
the pavilion also suited the artist's inten-
tions, as in a way it showed in a public
space the work done in the translators'
booths in the Finlandia Hall, while the
entire solemnly ritualistic scene of the
main conference hall was also docu-
mented by means of a black-and-white
photograph.

We were reminded of the theatre of
politics, of its diplomatic manoeuvres,
which were communicated with the help
of the invisible or half-visible actors in
the translators' booths whose respon-
sibility it was to translate all this into
a field of communication and mutual
understanding.

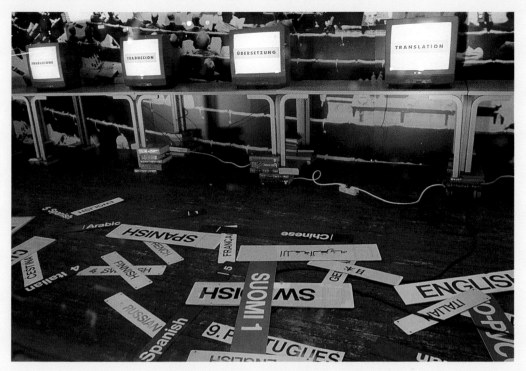

The Transmission

1996

Atlanta, USA – Madrid, Spain
7 May 1996

Direction, production and collaboration:
Caterina Borelli, Bernard Busby, Cedric DeSouza, Fundación Telefónica, Claudia Giannetti, Evan Green, Stephan Hillerbrand, Sara Hornbacher, Michael Kaschewsky, Rafael Lozano-Hemmer, Cathy McCabe, Robert Natowitz, Susie Ramsay, Christopher Scoates, Jim Thomas, the audience at 5CYBERCONF

• This project consisted of a simultaneous transmission through a two-way video conference system. The speakers, Muntadas and Claudia Giannetti – invited to collaborate by Muntadas – took part from Atlanta (local time: 14.00) and Madrid (local time: 20.00) respectively. Muntadas was in a private space (PictureTel headquarters) with students and collaborators on the eve of the Olympic Games that were to be held that year in the city. Claudia Giannetti was in a public auditorium (at the Fundación Arte y Tecnología) before an audience of experts on digital culture. The conversation through comments and questions in the form of images and texts was a symbolic interchange between the two speakers and their different contexts. The constant switching of languages (Spanish, English, German and Portuguese) and the role of the simultaneous translation added new elements for thought in an encounter where the *lingua franca* was English.

• • *On Translation: The Transmission* was conceived as part of 5CYBERCONF, the international congress on cyberculture, art and new technologies held in Madrid. Its intention was to question the protocols generated by the new communication devices. To do so, the work was conceived as a long distance debate in which two supposedly antagonistic events were related: one cultural and specialised, the cyberculture congress, the other popular and media oriented, the Atlanta Olympic Games.

• • • A technological medium like the video conference, mostly used by expert professionals for a commercial and corporate purpose – agreements, ratifications, economic transactions, etc. – acts here not only as a vehicle or channel for transmitting a dialogue but also as a parody of stereotyped communication systems, questioning a certain confidence in technology and assembling an analysis of the idea of virtuality, in which direct physical relations with the world are replaced by a series of new forms of experiencing reality.

Internet is mostly in English and that is a limitation, a problem to begin with. On Internet there is some censorship, because a standard language is used. I have talked about that "loss" in a project like On Translation: The Transmission, *a video conference between Atlanta and Madrid, which, amongst other things, questions the way in which English is becoming a language of cultural colonisation. How can we maintain specificity if everybody uses the same language?*

Muntadas, *Transversal*, nº 1, 1996, p. 11

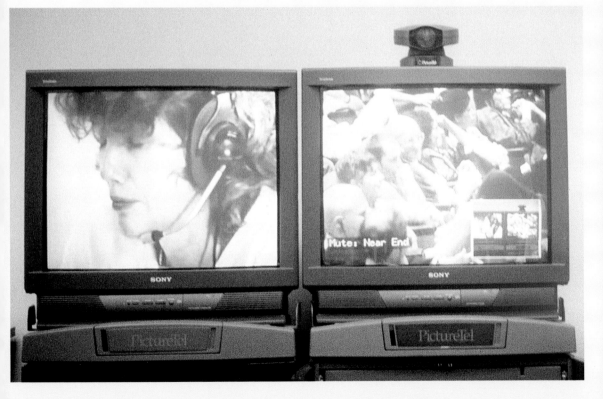

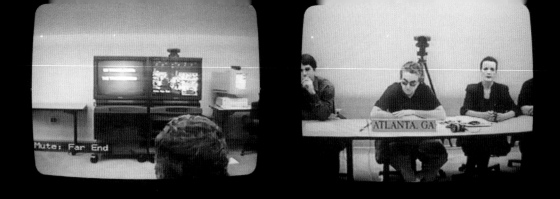

On Translation: The Transmission: The Context
Rafael Lozano-Hemmer and Susie Ramsay

On Translation: The Transmission was a key piece at the Fifth International Congress on Cyberspace, 5CYBERCONF, organised at Fundación Telefónica in June 1996. The congress had always been held in North America, sponsored by Allucquère Rosanne Stone and Michael Benedikt, with the emphasis on research into virtual reality, simulation and interactive environments. The Madrid congress was to be the first of the series in which the term "cyberspace" would be applied more broadly to the "non-place" created by the communications networks and the Internet in particular.

The congress took place a few months after the American activist John Perry Barlow distributed his "Declaration of the Independence of Cyberspace", a utopian document which denounced intervention by nations in the free circulation of information on the net and proclaimed the sovereignty of "a space without frontiers, without privilege or prejudice... an act of Nature [which] grows itself through our collective actions." The text, which moved the magazine *Yahoo Internet Life* to call Barlow the "Thomas Jefferson of the Internet", was published on thousands of web sites and soon became the target of critics, most of them European, who regarded it as deeply ingenuous and far removed from the political, economic and cultural realities of the so-called Global Village. 5CYBERCONF brought together for the first time outstanding exponents of the "Californian ideology", who believed in emancipation through technology, such as Barlow and the inventor of VRML Marc Pesce, and the fiercest critics of those ideas such as the creators of the Nettime list Geert Lovink, Pit Schultz and Diana McCarty.

Up to a point, aware of the confrontation between positions that might unfairly be called "European" and "American", the congress presented contents that deliberately complicated that antagonism. The participation of theoreticians and artists such as Ravi Sundaram (India), Olu Oguibe (Biafra), Sally Jane Norman (New Zealand), Manuel de Landa (Mexico) and Guillermo Gómez-Peña (Mexico), helped the congress to put forward major tangential lines that expanded the field of vision of the event.

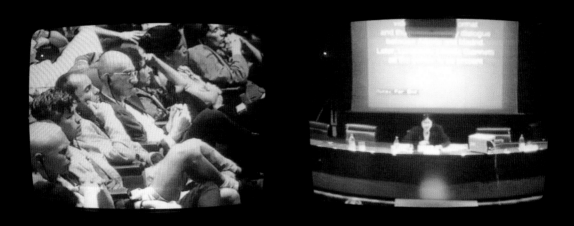

The piece Muntadas proposed for 5CYBERCONF is strategically placed as a vehicle for that expansion. With Claudia Giannetti in Madrid and him in Atlanta, *On Translation: The Transmission* emphasised the form in which communication is not only a product of technology, or of language, but also of those spaces for shared relations, of time lag and echo, of confusion and misunderstanding. Faced with Barlow's monolithic, generalising idea of "the new home of Mind", the multilingual exchanges between Muntadas and Giannetti emphasised the fragility – and therefore the flexibility – of messages, where poetry naturally emerges from the ambiguity of the text and not from its efficacy.

On Translation: The Transmission also operated as a self-reflexive intervention at the congress. The project could be read as a meta-criticism of the corporate dimension required for communication. In the end, 5CYBERCONF was taking place at the corporate headquarters of the biggest Spanish multinational, the same one that was preparing to spread its influence to other countries in the world, especially

Latin America. The complicated logistics of organising the technological paraphernalia used for the video connection, from the PictureTel equipment to the Siemens hubs and the Telefónica digital lines, remind us that telecommunications will never create neutral spaces, free from pre-established interests. In contrast to Barlow's position that the only managers of cyberspace must be the Internauts, the video conference connection showed the layers that interfere in connectivity, the strata which, as was shown by the other modules in the *On Translation* series, are in fact agents of transformation and displacement of meaning.

In the end, *On Translation: The Transmission* happened at the apogee of the congress. An ephemeral connection between America and Europe, multiple robot cameras, simultaneous interpretation, texts and images, all mixed in a long-distance intervention with the aim of disordering – and therefore questioning – the ethical and utopian clichés of the new technologies on both sides of the Atlantic.

Communication and the Failure of Translation.
A Re-reading of *On Translation: The Transmission*
Claudia Giannetti

The images of and reference to the two fires in Margaret Mitchell's house in Atlanta begin Muntadas's transmission, regarding which Muntadas talks about the "silence of the media, hiding certain realities and exploiting others". That example introduces the two central themes of the project *On Translation: The Transmission*: the generation of reality through the selection of the information transmitted; and the role of translation – understood as the conversion of a message from one language to another with no loss of information – in communication. At this event, through video conference, both Muntadas from Atlanta and I from Madrid (5CYBERCONF) tried to avoid the idea of an intercommunication in the form of a conversation and promote a continuous questioning (without answers, of course) of the central themes related to the notions of translation, code, convention and transmission in the context of communication, culture and art.

Some of the political, economic and social events of the last six years have heightened the transcendence of those issues.

A good deal has been written and said about the Gulf War, where censorship was directly related to the demands of the mass media in terms of the visual effects that might bear witness to a "real" war. Nevertheless, the aim of highlighting the flashy US armaments as a display of strength meant that, in the media, the war events were totally preponderant and the human consequences and victims were made to "disappear". Something similar happened again with the events of 11 September and the war in Afghanistan, which showed a profound change in the forms of media representation (and therefore of translation) of disasters and wars in comparison with the earlier preconceived idea – constructed by the media themselves – of the forms in which that type of information should be visualised (transmitted). Individual human tragedies fade away in the face of national interests (state strategies); the translation of the events (the "reproduction" of reality through information) is transformed into free interpretation, with a corresponding loss of information

¿Es la traduccion una de las cuestiones principales?

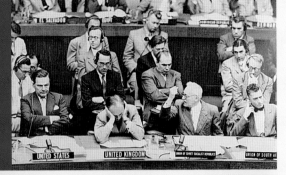

Are conferences based on translation?

¿Cuánto se pierde en la traducción?

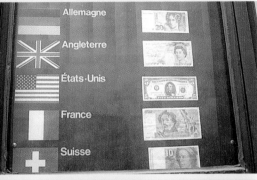

Which is more important, the words or the spaces between?

語

language

and the construction of reality according to the politically correct mass-media version. We are inevitably doomed to be second-hand observers, i.e., observers of observation made by the media.

The translation and transmission of information through the media becomes a synonym for selection, artificialization and persuasion. Niklas Luhmann has come to the correct conclusion that "the media are not guided by the code of truth/falsehood (as science is), but by the code of their programmatic field: information/non-information. That is especially clear because the media do not use the truth as a value of thought."[1] Since social memory feeds on the tales of the mass media, there is a risk that they will be laid down as history.

If at present the flows of information and images make up the basis of the shaping of public opinion, the mass media therefore play the main part in the generation of society's values, beliefs and points of view. Since that participation takes place through the filtering of information and the way in which it is presented in the media, control of public opinion becomes invisible, though effective.[2] In view of that, the active presence in the media, whether of political ideas and projects, or economic, social or cultural concepts, becomes indispensable for their acceptance and integration into public consensus. And artists are increasingly aware of that.

The implicit question in Muntadas's project is still alive: in the face of those serious questions, what are the artist's role and context today? Does some small patch of freedom remain to him to use those media critically? Or is the artist used as an alibi for the people who dominate the media so that they can forge ahead with their strategies?

1. Niklas Luhmann, *La realidad de los medios de masas.* Barcelona, Anthropos Ed., 2000, p. 56.

2. Cfr: Claudia Giannetti, *Estética Digital - Sintopía del arte, la ciencia y la tecnología.* Barcelona, ACC L'Angelot, 2002, pp. 70-71.

¿Que es la razón cultural por la que no hablamos el mismo idioma?

Does this mean that English is "the" language?

¿Perdemos nuestras "diferencias" por la estandarización del idioma?

Can our "cultural differences" be maintained by using different languages on the Internet?

The Games

Atlanta, USA
7 de June – 4 August 1996

Direction, production and collaboration:
Chester Burton, Ronald Christ, Cedric
DeSouza, Don Hasler, Stephan Hillerbrand,
EK Huckerby, Cathy McCabe, Vinhthang
Nguyen, Victor Nubla, Van Maroseck,
Christopher Scoates

• This installation consisted of various parts. The central element was a large glazed, soundproofed booth similar to the kind used by professional simultaneous interpreters. In the interior, on a screen inclined at a forty-five degree angle, video interviews done by Muntadas with eight translator-interpreters at work were shown. The images alternated with slow motion black and white shots of these translators working. The content of the interviews was not audible directly, but through an interpreter speaking Vietnamese, the language of the country with the smallest number of representatives in Barcelona in 1992, the previous venue for the Olympic Games. Through earphones placed around the booth the translation from Vietnamese to English could be heard. Lastly, from the interior of the booth a collage of national anthems could be heard at intervals: *Himne dels himnes*, an audio piece composed by Muntadas and Víctor Nubla.

On the four walls of the exhibition room were four identical clocks showing the time in Athens and Atlanta – venues for the first Olympiad and the one being held that year respectively – and in Barcelona and Sidney, the previous and next Olympic host cities.

Also on the walls was an archive-series of sixteen panels with the frames painted in the official colours of the Atlanta Olympic Games Committee, which showed documents with images arranged in categories such as "technology", "audience", "currency", "flags" and "security".

The installation was completed with a publication containing five interviews done by the translator and writer Ronald Christ with different language experts and a selection of images collected by a group of art history students coordinated by the lecturer Cynthia Kristan-Graham. Those images represented the students' reactions to five emotions – love, anxiety, fear, triumph and joy –, in allusion to the official Olympic Games exhibition which was being shown simultaneously at High Museum Atlanta, devoted to the same emotions.

• • The Atlanta College of Art Gallery, in association with the 1996 Olympic Arts Festival, gave over part of its programme to the organisation of the Olympic Games in the city. In that context, Muntadas' work was conceived as a critical look at the concept of competition and its representations – anthems, flags, medals –, questioning the symbolic values that define the identity of a country and its codes of translation and mediation in the political, cultural and diplomatic spheres. At the same time, *On Translation: The Games* gave similar importance to professional simultaneous interpreters, whose work – anonymous and invisible, monotonous and isolated – thus left its usual peripheral enclave to occupy a central position.

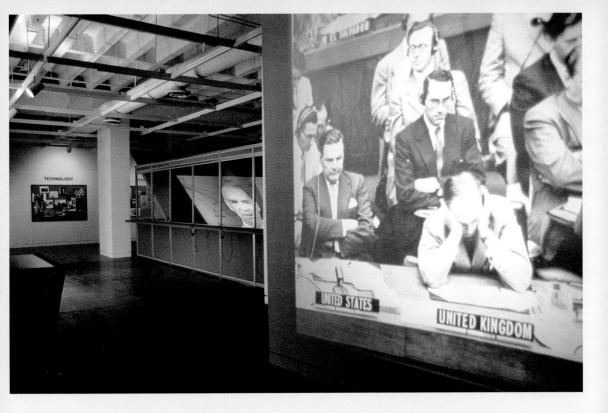

*For the Atlanta presentation, I especially
wanted to consider the role of translation as a
visible/invisible fact, making use of metaphor
but also incorporating this fact in the actual
physical construction of the installation. Since
the translators are always hidden, why not bring
them forward and make them not only present in
but central to the work?*

Muntadas, project notes

• • • For some of the inhabitants of the city, the organisation of the Olympic Games in Atlanta in 1996
was an opportunity to explore the procedures of big conventions and the institutional mechanisms
of official culture. Competition between nations in the strictly sporting sphere was an invitation to
draw antagonistic parallels and to rethink language hierarchies, which also reproduce forms of eco-
nomic, political and cultural supremacy.

On Translation: **In Perspective** Christopher Scoates

Not every word in one language has the same or equivalent in another. Thus, not all concepts expressed through the words of one language are exactly the same as the ones that are expressed through the words of another.

My memories of the summer of 1996 are still very clear and vivid. For thousands of us living in Atlanta, who could ever forget the impending fear of the International Olympic Committee juggernaut coming to town? It was, of course, the year of the Atlanta Summer Olympic Games. It was also the culmination of years of hard work for city officials, politicians, local businesses, and scores of volunteers. It's hard to erase the image of Mohammed Ali lighting the Olympic cauldron, the golden running shoes of American sprinter Michael Johnson, the endless television profiles highlighting American athletes, the enormous logos of corporate sponsors cluttering the cityscape, or Richard Jewel, and the Olympic Park bombing investigation. Indeed, it was a summer when the world focused on Atlanta and the organisation of a global sporting spectacle.

I had followed the work of Muntadas for several years. The relationships between politics, the art world, and the audi-ence had been the focus of his work for several projects. He had developed a substantial body of socially-oriented art that explored a plethora of challenging issues. With installations like his 1988 *Exposicion*, which focused on the art gallery itself and issues of public display, his 1988 work *Board Room*, which drew comparisons between financial power and the rhetoric of religious figures, and his 1989 work *Stadium (Homage to the Audience)*, which explored the media's effect on sporting events, political rallies and cultural entertainment, it seemed only appropriate that for his next large-scale work *On Translation: The Games* the 1996 Olympic Games would be the perfect backdrop.

On Translation: The Games was the second project in *the On Translation* series, the first being *On Translation: The Pavilion*, an exhibition that took place in Helsinki. It is not surprising that Muntadas employed many of the same formal devices and themes employed in some of his earlier works in this new installation. Like those earlier works, *On Translation: The Games* echoed Muntadas's larger thematic interests in exposing the concealed mechanisms, both visible and hidden, of global mass communication. However,

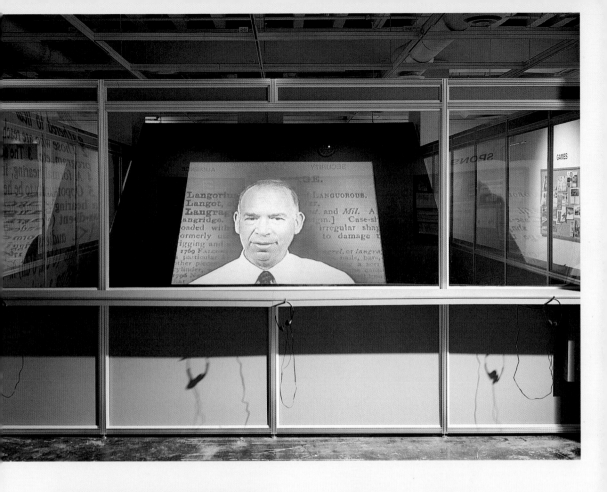

2

Par.si.] 1. translated 2. translation
trans·late (trans lāt′, tranz-; trans′lāt, tranz′-) *vt.* -lat′ed, -lat′ing [< L. *translatus*, used as pp. of *transferre*, to TRANSFER] 1. to change from one place or condition to another specif. *Theol.* to carry up to heaven without death 2. to put into the words of a different language 3. to change into another medium or form [*translate* ideas into action] 4. to put into different words; rephrase — *vi.* 1. to make a translation into another language. 2. to be capable of being translated — trans·lat′a·ble *adj.* — trans·la′tor *n.*
trans·la·tion (-lā′shən) *n.* 1. a translating or being translated 2. writing or speech translated into another language — trans·la′tion·al *adj.*

Gabrielle Merchez

Who set out to be a simultaneous
interpreter but now translates works
as divergent as American thrillers
and Elizabeth Bowen's novels, gives a
French perspective.

the primary themes in *On Translation: The Games* dealt more directly with the concept of the largely invisible role played by the translators at international events. As critic Christopher Phillips points out in his catalogue essay, "Muntadas makes clear that the social terrain in which the translators' work takes place is already demarcated by the power relations that exist between the 'dominant' and 'marginal' languages of global culture." Producing *On Translation: The Games* from a curatorial perspective was all about process. It is important to note that the process of creating this work began years before it was finally installed. Because Muntadas worked with different "specialists" in the community, he attempted to create long-term commitments and relationships with those people so that he could begin to better understand the delicate and complex nature of their work. Without assuming that everybody working on the project understood the goals of the work in the same way, Muntadas would bring all the parties collaborating together to address any questions they may have had. In other words, Muntadas seemed acutely aware of the fact that there were many different technical groups, educational constituencies and audiences working together who all gained from the effort in terms of knowledge and artistic statement. Reflecting on this installation six years on has only solidified how important and vital the venue, the city, and the context of the Olympic Games were for the success of this project. Muntadas created a work that not only raised important questions regarding translation, transcription and codification in its various forms, but created a physical space for the visitor through which the intangible processes of power relations, language and mass visual spectacle could begin to be understood by means of a metaphor made material in a beautiful and exciting way. The translation booth, like the museum, the art gallery, the board room, the stadium, the home and the automobile, was in a long line of archetypal social spaces Muntadas has examined in his concise and spare installations. Like in these other works, Muntadas was able to suggest how the translation booth can function to foster and propagate ideology, particularly when highlighted and seen in the context of a mass spectacle like the Olympic Games.

1. *Muntadas. On Translation: The Games.* Atlanta: Atlanta College of Art Gallery, 1996.

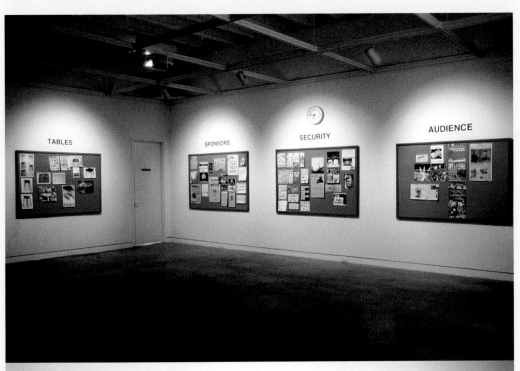

TABLES SPONSORS SECURITY AUDIENCE

TECHNOLOGY

TABLES

APPARATUS

TIME

CLASSROOM

The Bank

		COMPRA	VENTA
DOLAR		29.50	32.50
EURO		29.50	32.50
ARG.		7.50	9.50
REAL		9.00	11.50

1997
2002

New York, USA

1997 - 2002

Direction, production and collaboration:
Andrea Frank, Kent Gallery Editions,
Douglas Walla

• This computer composed image-collage reproduces the stereotyped format of the exchange rate panels usually to be found in banks. Against a background with the rates for the different currencies is a reproduction of a thousand dollar bill beneath which, superimposed on the silhouette of an icon of an hourglass, we can read the phrase "How long will it take for a $1,000 to disappear through a series of foreign exchanges?" Alongside the two elements, in two vertical columns, we can see the miniature flags of twenty-two countries.

• • The work was conceived as part of the group exhibition *The Bank: Inside the Counting House*, which was held in an old branch of Chase Manhattan Bank. On that occasion the theme of translation was approached from the metaphorical perspective of monetary transactions, in which exchange operations in different currencies also involve a series of devaluations which affect the symbolic and real value of the money.

• • • The memory of the building that served as the setting for the project, a deserted bank, brought into the work some thoughts on certain mechanisms of disappearance and dispersion, exemplified economically by the constant fluctuations in transnational mercantile activities, but which can be extended to another type of "invisible movement".

FOREIGN EXCHANGE

FEDERAL RESERVE NOTE

THIS NOTE IS LEGAL TENDER
FOR ALL DEBTS, PUBLIC AND PRIVATE

C 00344788 B

SERIES OF 1934

7 C 00344788 B

THE UNITED STATES OF AMERICA
WILL PAY TO THE BEARER ON DEMAND
ONE THOUSAND DOLLARS

1000

WASHINGTON, D.C.

**How long will it take
for a $1000 to disappear
through a series of
foreign exchanges?**

f-Argent (Peso)				
Brazil (Real)	.9144	.9158	1.0936	1.0920
ound)	1.6106	1.6018	.6209	.6243
fwd	1.6068	1.5995	.6224	.6252
60-day fwd	1.6068	1.5975	.6224	.6260
fwd	1.6027	1.5955	.6239	.6268
Dollar)	.7196	.7201		
fwd				
60-day fwd	.7214	.7227	1.3862	1.3837
Peso)	.002411	.002416	414.80	
China (Yuan)	.1202	.1202	8.3175	8.3171
Colombia (Peso)				
Rep (Koruna)	.0299	.0299	33.40	33.40
(Krone)				
ECU (ECU)				
Sucre)	.000243	.000244	4110.00	4105.00
Pound)	.2943	.2943	3.3983	3.3983
Mark)	.1893	.1884	5.2825	5.3091
France (Franc)	.1674	.1680	5.9755	5.9515
(Mark)	.5620	.5643	1.7793	1.7721
fwd	.5632	.5655	1.7756	1.7682
fwd	.5644	.5666	1.7718	1.7648
90-day fwd	.5654	.5677	1.7687	1.7614
Drachma)	.003558	.003573	281.07	279.89
ng (Dollar)	.1292	.1291	7.7420	7.7440
(Forint)	.0051	.0051	194.56	194.34
y-India (Rupee)	.0275	.0275	36.345	36.390
Rupiah)	.000336	.000337	2975.00	2965.00
al)	.000333	.000333	3000.00	3000.00
Ireland (Punt)	1.4920	1.4965	.6702	.6682
Israel (Shekel)	.2857	.2855	3.5004	3.5025

z-Mexico (Peso)
Nethrlnd (G
N. Zealand
Norway (Kro
Pakistan (Rupee)
y-Peru (New
ilipins (P
oland (Zlot
Portugal (Escudo)
(Ru
Saudi Arab
ngapore (Dollar)
ovakRep (Koruna)
So. Africa (
Korea (
Spain (Pese
Sweden (Krona)
Switzerlnd (
 30-day fw
 60-day fwd
 90-day fwd
Taiwan (NT
Thailand (Ba
Turkey (Lira)
U.A.E. (Dirha
f-Uruguay (N
y-Venzuel (B

ECU: Europe
The Federal
10 other cu
Thursday, up 0.34 point

ON TRANSLATION: THE BANK

On Translation: The Bank Douglas Walla

While Muntadas frequently views the methodology of media interpretation as his art, it is rare that his examination has taken the form of an "intervention", an actual subversive piece of institutional furniture, which could slide seamlessly into the corporate suite. While banks and institutional investment firms typically pose as the site for the growth of capital, *On Translation: The Bank* poses the question of how long it would take money to totally vanish as a result of institutional currency exchange.

The question of money as a topic for art has previously achieved several humorous milestones. Duchamp created a check as a work of art to pay his dentist with *Tzanck Check* (1919), and later attempted to raise money for a gambling scheme with *The Monte Carlo Bond* (1924) which promised to pay 20% interest in 3 years. It took several months for Duchamp to lose most of the money, and from the 5000 francs raised, only 50 francs were repaid. It begins to sound like Wall Street here in New York.

In the seventies, Chris Burden with Crown Point Press created a series of 10,000 Italian lire notes, *Diecimila* (1977), duplicating the handmade paper and appropriate watermark, but within a large paper border to avoid the actual consequences of breaking monetary law. Also in 1977, in keeping with the post-Watergate spirit of America's Bicentennial, Burden published his *Full Financial Disclosure*, detailing his income and expenses, related to his desire to turn his financial resources into viable works of art.

In all, this project struck me as a particularly significant development within Muntadas's oeuvre in that it operates "within" the means of production, rather than through the view of an outsider. Consumers and institutional distributors of currency across international and cultural lines become the meaning, wittingly or not, of the work of art.

大通銀行
誠意邀請
閣下到一個
商業／個人
銀行服務
的新世界
Chase
Invites
You
To A
World Of
Business
And
Personal
Banking

The Internet Project

1997

http://
adaweb.walkerart.org/
influx/muntadas

Kassel, Germany
21 June - 28 September 1997

Direction, production and collaboration:
Documenta x, ada 'web, Cherise Fong,
Andrea Frank, Goethe-Institut and
the chain of translators in 22 countries,
Simon Lamunière, Benjamin Weil

• The project consisted of the creation of a web page for Documenta X, which followed the process of translation of a single phrase from one language to another up to a total of twenty-three languages in the course of the artistic event. The phrase "Communication systems provide an opportunity to develop greater understanding between people: in what language?", originally in English – the standard language of exchange and publication on Internet – was subjected to a chain of translations done by different professional translators. The plentiful documentation and correspondence generated over the period of the project, which was coproduced by Documenta 10, Adaweb and the Goethe-Institut, can be consulted on the Internet.

• • Using the children's game "Chinese whispers" – known in other latitudes as "teléfono", "il telefono senza fili", "Stille Post", "el teléfono descompuesto" or "el joc dels disbarats" – as a metaphor, *On Translation: The Internet Project* looked at the difficulty involved in distributing information on the net, as well as its errors and metamorphoses, its mutations, illegibilities and losses of meaning.
The work aimed to show the problems intrinsic to any process of cultural understanding from a linguistic point of view and at the same time to question the sovereignty of technology as the only channel for those exchanges. As the original phrase suggested, far from providing a better understanding between individuals, the evolution of communication systems masks many doubts and questions relating to the growing degradation of information and its consequent manipulation for the sake of a future which is as visionary as it is, sometimes, blind. The spiral of unexpected twists and turns through which a message gradually loses its literal meaning not only constituted the graphic image of the project and the access interface to the website, it also appeared as a faithful reflection of the changeable character inherent to all translation.

Location: http://adaweb.walkerart.org/influx/muntadas/bk_proj.html What's Related

PROJECT DESCRIPTION

ON TRANSLATION - THE INTERNET PROJECT
is part of the series
ON TRANSLATION, which was started in 1994.

THE INTERNET PROJECT addresses issues of interpretation, transformation, and changes of meaning through the process of translation.

The project was originally conceived in January 1996 as follows:

ON TRANSLATION
The trans/circle/net project. (tentative title)

conceptual bases:

1. a children's game: "telephone", "Stille Post", "Chinese whispers", "téléphone arabe", "il telefono senza fili", "el teléfono descompuest
2. the translation process
3. the internet: the system and the network

An English sentence is sent to a Japanese station to be translated into Japanese, and then to Germany for translation from Japanese to German. After that, it is forwarded to Pakistan to be translated again. The process continues in this manner through a total of twenty different sites until the circle is closed with a translation from Russian back into English. From the last station, the process begins again and goes on indefinitely.

A sentence like: "Communication systems provide the possibility of developing a better understanding between people: in which language?" will go through a chain of translators, who may or may not be using translation devices.

The project proposes that there be a constant flow of changing language in translation. The main focus of the project lies on translation, interpretation, and cultural differences.

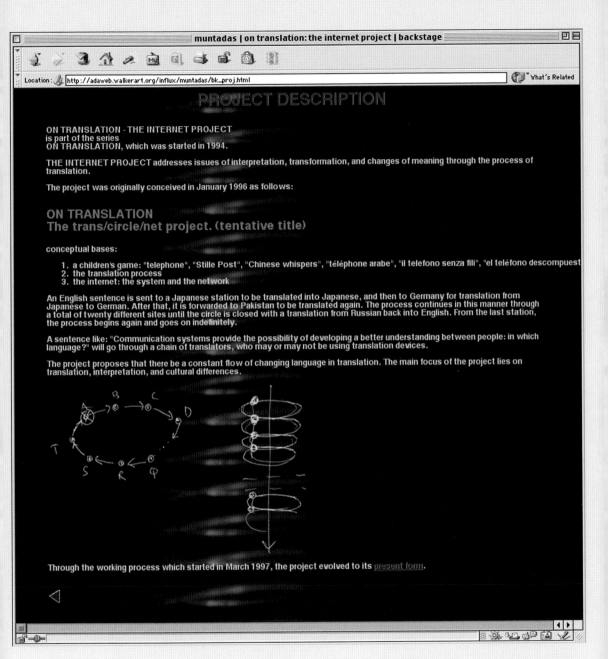

Through the working process which started in March 1997, the project evolved to its present form.

On Translation: **The Web** Benjamin Weil

On Translation: The Internet Project (often referred to as *OTTIP*) explores three functions in three interrelated dimensions of the translation process, three analytical layers that somewhat typify Muntadas's working process.

The first dimension documents the three earlier iterations of *On Translation*, thus presenting a conceptual grounding for the new instalment of the work, while reflecting upon the notion of documentation as a process of translation in itself: with this part, Muntadas was interested in tracing the perceptual shifts generated by the transposition into a new medium.

The second component attempted to use the network for its capacity to transmit information in an almost instantaneous fashion: it was set to observe the way meaning gets distorted through the translating process, by offering a real-time examination of the shift in meaning. A chain of 22 translators, disseminated

around the world, and each representing one of the 22 most spoken languages on the planet, translated a sentence, posted it to the web site, and passed it on to the next translator. Once the cycle was completed, the sentence was processed a second time.

The third part of this work reflects upon the false assumptions made about the network, in the development of the translation "engine": indeed, while *OTTIP* was being conceived, Muntadas assumed it would be possible to use email in order to transmit the ongoing translation of the original sentence, and automatically post it to a web interface. However, because computers function with different character sets that are not compatible, it was impossible, for instance, to read a message written in Japanese on a computer set to function with the Roman alphabet. Equally impossible was posting onto the server messages in any

Όλα τα ακριβή συστήματα ανάλυσης μπορούν να καλυτερεύσουν την ποιότητα του διεθνούς μηχανισμού, ο οποίος χρησιμεύει στην ανταλλαγή πληροφοριών. Το μεγάλο πρόβλημα αφορά την εφαρμοσμένη γλώσσα.

Все точные системы анализа могут улучшить качество международного обмена информацией. Большая проблема состоит в отсутствии единого языка общения.

आज की सभी सही प्रणालियाँ सूचना के
आदान- प्रदान के अंतर्राष्ट्रीय संयंत्र के
गुण सुधार सकती हैं।
बड़ी समस्या है संपर्क की एकसूत्र भाषा
की अनुपस्थिति।

Elke relevante onderzoeksmethode kan de kwaliteit van het internationale apparaat van informatie - uitwisseling verbeteren. Het grote probleem hierbij is het ontbreken van een eenduidige voertaal.

هر متعلقہ ریسرچ کا طریقہ کار الغارمیشن کے تبادلے کے ذریعے بین الاقوامی
مشینری کی کوالٹی کو بہتر کر سکتا ہے ۔
جواصل مسلہ درپیش ہے وہ غیر پیچیدہ طریقہ ہدایات کی کمی
کی وجہ سے ہے ۔

O anumita metoda de cercetare poate îmbunatati calitatea masinariei internationale printrun schimb informational. Problema reala pe care o infruntam se datoreaza lipsei a unor metode instructive necomplicate.

Njia fulani ya utafiti yaweza kustawisha kiwango cha mienendo ya kimadola kupitia kwa mawasiliano. Tatizo hasa tunalolikumba ni ukosefu wa mbinu nyepesi za kuelimishana.

Určity způsob bádání může zdokonalit úroveň mezinárodních akcí prostřednictvím komunikace. Obzvláštuím problémem, který mám na mysli, je nedostatek rychlého systému vzájemného vzdělávání.

A certain means of research could raise the standard of international activity through the medium of communication. The particular problem, which I have in mind, is the inaccessibility to a rapid system of mutual education.

ある種の研究方法は、国際的な活動の基準をコミュニケーション・システムによって向上させることができる。

non-Roman characters, including Arabic, Cyrillic, Chinese, and others... This resulted in having to revert to manual posting of messages sent via "analogue" means of communication (i.e. the fax machine); messages were then scanned, and posted on the web site, as opposed to being posted in real time thanks to an automated system. This "backstage" dimension of the site also served as a repository for source materials related to the translation process, including all the related correspondence, as well as reflections on the automation of such process. It was at about the same time such software as Babelfish was used in web sites such as AltaVista, to enable the immediate – yet somewhat approximate – translation of web pages. Texts, and links to other reference material, also included a mechanism that enabled visitors to add to the database.

Simon Lamunière

Dear Muntadas,

How time has gone by since the project we did for Documenta 10! Indeed, enough time for Documenta 11 to come round. That seems long enough ago to me to conjure up some memories, and yet it all remains quite up to date.
I regularly show my students that project and tell them about its misadventures and complications (that it was difficult to translate a simple phrase!), but especially I list its intellectual and political aims, the link with its other phases (Helsinki, Atlanta, Madrid) and the apparently simplistic analysis of the medium. They are very attentive and amused by the project, and faced with their reaction, I tell myself that despite the time that has gone by and the rapid evolution of the medium, *On Translation* is still up to date.
But now that you are asking for some sort of testimony, that brings back other memories, more disquieting but very much present: notably the stress and exhaustion of your assistant Andrea, who did everything to pass that phrase on from translator to translator, and the precise calm of Cherise, who found a good interface, etc. What I liked about that communal work was each person's commitment in terms of the complexity of setting it up. It goes to show simple ideas are not always easy to put into practice.
So what all that conjures up for me is also the work on the whole Documenta site. Despite many changes "if it was to be redone", I remain convinced that the fact of inviting artists like you, with a language of their own, an experience of the medium and a committed discourse, was what had to be done. The site could have looked different: that is not very important. What is very strong, though, is that *On Translation* exists in its Internet version: its strength is intact, it is an independent project. Even if you link it to other versions, for me it is self-sufficient. It evokes in itself and alone its own genesis and death, and thus knows how to stay alive.
Yours,

Simon Lamunière, 25 June 2002

[cycles]

ある種の研究方法は、国際的な活動の基準をコミュニケーショ
ン・システムによって向上させることができる。
私にとって取り分け問題となっている点は、相互教育の早いシス
テムにたどり着けないことである。

Bestimmte Forschungsmethoden können je nach Kommunikationssystem Grundlagen internationaler Aktivitäten
verbessern. Der Punkt, der für mich besonders zu einem Problem geworden ist, ist, daß man nicht endlich zu einem
schnellen System gegenseitiger Erziehung gelangen kann.

특정한 연구방법들은 각각의 의사전달시스템에 따라 국제적인
활동의 토대를 개선할 수 있다.
본인의 관점에서 특히 문제가 되는 점은 상호 교육를 위한 신
속한 시스템의 달성이 못내 이루어지지 못하고 있다는 것이다.

Los determinados métodos de investigación, según su sistema para la transmisión de intenciones, pueden mejorar la
base de la acción internacional. Según mi punto de vista, lo que es el problema especial es que no lleva a cabo
todavía la realización del sistema rápido para la educación mutua.

إن مناهج البحث المحددة ، تبعا لنظمها في نقل السوايا والاتجاهات ، من
الممكن أن تؤدي الى إصلاح قاعدة النشاط الدولي
ولكن المشكلة الرئيسية من وجهة نظري هي أننا لم نتوصل بعد الى
تحقيق منهج يكفل السرعة اللازمة لعملية التعليم المتبادلي.

Os métodos determinados de pesquisa, segundo seus sistemas de transmissão de intenções, podem melhorar as
bases de atividade internacional. Segundo meu ponto de vista, o problema particular consiste no fato de que ele não
culmina com o estabelecimento de um sistema rápido de educação mútuo.

שיטות המחקר המסוימות, לפי מערכות של העברת כוונות, יכולות לשפר
את בסיס הפעילות הבינלאומית.
לפי השקפתי, הבעיה הייחודית נובעת מהעובדה שהיא מסתיימת עם יצירה
של מערכת מהירה של חינוך הדדי.

De aktuelle forskningsmetoder innen systemer til analyse av hensikter er i stand til å forbedre grunnlaget for det
internasjonale arbeidet. Det vesentlige problemet bunner - i følge mitt syn - i det faktum at det ikke avsluttes med
skapelsen av et raskt fungerende system for gjensidig utdannelse.

I metodi di ricerca attuali all'interno dei sistemi per l'analisi delle intenzioni è in grado di migliorare la base per il lavoro
internazionale. Il problema essenziale prende origine - secondo me - nel fatto che non cessa con la creazione di un
sistema funzionale rapido per l'istruzione reciproca.

Metode-metode penelitian yang digunakan pada masa kini dalam bidang sistem untuk penganalisaan maksud dapat
memperbaiki dasar pekerjaan yang bersifat internasional. Permasalahan pokok - menurut pendapat saya - berasal dari
suatu kenyataan bahwa tidak akan berakhir dengan menciptakan sebuah sistem yang berfungsi dan cepat untuk instruksi
yang bersifat timbal balik.

Tutkimusmenetelmät, joita nykyisin käytetään tarkoituksenanalysointi-järjestelmän alalla, voivat parantaa kansainvälistä
laatua olevan työskentelyn perustaa. Pääasialliset ongelmat - minun mielestäni - saavat alkunsa sellaisesta tosiasiasta,

Tutkimusmenetelmät, joita nykyisin käytetään tarkoituksenanalysointi-järjestelmän alalla, voivat parantaa kansainvälistä laatua olevan työskentelyn perustaa. Pääasialliset ongelmat - minun mielestäni - saavat alkunsa sellaisesta tosiasiasta, että ne eivät tule loppumaan siten, että luodaan järjestelmä kaksipuolista toimintaohjetta varten, joka toimii ja on nopea.

Metody badań stosowane obecnie pod systemem analizy znaczeń mogą usprawnić jakość podstawy pracy międzynarodowej. Moim zdaniem główne problemy wynikają z faktu takiej rangi, że nie można się ich pozbyć poprzez rozbudowanie sprawnego i szybko dzalającego systemu na potrzeby dwustronnej instrukcji dzialania.

Les méthodes de recherches appliquées, actuellement dans le système d'analyse des significations, peuvent améliorer la qualité de la base du travail international. A mon avis, les problèmes principaux résultent d'un fait si important qu'on ne peut pas s'en libérer en développant un système efficace, fonctionnant rapidement, au profit d'un mode d'utilisation bilatéral.

实用研究方法在当前的意义分析中可以改善
国际事物。
我认为主要问题源于这样一个事实：这些问
题非常重大，只有在开发一种有效体系中才
能从这些问题中解脱出来。这个体系运作应
该非常迅速，以有利于双边使用方式。

Αναλύοντας το σημερινό νόημα της κατάλληλης μεθόδου έρευνας, είναι δυνατόν να βελτιωθούν τα διεθνή δεδομένα.
Κατά τη γνώμη μου, το κύριο πρόβλημα πηγάζει από το εξής γεγονός: αυτά είναι σοβαρότατα ερωτήματα, των οποίων οι απαντήσεις μπορούν να βρεθούν μόνο εάν τεθεί σε λειτουργία ένα αποτελεσματικό σύστημα. Αυτό το σύστημα πρέπει να χρησιμοποιηθεί πολύ σύντομα γιατί ο τρόπος εφαρμογής του θα εξυπηρετήσει και τις δύο πλευρές.

Мировые стандарты могут быть улучшены при анализе соответствующего метода исследований.
Основная проблема заключается в следующем. Существуют серьёзнейшие вопросы, ответы на которые могут быть даны лишь тогда, когда будет введена в действие, и, желательно, как можно скорее, какая-нибудь результативная программа, способы реализации которой принесут пользу рбеим сторонам.

अनुसंधान के उचित साधनों के विश्लेषण के माध्यम में विश्व स्टैंडर्ड सुधारे जा सकते हैं।
anusandhān ke ucit sādhanõ ke viślesaṇ ke mādhyam se viśv standard sudhāre jā sakte hāi.

मुख्य समस्या इस प्रकार की हैं भुत ही गंभीर

अनुसंधान के उचित साधनों के विश्लेषण के माध्यम
से विश्व स्टैंडर्ड सुधारे जा सकते हैं।

anusandhān ke ucit sādhanõ ke vislesañ ke
mādhyam se visv standard sudhāre jā sakte hãi.

मुख्य समस्या इस प्रकार की हैं। बहुत ही गंभीर
सवाल हैं जिन के जवाब तभी मिल सकते हैं जब
जल्दी से जल्दी कोई न कोई कार्यक्रम लागू किया
जाएगा जिस के उपलब्ध करने के सिद्धांत दोनों
पक्षों को लाभदायक होंगे।

mukhya samasyā is prakār kī hai. Bahut hi
gambhīr savāl hãi jis ke javāb tabhī mil
sakte hãi jab jaldī se jaldī koī na koī
kāryakram lāgū kiyā jāyegā jis ke up-
labdh karne ke siddhāt donõ makšõ ko
labhdāyak hõge.

Door een analyse van geschikte hulpmiddelen bij onderzoek kunnen universele standaarden worden verbeterd. Het voornaamste probleem is het volgende. Er zijn zeer serieuze vragen die men pas dan zal kunnen beantwoorden wanneer zo snel mogelijk een of ander programma zal worden uitgevoerd. De principes om dit te verwerven zullen in het voordeel van beide partijen zijn.

<div dir="rtl">

معاشرتی لحاظ سے بہتری لائی جا سکتی ہے تحقیق کے مناسب ذرائع کے تجزیے کے ذریعے

سب سے اہم مسئلہ یہ ہے کہ بہت ہی سنجیدہ سوال ہیں جن کے جواب تب ہی مل سکتے ہیں

جب جلد از جلد کوئی نہ کوئی پروگرام لاگو کیا جائے گا جس کے حاصل کرنے کے اصول دونوں

فریقین کے لیے فائدہ مند ہوں گے۔

</div>

Standardele pot fi mai departe îmbunatatite la scara mondiala prin cercetarea obiectelor necesare asistentei. Esenta problemei consta în gasirea unor raspunsuri corecte la întrebari fundamentale. Aceasta e posibil doar prin efectuarea porpriu-zisa a cercetarii. Ambele partide profita prin adoptarea acestui principiu.

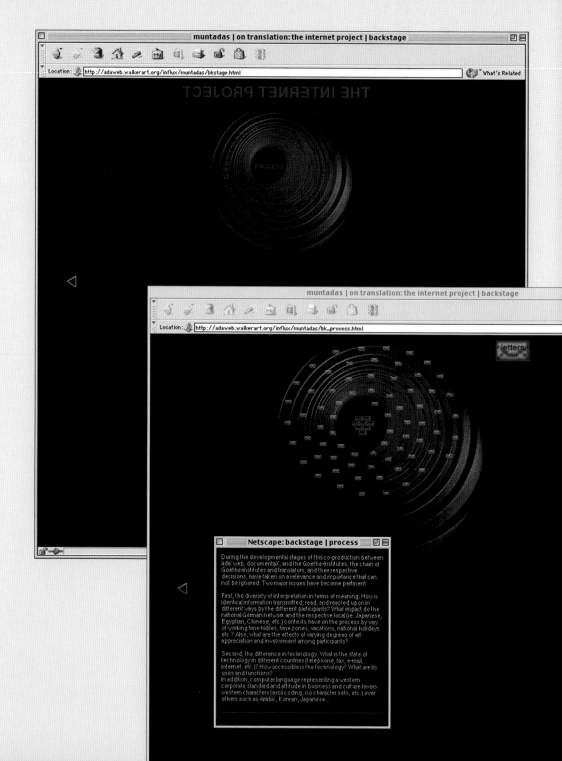

muntadas | on translation: the internet project | backstage

Location: http://adaweb.walkerart.org/influx/muntadas/bkstage.html What's Related

THE INTERNET PROJECT

PROCESS

muntadas | on translation: the internet project | backstage

Location: http://adaweb.walkerart.org/influx/muntadas/bk_process.html

letters

Netscape: backstage | process

During the developmental stages of this co-production between àda'web, documentaX, and the Goethe-Institutes, the chain of Goethe-Institutes and translators, and their respective decisions, have taken on a relevance and importance that can not be ignored. Two major issues have become pertinent.

First, the diversity of interpretation in terms of meaning: How is identical information transmitted, read, and reacted upon in different ways by the different participants? What impact do the national German network and the respective local (ie. Japanese, Egyptian, Chinese, etc.) contexts have on the process by way of working time-tables, time zones, vacations, national holidays etc.? Also, what are the effects of varying degrees of art appreciation and involvement among participants?

Second, the difference in technology: What is the state of technology in different countries (telephone, fax, e-mail, internet, etc.)? How accessible is the technology? What are its uses and functions?
In addition, computer language representing a western corporate standard and attitude in business and culture favors western characters (ascii coding, iso character sets, etc.) over others such as Arabic, Korean, Japanese...

Location: http://adaweb.walkerart.org/influx/muntadas/interpre.htm

What's Related

INTERPRETATIONS

LINKS TEXTS TRANSLATIONS

Visitors were invited to post a link which addressed translation and technological issues, such as:

- New York Times (05-09-97)
 Polish Translation of Pope Bio Left Crucial Passages Out

 Just days before pope John Paul II visits his Polish homeland, the best-selling biography "His Holiness" has become the center of a rare international battle over censorship that pits investigative reporter Carl Bernstein and his New York publisher against a defiant Warsaw publishing house.

- The I Can Eat Glass Project

 The concept of the "I Can Eat Glass" Project is simple—to compile a list of ways to say the phrase "I can eat glass, it doesn't hurt me" in various languages. Pretty easy, eh? The Project lists the language, the location in which it is spoken, how it would be written in the language (if the tongue uses the Roman alphabet), and a transliteration if available. Transliterations are in italics. Languages are now grouped by area. Several sounds have been added.

- 'On se comprend,' by Antoine Moreau

 'On se comprend,¿ (or, "We understand each other.") consists of a window with 8 frames, each containing 12 sentences. Each sentence is translated into 8 languages (English, Mandarin, Arabic, Hebrew, Portuguese, German, Japanese, and French) and corresponds to a site hosting the project. Each site's homepage appears in the center frame after clicking on the last of the 12 sentences.

- Le Monde Diplomatique
 "Demain, la traduction automatique"

 Depuis le mois d'avril 1996, Globalink vend également un programme, Web Translator, qui permettrait aux internautes d'obtenir « une traduction allant à l'essentiel » des textes en anglais, espagnol, allemand ou français rencontrés sur le Web. A la différence des logiciels précédents, Web Translator cible surtout la version : « Pour la première fois, chacun pourra avoir accès à l'information, quelle que soit la langue dans laquelle elle est rédigée », prétend M. Jim Lewis, président de Globalink. Comment de telles promesses sont-elles tenues ?

- El Pais (28-06-97)
 Una Firma de Goya permite reconstruir la evolución del lenguaje para sordos en España

28 March 1997

Location: http://adaweb.walkerart.org/influx/muntadas/letters/mar28fx

What's Related

Fax an Dr Heinz-Hugo Becker
Von Andrea Frank

 28.3.97

Betr. ON TRANSLATION - THE INTERNET PROJECT

Sehr geehrter Herr Becker,

Da nun alle beteiligten Partner der Runde startbereit sind, beginnen wir schon früher als erwartet mit.
Bitte lassen Sie folgende 2 Sätze ins Japanische übersetzen und emailen Sie sie (als "attachment" nach Deutschland:

Communication systems provide the possibility to develop better understanding between people: In which language?

Translation is a means to convey content and meaning. Which, then, is more important, the words or the spaces between them?

Sollte es irgendwelche Schwierigkeiten geben, lassen Sie mich das bitte wissen. Wir sind gespannt, wie das Projekt laufen wird! Vielen Dank für die Mitarbeit.

Mit freundlichen Grüßen,

Andrea Frank

Connect: Host adaweb.walkerart.org contacted. Waiting for re

La mesa de negociación

1998

Madrid, Spain
September – November 1998

Direction, production and collaboration:
Enric Franch, Fundación Arte y Tecnología,
Isaac González, Anton Hansen,
Antoni Mercader, Valentín Roma

• The work consisted of a large round table made up of twelve furniture modules with legs of different lengths and shapes. The table was levelled by piles of books which acted as wedges to balance it. Those heaps of copies, whose spines revealed an avalanche of titles and authors' names in different typographies, alluded ironically to the battles in the telecommunications market. The surface of the table was covered by twelve illuminated maps which referred to different representations of the distribution of wealth between countries.

• • Located in a space not generally used for exhibitions, amidst the historical and technological collection of the Fundación Arte y Tecnología in Madrid, *On Translation: La mesa de negociación* was part of the show entitled *Muntadas. Proyectos*, which also included the video show *Portrait* (1995), the InterRom *Media Architecture Installations* (1995-1998) and the installation *Confrontations* (1973-1974), as well as a set of light tables with documents on the projects done by Muntadas between 1974 and 1998.

• • • Although the work had been conceived in the summer of 1997, by the time it was presented it had acquired an enlarged dimension due to the outbreak in Spain of the so-called "digital war", during which the main media corporations in the country were plunged in an interminable succession of agreements and counter-agreements to share out the exploitation of digital television. Moreover, the work was exhibited at the Fundación Arte y Tecnología in Madrid, in the headquarters of Telefónica, one of the companies involved in the operations.

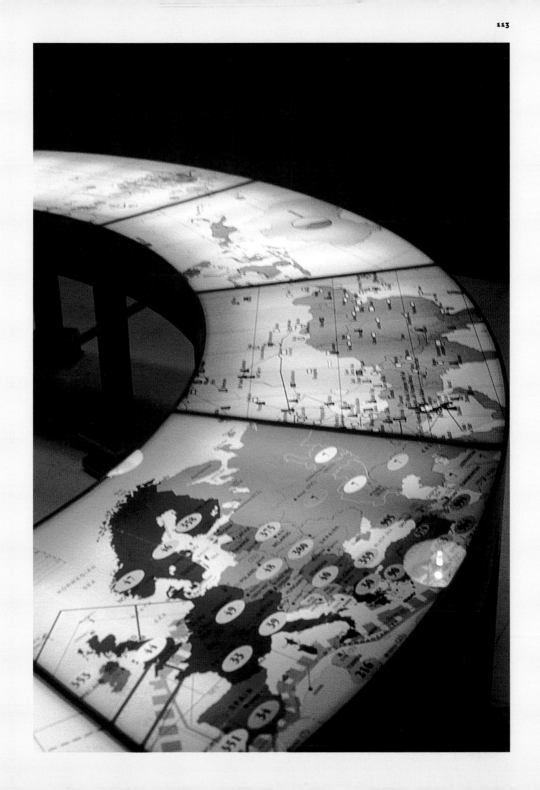

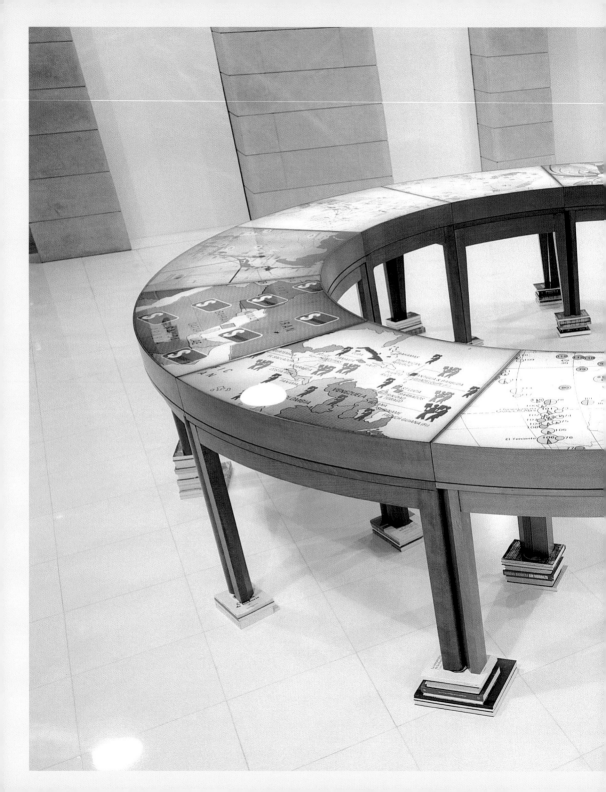

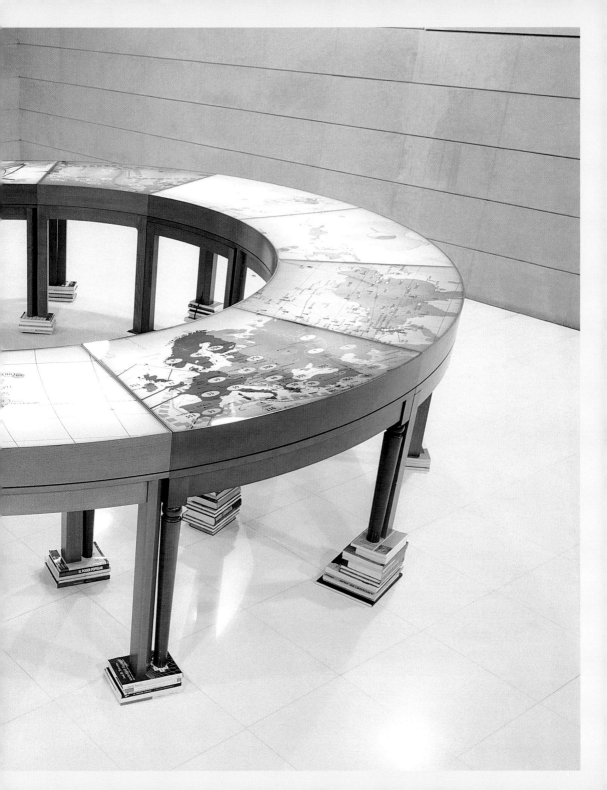

Carpentry and Cartography of the Exhibition
Antoni Mercader

We had just solved a problem; we had been working hard all morning and it was already well after three when we went into the bar-restaurant opposite the workshop. We were hungry and satisfied with what we were leaving immediately behind.

The customers in overalls were setting off to start the afternoon shift.

The first concern of the work team consisting of the author, the designer entrusted with the show, the documentary expert, the technical engineer of the industrial company producing it and the curator of the exhibition *Muntadas. Proyectos* (Madrid: Fundación Arte y Tecnología, 1998) was to solve the complex formal structure of *On Translation: La mesa de negociación* (1998) and its location. We needed to sit down and negotiate.

We did so and the result was to set off to Poble Nou, the Barcelona district where all the post-Olympic hustle and bustle is located now and which had been – and in a way, as you will see, still is – a nest of masters of all trades. And we succeeded: a good professional carpenter who usually worked with the designer and the engineer (they proposed him) joined the group.

The implementation of *On Translation: La mesa de negociación* raised an issue that was half-documentary, half-constructive: we were all aware of it and so we believed in it from the outset. Above the original ideas and the exhibition and communication concepts, however,

hovered a third intangible part that was struggling to make its presence felt.

Later we found out that it was the cartographic part, and by that I do not mean the maps that feature in the plan of the round table, or the exhibition plans, but how the project was organised within the internal space of the work itself and in the external space of the single room on the third floor of the premises which Fundació Arte y Tecnología (now Fundació Telefónica) used as company headquarters – within the museum – where it had been planned to locate it.

We were aware that the logistical and strategic deployment that would make the materialisation of the piece and its location within the show viable was closely linked to the set of main conditions we had to confront.

The inclusion of the master carpenter in the team helped us to get effectiveness in the negotiations and resolution; he, with his professional skill, made the contribution that resolved the exhibition cartography, helping with the procedures of creation, realisation and presentation from his know-how.

Inculcated in the systematics of intuition and the programmatic rigour of the well-learned trade and art, we on the *On Translation: La mesa de negociación* team – in the twinkling of an eye – had the feeling that we were out of danger. We had been protected by the operative application of the parameters of team-

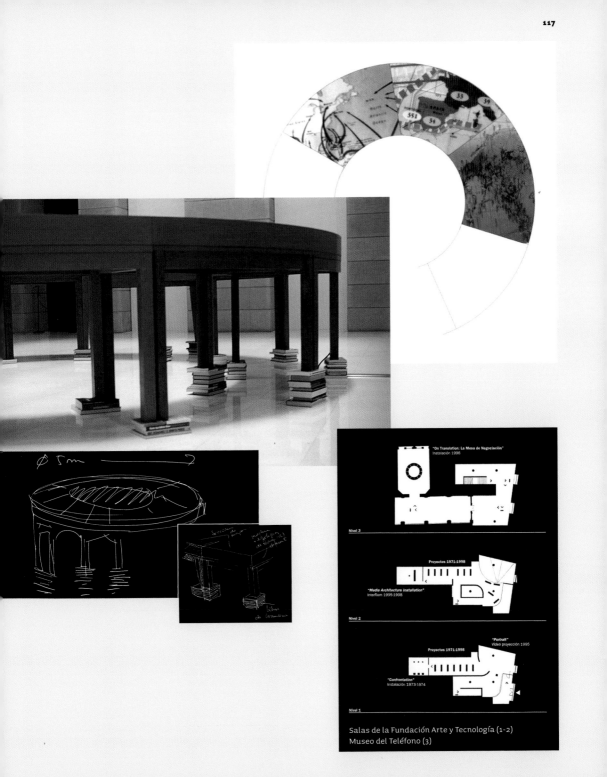

"On Translation: La Mesa de Negociación"
Instalación 1998

Nivel 3

Proyectos 1971-1998

"Media Architecture Installation"
InterRтом 1995-1998

Nivel 2

"Portrait"
Video proyección 1995

Proyectos 1971-1998

"Confrontation"
Instalación 1973-1974

Nivel 1

Salas de la Fundación Arte y Tecnología (1-2)
Museo del Teléfono (3)

work and the proper gestation, application and management of the project. A usual formula and typology of contemporary expression and creation which Muntadas has not only been using for donkey's years, but which he has helped to shape. A modality developed from the structured, documented and thought out overall idea, in which process and confrontation, discussion and group decision-making are of crucial importance. We were sitting at the marble table, no napkins, duralex plates, splendid food: Issac González, carpenter; Antoni Hansen, project engineer; Enric Franch, designer; Muntadas, author and myself, exhibition curator.

Learning to Speak is Learning to Translate
Valentín Roma

I see on Octavio Paz's book *Traducción: literatura y literalidad* a magnificent cover. On it is a photograph of the writer in the foreground and immediately below, separated by a fillet indicating the number of the Tusquets edition, the same image but inverted, as if reflected on a watery surface.

I do not know if it is a representation of Paz's narcissism – I do not think so – or if that cover is a visual metaphor for translation. In any case I have remembered it now because it was one of the two books I was reading during the preparation of *On Translation: La mesa de negociación*. The other was a copy with a battered spine and pages with underlinings entitled *Historia abreviada de la literatura portátil* by Enrique Vila-Matas, with a dedication signed by one María Teresa, which stated roundly and

rather harshly: "for Nicolás, the short." I bought that book in one of those markets where you can buy publications by the pound, a bazaar formed spontaneously by a young man from the Far East who, escaping from the harassment of the police, dragged three or four fruit boxes with piles of books through the streets near Plaza Walter Benjamin – one of the outstanding members of the secret society of portable literature. I mention this event because the improvised library of the smiling Eastern boy, as well as others belonging to Indian women, retired Argentineans, Moroccan poets and laconic booksellers in Calle Muntaner, were the sources of the copies that propped up the legs of the great table of *On Translation: La mesa de negociación*. And the fact is that if there is an idea opposed to the image of Borges' labyrinth, that library that contains all the wisdom of humanity and is set up as a world within a world; if there is a metaphor that opposes Borges' exquisite, idealistic cartography, it is that of the junk literature market, whose anthology of strident titles and fossilised authors is, under the legs of *On Translation: La mesa de negociación*, a skyline of slogans on printed paper, an apocalyptic, Kafkaesque boulevard, a memory of the subsoil.

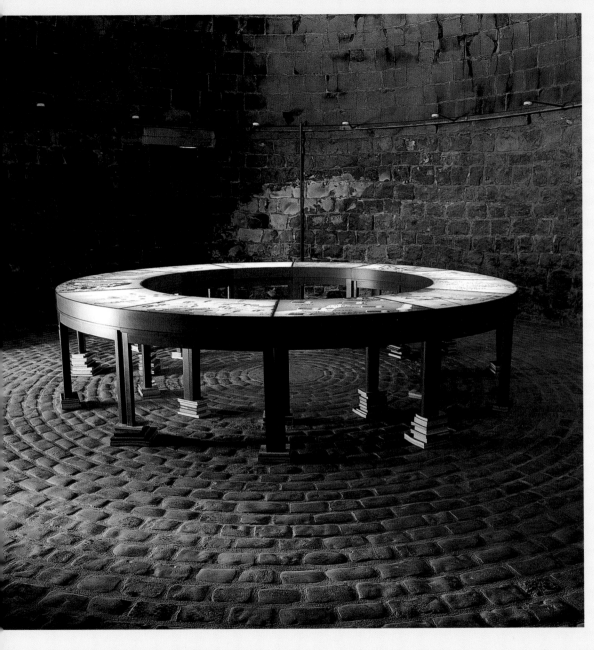

Culoarea

1998

Arad, Rumania
1998

Direction, production and collaboration:
Judit Angel, Sándor Bartha, Andrea Frank,
Mihai Grecea, Dario Grossi, Cristina Panaite,
Leo Serban

• This book, 20 x 14.5 cm, was edited by Judit Angel and printed in Cluj, Rumania, with a print run of five hundred copies. It is a collection of forty-three photographs taken by Muntadas in the city of Arad. On the cover there is only the Rumanian flag with a circle highlighting the blue part of the three-coloured emblem. The publication is completed by two texts: one by Miahai Grecea in Rumanian and English, and a fragment of a letter from Leo Serban to the artist.

• • From his arrival in Rumania from Hungary and from many wanderings around the city, Muntadas noticed the paradoxical and frequent use of the colour blue – similar to the blue on the Rumanian flag – on elements of different kinds: telephone boxes, public transport, maps, awnings, street signs, book covers, roofs of houses, signs in shops, traffic signals and other objects. He then made a collection of over seven hundred photographic records of those images of the layout of the city, from which he selected and published forty-three in the book. The exhibition held at the Arad Art Museum consisted of giving the book to the visitors and a page by page slide show of the images reproduced.

• • • Ceaucescu's authoritarian political regime in the old communist Rumania used the colour red ideologically as a symbol with propagandistic connotations of collective identification. The fall and violent death of the dictator in 1989 marked the beginning of a new historical period for Rumanians. And so the repeated presence of a new colour code, now blue, could be interpreted as a gesture of concealment of the country's past and a reorientation towards a different future.

A colour can be a code, an identification, a choice... implications can be aesthetic, but also more complex, related to meaning and decoding... political, commercial, advertising... A colour's interpretation, transcription and consistence reproduction also depends on other values: technological, economical, etc.

Muntadas, project notes

The Color Blue: A Short Story Judit Angel

I first met Muntadas in autumn 1995 in Bucharest. In 1996, when we met again in New York, we were already talking about a project in Hungary and in Romania, in the Arad Art Museum, where I was a curator at that time. Initially, the Romanian version of the project was to have focused on the subject of monuments, more specifically on public monuments displaced or erased during the upheavals of recent Romanian history, but this would have needed much preparatory research, and since it was not possible to raise the necessary funds, the project took on a more spontaneous nature. Muntadas came to Arad in spring 1998 for a short stay, interrupting his documentation stage in Budapest. He immediately started to take pictures, and the colour blue soon emerged as a kind of interface between him and the city. I remember him enthusiastically coming back from

his third or fourth walk in the city and putting down the structure of the "blue book". As far as I know, nobody identified the colour blue as a code for Romanian reality before Muntadas did. As a foreigner and a trained observer, Muntadas pointed out something invisible, pertaining to the discursive mechanism of the local public space. It was up to the inhabitants to interpret the occurrence of this colour in various contexts. In the publica-

tion this task is performed by two Bucharest-based writers, Alex Leo Serban, a former acquaintance of Muntadas, and Mihai Grecea, contacted through our common friend Dan Perjovschi. Recently Muntadas's perception has once again been confirmed by a young Romanian artist, Gabriela Vanga, who had a similar experience while doing a photographic research on representative street images in Romania.

The Monuments

**1998
1999**

Budapest, Hongary
12 November 1998 – 3 January 1999

Direction, production and collaboration:
András Böröcz, C3 Center for Culture and
Communication, Dóra Hegyi,
Kortárs Müvészeti Múzeum – Ludwing Museum
Budapest – Museum of Contemporary Art,
Eszter Nagy, Katalin Néray,
Miklós Peternáck, Katalin Timár

• This installation was made up of a double video projection on two screens, each of which was divided into seven levels: seven screens – in allusion to the seven bridges across the Danube as it flows through Budapest – hung at different heights in a rectangular space. In that way the double projection, which can be seen from both sides of the room, is segmented as if it were being projected onto a flight of stairs.

The images projected on those two screens had been previously recorded by Muntadas and the Hungarian artist András Böröcz. They reproduced, in the form of a symmetrical dialogue, the subjective sequences they both made following the same itinerary – agreed beforehand – around different parts of the city which, in earlier years, had been affected by history or the successive processes of transformation and modernisation.

•• *On Translation: The Monuments* was presented as part of an exhibition of the same title, along with other of works by Muntadas such as *La Televisión* (1980), *Media Sites/Media Monuments* (1982), *CEE Project* (1989-1998), *Architektur/Räume/Gesten* (1991), *Portrait* (1994), *Portraits* (1995), and a new version of the second of those projects entitled *Media Sites/Media Monuments: Budapest* (1998). In the work Muntadas retrieved the memory of his first visit to Budapest in 1989, a time when Hungary had still not completely moved away from the guardianship of the Soviet Union and complemented it not only with an updated vision ten years later but also through the interchange of readings and reactions with András Böröcz, an artist and a native of the city. The fact that at that time Muntadas only knew the situation of Budapest in part encouraged him to propose to Böröcz that he act as introducer and translator of the context he was working in.

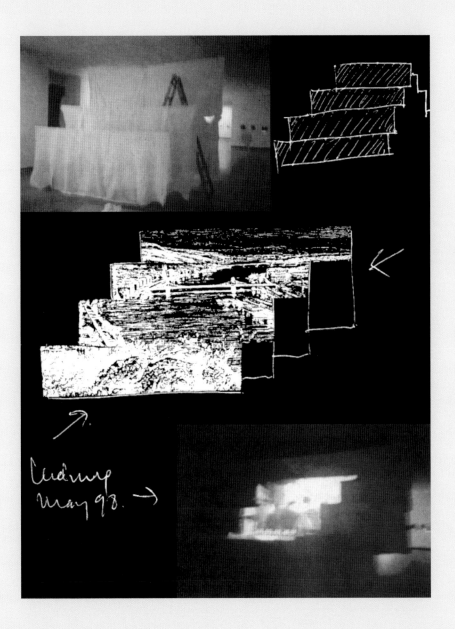

• • • The project was set in the context of a country marked in its recent history by significant social, political, economic, architectural and other changes, which could be extended to the whole of Eastern Europe. The title alluded to the direct connection between those processes of transformation and the city monuments that reflect them, which in a way bring together its historical evolution and memory.

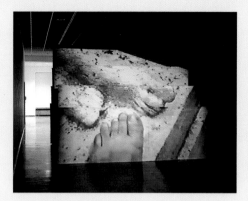 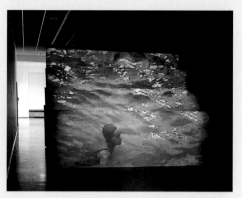

Translating the Past for the Present.
Muntadas in Budapest Katalin Néray

The first visit of Muntadas to Hungary coincided with the political change of regime in Central and Eastern Europe, and since that time he was obsessively interested in the visual traces of the social changes in this region. He started to research the role of the media, the change of meaning or removal of public monuments. He was interested in the *context*, the changing symbols, the mass-media-manipulated content. During his researches on the spot, with the help of Hungarian friends, he found enigmatic press photographs, showing scenes of Budapest during the 1956 Revolution, and he decided to confront them with the same locations at the current time. The change was obvious, and in most cases one cannot feel any hidden messages in the background. Or does one feel? If you investigate the photos more seriously, a strange feeling of absence occurs.

The scenario was rather similar in Hungary and in the neighbouring countries: the hated political monuments were quickly destroyed or removed, and the streets bearing names or events of the Soviet era re-named. The scored-out street signs, side by side with the old-new ones, were functioning as outdoor conceptual art. It was a rich source for artists with political affinity, for talented *voyeurs* like Muntadas or the French

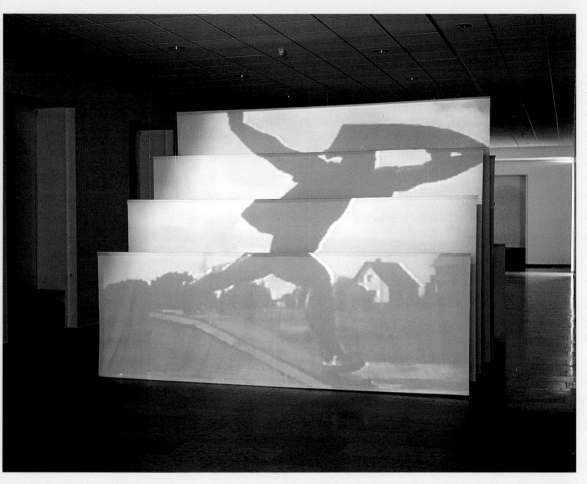

Sophie Calle, who did a project of the same kind in Berlin. Continuing the story of our political monuments, they were gathered in a suburb of Budapest in the [so-called] *Sculpture Park*. There was a long debate about the possible effect of such a place: some people feared that it might easily become a cult site for the extreme left. The opposite happened: it became a tourist target – especially for Western people.

I was wondering what such an out-of-context installation could mean to someone who had not witnessed our history. These statues are mostly bad, made by less talented or even bad artists, which means that the good ones tried to avoid such a commission. On the other hand, if you are familiar with the town, sometimes you can feel the absence of something in a public space, but the truth is quickly forgotten.

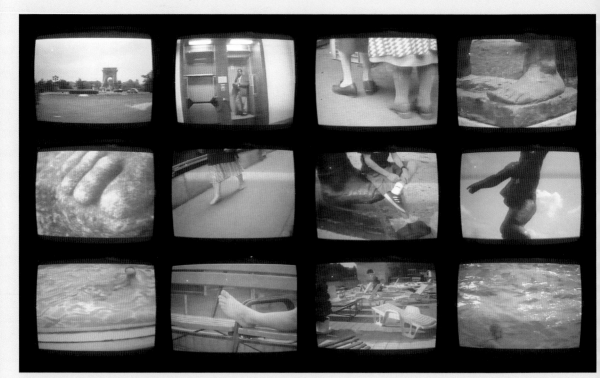

I met Muntadas at the Banff Art Centre In Canada more than ten years ago. During our conversations, he was always interested in events, the history and art of Hungary.

In 1989, he came to Budapest for the first time and his knowledge about the place became firsthand and personal.

His suggestion that his solo show at the Ludwig Museum in Hungary should include a collaboration piece with me is an honor. I liked his concrete idea about making an installation that included two videos, which we made concurrently on a joint trip to Budapest in July 1998. In *On Translation: The Monuments*, the symmetrical installation of seven screens and two projectors facing each other simultaneously project – both Muntadas's and my images on to the same location. The viewer has to walk between the two opposing locations in order to see the separate videos. The screens become sculpture unlike the neutral abstracted surface of a single focus projection in a movie house. The screens remind me of a mirror because of their symmetry and the reference to the simultaneity of time and location of the actual photo shoot. The parallel horizontal nature of these screens also refer to the bridges of Budapest and conjure up sails of old boats.

András Böröcz *On Translation: The Monuments, 1998*

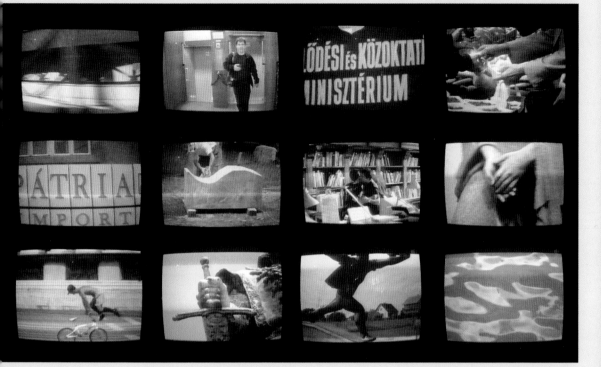

Just as sculpture deals with, refers to, converses and struggles with a physical space, with the space where it is located, scale, size, volume, texture, physical monument, there are works that struggle with another kind of space. A mental, sociological space, the space created by cultural, social and political structures and implications created around us and in the context we live in.

Muntadas. "Detrás de la imagen. Consideraciones personales-públicas", *Telos*, nº 9, Madrid, 1987

The Audience

1998
2001

Rotterdam, The Netherlands
19 October 1998 –
7 November 1999

Direction, production and collaboration:
Ahoy, Gé Beckman, Cinerama, Michel Duits, Paul van Gennip, Yvonne van de Griendt, Line Kramer, Kunsthal Rotterdam, Bartomeu Marí, Maritiem Museum, Museum Boijmans Van Beuningen, Museum voor Volkenkunde, Nederlands Architectuurinstituut, Nederlands Foto Instituut, Rotterdamse Schouwburg, Schielandhuis, Schoolmuseum, Wouter de Nooy

• Composed of different parts, the project *On Translation: The Audience* began with a panel on wheels that spent a year circulating around twelve cultural institutions in Rotterdam – not necessarily connected with the world of contemporary art –, moving every four weeks according to a pre-set schedule to a new institution. The itinerant panel, in the form of an anonymous triptych, reproduced three juxtaposed images taken from the following spheres: cultural expressions (books, paintings, films, musical events), audiences in different attitudes (hands clapping, eyes looking, people watching) and, between the two, the intermediary "filters" between one concept and another (architecture, media and cultural institutions).

The triptychs were deliberately located in transit areas, such as the entrances to museums and cinemas, the precincts of sports facilities and theatre foyers. Those spaces belonged to the typology of "non-places", in other words, they were public spaces defined and signposted by a series of particular semantic codes, lacking neutrality of any kind. On the elements designed to publicise the project – leaflets, posters, website, etc. – the phrase "Warning: Perception requires involvement" was placed, with the subtitle "If you are curious enough to know about the content of this work, we invite you to reconstruct the puzzle of this 12-month project." That phrase was not only a notification of the duration of the project, but also an invitation to take part in it. The project was completed by a website – *On Translation: The Audience: The Web Site* – and a catalogue – *On Translation: The Audience: The Publication* –, which contained a visual intervention by Muntadas entitled *On Translation: The Audience: The Picture Collection*.

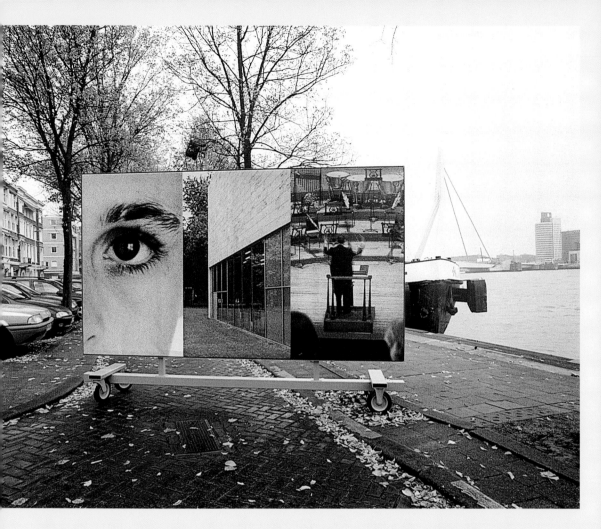

Once again I have to say that each context is different, that there is a cultural history and contemporary priorities. That diversity means that you can betray and act in the same way for all contexts. You have to work with and for. That with and that for are important issues for the artist. With refers to the contractor, the colleagues, the contributors, the interlocutors, everyone who ends up gravitating towards a project. For refers to the audience, the public who will be receiving the intervention.

Muntadas. "Marseille/Givors: de la commande publique à l'intervention temporair", interview with Sylvie Amar, in *Art et Mégapole RN86*. Paris: Mardaga, 1989

•• *On Translation: The Audience* was produced by the Witte de With center for contemporary art in Rotterdam from October 1998 and evolved over the following twelve months, concluding with a presentation at the centre of the twelve triptychs constructed as it evolved. Each of them was exhibited with an "anthropological" type showcase, the documentation that had emerged at the different locations (photographs of the interventions, leaflets and correspondence between the managers of the institutions involved in the project). The catalogue *On Translation: The Audience: The Publication* was also presented at the exhibition. There were also other works by Muntadas, such as the installation *The Board Room* (1987) and a new presentation of *Between the Frames: The Forum* (1983-1993), reinterpreted in association with Wouter De Nooy.

Later *On Translation: The Audience* was contextualised and presented at two institutions in other cities. The first was the Musée d'Art Contemporain in Montreal, where it was entitled *On Translation: Le Public*. To the triptychs created at Witte de With and their associated documentary materials a new one emphasising aspects related to the city of Montreal was added. Once again the exhibition included the work *The Board Room* and a new version of *Between the Frames: The Forum*, in this case reinterpreted by the sociologist Guy Bellavance. The second was held at the Berkeley Art Museum and also had a special triptych for the exhibition, located - like the earlier ones - in the museum entrance area. At the show *The Board Room* and another version of *Between the Frames: The Forum*, in this case reinterpreted by the philosopher John Rapko, were on show once again.

••• Put together from different specific cases and different contexts, *On Translation: The Audience* was part of a broad exploration of the relations between culture and the audience, which pass through what we might call "filters" between them: cultural institutions, media devices and architectural scenarios. With it he is questioning both the central role of those filters as "translators" or intermediaries, and their influence on the construction of values and meanings, in order to show up the factors that determine and interfere in spectators' access to culture, its interpretation and perception.

Translations Bartomeu Marí

On Translation. The Audience was a four weeks installation of a "visual artefact", a kind of advertising panel on wheels, a mobile, travelling object, at the entrances to each institution. The artist had visited the city and its cultural venues, had travelled the streets and public places. The triptychs were put together by Paul who, from the photographs taken by Muntadas, checked their manufacture at an advertising material company. Gé and Lynne transported the materials and mounted the object and the frame at the entrances to the institutions chosen. The incidence of the project in each location was registered through images. We could not – how could we

possible have? – register its incidence on the users, and on the people who worked for each institution.

The work followed a route, a first journey in which it "turned up" in unexpected, or at least unconventional, places. And at the end of that journey, the presentation at the art center conferred a quite different status on it, although the materials were the same, accompanied by documentation on each presentation. Reception of the "artefact", its images, its presence and its disappearance was probably quite different at each place, ranging from indifference to surprise. Had someone forgotten that artefact there? Who? Where did it come from?

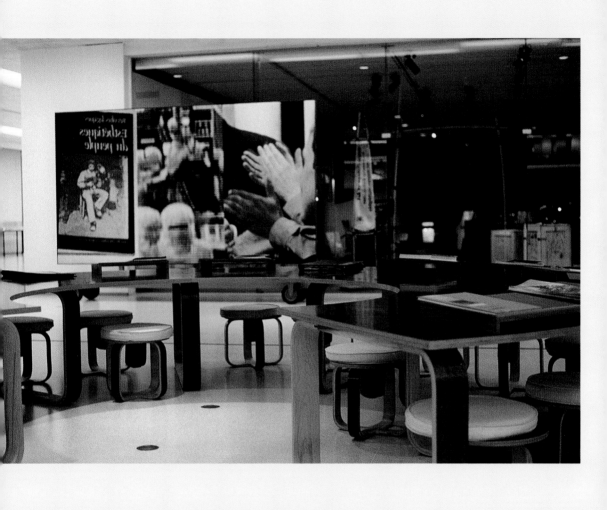

Is there a relation between the audiences of the different cultural institutions? The intention of the work had an interrogative meaning, based on the nature of perception, of visuality, of the access and involvement of the spectator in the different events, formats and materials of culture.

Rotterdam has a million inhabitants according to the most generous estimates. The city has rebuilt a well-deserved reputation as hard-working and in constant movement. Tourism is almost non-existent and it is the region of Holland with the highest unemployment. The city has a dense network of cultural institutions covering a wide range of sizes and goals, from the kind that are typical of a port city in the center of Europe (maritime museum, customs museum...) to museums of architecture, modern art, convention centers or theaters. *On Translation: The Audience* provided an opportunity to react to a series of features of the art of today which have to do with the contrast between the intention contained in the message broadcast and the information received in the end.

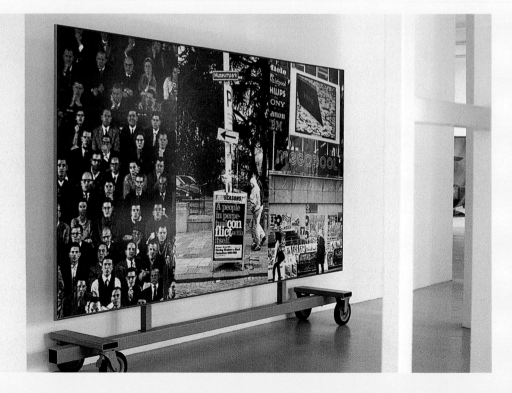

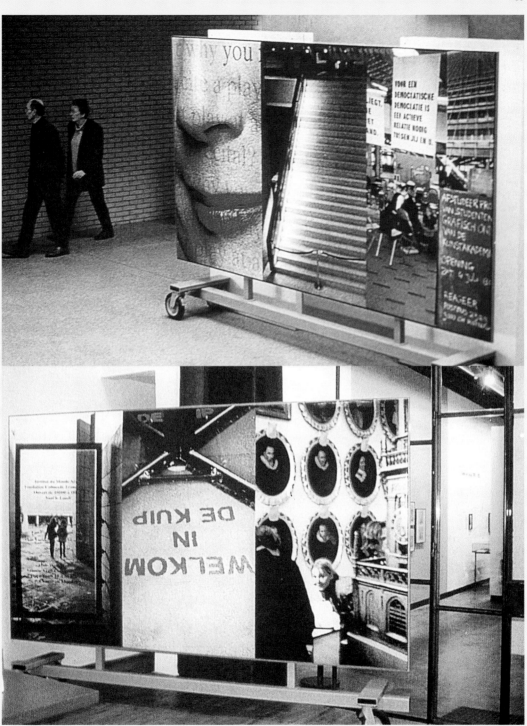

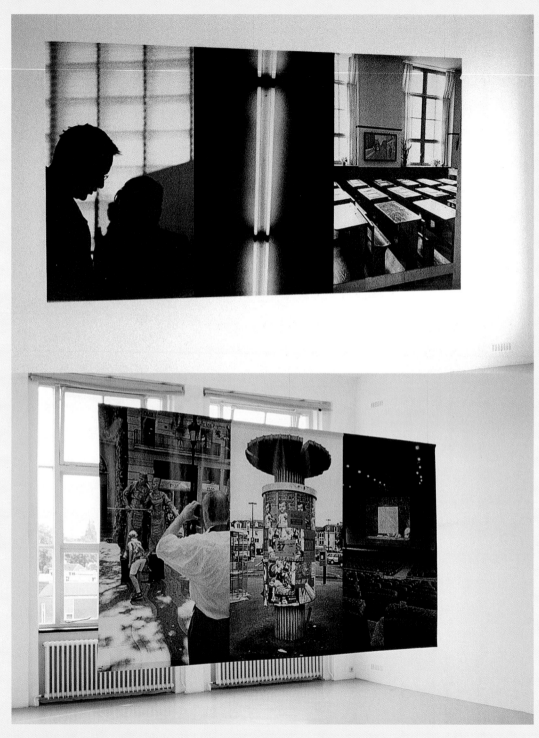

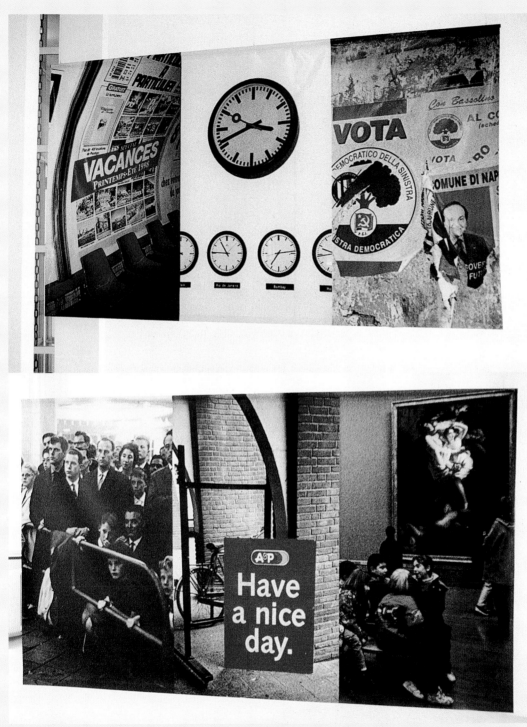

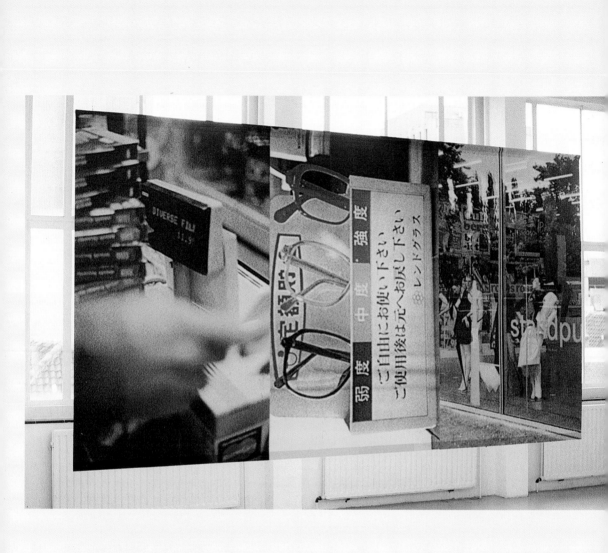

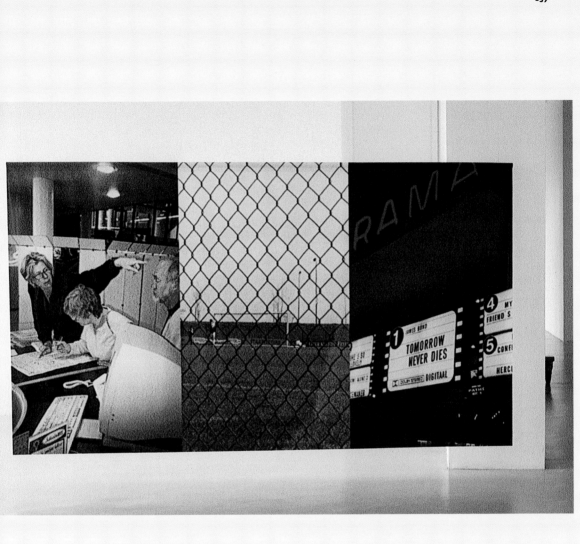

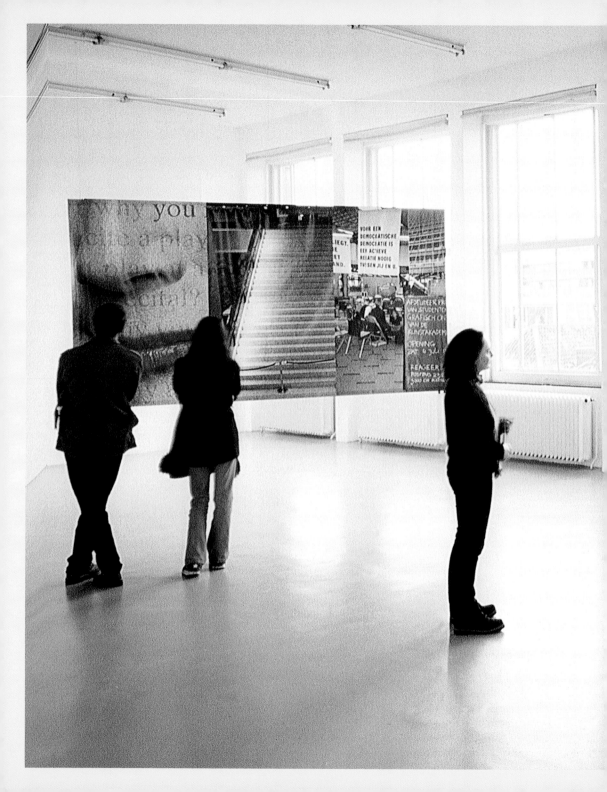

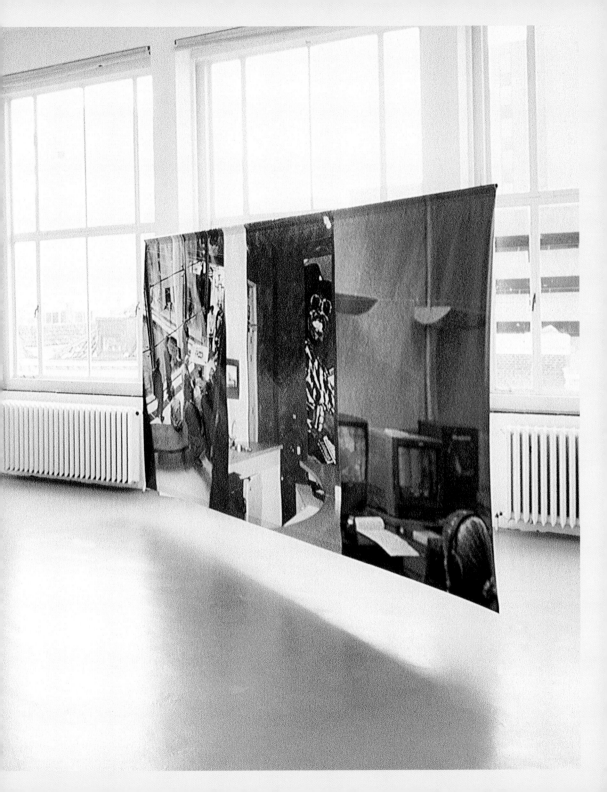

2000
2001

Montreal, Canada

12 October 2000 - 7 January 2001

Direction, production and collaboration:
Guy Bellavance, Musée d'Art Contemporain
de Montreal, Pierre Landry, Emeren García

On Translation: The Audience
Vue du projet en cours de réalisation
Rotterdam, 1998-1999

Muntadas
ON TRANSLATION : LE PUBLIC
DU 12 OCTOBRE 2000 AU 7 JANVIER 2001

ORIGINAIRE DE BARCELONE, ANTONI MUNTADAS VIT ET TRAVAILLE PRINCIPALEMENT À NEW YORK. SON ŒUVRE A FAIT L'OBJET DE NOMBREUSES EXPOSITIONS À TRAVERS LE MONDE (BIENNALES DE VENISE, DE SÃO PAULO, DE PARIS, DOCUMENTA DE CASSEL...) LA PRÉSENTATION MONTRÉALAISE DE CETTE EXPOSITION EST UNE COPRODUCTION DE WITTE DE WITH, CENTER FOR CONTEMPORARY ART (ROTTERDAM) ET DU MUSÉE D'ART CONTEMPORAIN DE MONTRÉAL. UN PROGRAMME VIDÉO RÉUNISSANT DES ŒUVRES DE MUNTADAS RÉALISÉES DEPUIS LA SECONDE MOITIÉ DES ANNÉES 70 LA COMPLÈTE. APRÈS MONTRÉAL, L'EXPOSITION SERA PRÉSENTÉE AU UNIVERSITY ART MUSEUM (BERKELEY, CALIFORNIE), AU DÉBUT DE 2001.

Depuis les années 70, Muntadas pose, par le biais de son œuvre, un regard critique sur la façon dont le sens s'élabore et se transforme à travers différents systèmes de représentation. Dans un monde marqué par l'emprise grandissante des médias et du secteur des communications, ses travaux s'appliquent à dégager les mécanismes sous-jacents à la transmission de l'information et au conditionnement des publics. Sur un mode volontiers métaphorique et sous de multiples formes (vidéo, photographie, son, Internet; imprimés, installations à caractère architectural...), techniques qu'il utilise généralement de façon combinée), Muntadas explore cet espace qui, entre la source d'une information (qui est souvent la source d'un pouvoir) et sa réception par le public, est le lieu de diverses manipulations.

L'exposition *On Translation : Le Public* réunit trois installations majeures de Muntadas réalisées au cours des deux dernières décennies : *The Board Room*; *Between the Frames: The Forum*, et *On Translation: The Audience*. Outre le fait que ces œuvres témoignent avec éloquence des principales préoccupations de l'artiste, leur réunion a pour but de mettre en lumière trois approches différentes relativement au travail de mise en exposition : la «reconstruction» : la mise en place de l'œuvre *The Board Room* répond à des instructions précises, reprises d'une exposition à l'autre; la «réinterprétation» : telle une partition musicale, l'installation *Between the Frames: The Forum* fait l'objet d'une nouvelle interprétation à chaque présentation de l'œuvre; et la «recontextualisation» : créée au regard du réseau des institutions culturelles de Rotterdam, l'œuvre *On Translation: The Audience* voit le nombre de ses composantes augmenter et son champ de références s'élargir en fonction de chaque nouveau lieu d'exposition.

Muntadas
On Translation : Le Public

MUSÉE D'ART CONTEMPORAIN DE MONTRÉAL
Québec ᵃᵃ

1. Ce titre est une adaptation, pour la présentation montréalaise, du original de l'exposition, *On Translation: The Audience*.

HORS-SÉRIE

LE JOURNAL DU MUSÉE D'ART CONTEMPORAIN DE MONTRÉAL

NUMÉRO 2

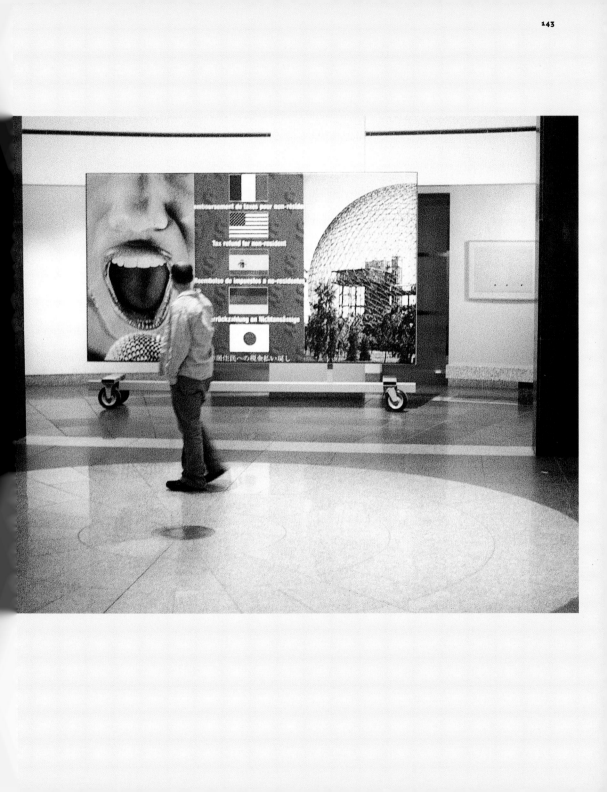

On Translation: The Audience. An Ethic Pierre Landry

Specific and evolutionary. Those two apparently contradictory terms seem to me to fairly define the dynamic at work in *On Translation: The Audience*. Since its beginnings in Rotterdam, *OTTA* has evolved in terms of precise running times and contexts. For eleven months, as many different photographic triptychs were shown, at the rate of one a month, in the circulation areas of a number of cultural institutions in the city. In a second period, the works were exhibited at the Witte de With center for contemporary art with promotional documents relating to the eleven institutions taking part and a twelfth triptych shown at the entrance to the exhibition venue. At the Musée d'art contemporain in Montreal (MACM), where the work was presented afterwards, a thirteenth triptych, done for the occasion, was also shown in a circulation area of the museum. And so on and so on; each new exhibition of the work was accompanied by the creation of a triptych produced by the artist in close association with the host institution. From one exhibition to another, *OTTA* evolves according to the place, the circumstances and its own history. In that respect, *OTTA* is also a work whose limits (both physical and concep-tual) are extensible. Following the example of other works in the *On Translation* series, it tackles the notion of translation in the broadest sense, which, above and beyond the strictly linguistic meaning of the term (passage from one language to another) also includes the multiple forms of transcription or transcoding inherent to the phenomenon of communication. *OTTA* thus brings about a host of relation-ships and overlaps between fields which are both distinct and related – fields that range from marketing to the art distribu-tion networks by way, notably, of archi-tecture and museography – and which all have in common the fact that they condi-tion interpretation or confer a value.

At once specific and evolutionary, *OTTA* goes beyond the dichotomy that often opposes "local colour" and "global vision". The exhibition of this work requires a double focus of the curator – a gaze brought to bear both on the local scene and on an extended network of values and influences. That dynamic, which the visitor is also invited to experi-ence, seems to be proposing – rather than a simple intervention strategy in a physi-cal and social space – a genuine ethic of artistic practice, and in that sense it is the best memory I have of the work.

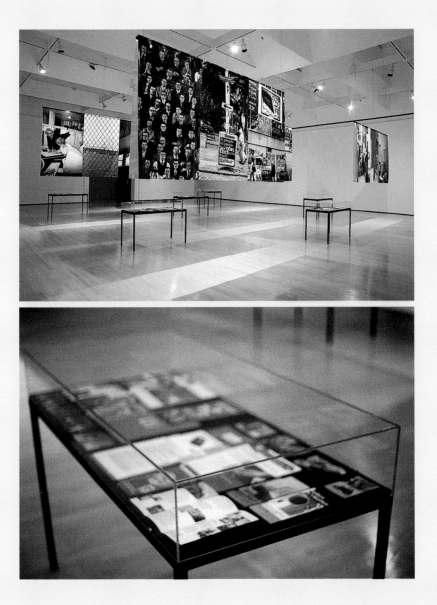

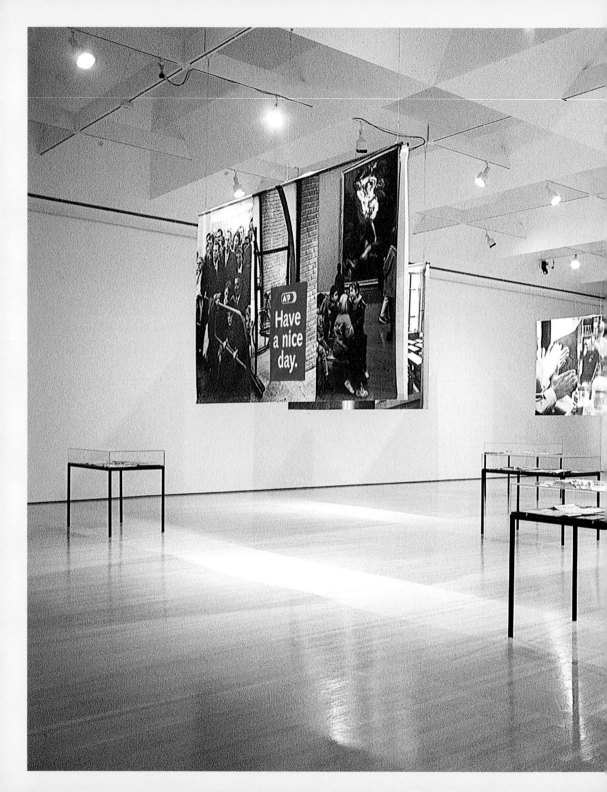

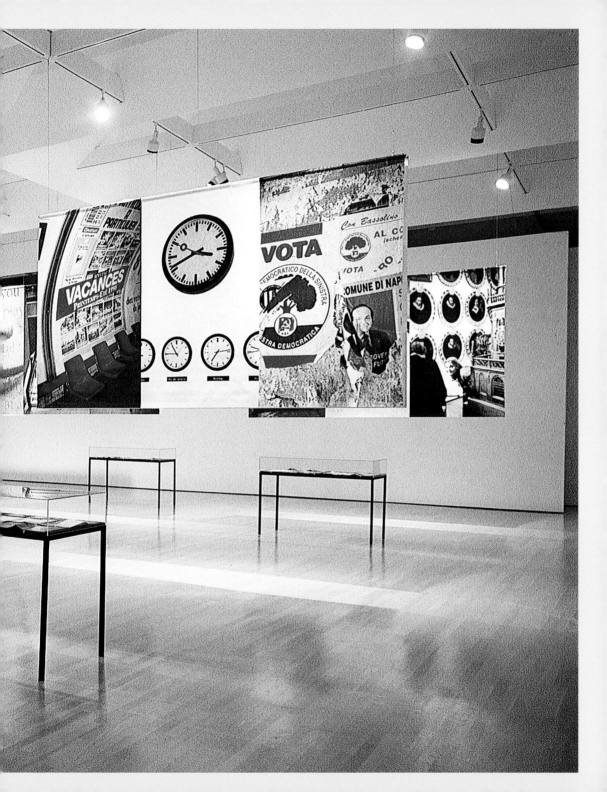

Direction, production and collaboration:
Constance Lewallen, Alla Efimova, Marc Augé

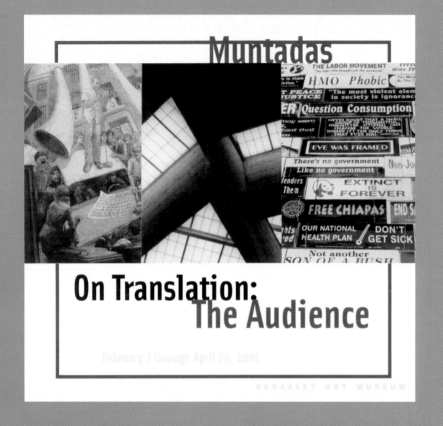

On Translation: The Audience in Berkeley Alla Efimova

When the Berkeley Art Museum opened in 1970, it was the largest university museum in the country. It stood in the midst of post-1968 Berkeley; its internal ramps and outside balconies were filled with young people for whom art and film mattered as much as anti-war protests. Despite the brutalist architecture and thick concrete walls, the museum con-nected, inside and outside, the spaces of contemplation and the spaces of active, political life.

Three decades later Muntadas tried to restore this original relationship of the building to its milieu, albeit in a nostal-gic form. The Berkeley triptych shows the museum skylight – the opaque membrane of the building – in the middle. A mural

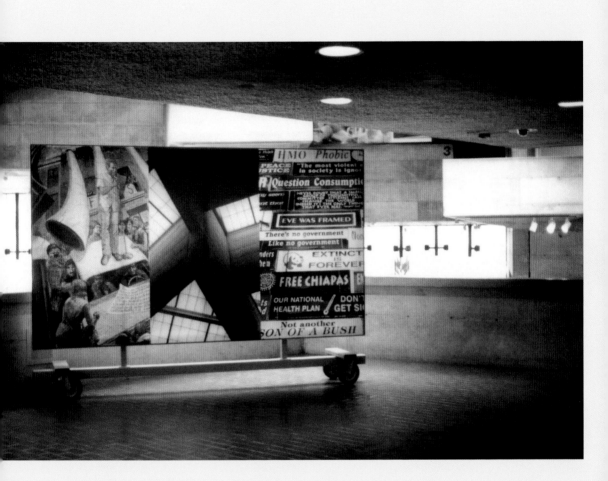

on the wall of the rest room in People's Park, two blocks south, is on the left side, a memorial to Berkeley's infamous past. A display of Berkeley tourist-trade nostalgia – a table of wry political bumper stickers for sale on Telegraph Avenue, two blocks west – is on the right side of the triptych. Thus the image of the museum is surrounded by two references, two visual representations of the past. But the triptych was placed inside the museum lobby and confronted today's visitors who, for the most part, treat the museum interior as a sanctuary. Three decades can change the meaning of a building. *On Translation* addressed this evolution.

The Audience:
The Publication:
The Picture Collection

1999

Rotterdam, The Netherlands
2 September – 7 November 1999

Direction, production and collaboration:
Andrea Frank, New York Picture Collection,
Monique Verhulst

• *On Translation: The Audience: The Publication* is a book with essays by Marc Augé, ethnographer and director of the École des Hautes Études en Sciences Sociales in Paris, and by Octavi Rofes, anthropologist and Studies Director at the school of design Eina, in Barcelona. In his essay, Augé suggested that it should be necessary to reconsider the mediating function of objects, and its contribution in the process of reconstructing reality. Rofes, in turn, presented in his essay an exercise of insertion in the city of Rotterdam taking the project *On Translation: The Audience* and the main traits of cultural turism as a starting point. The publication also includes a reprint of Walter Benjamin classical text "The Task of the Translator" and Barbara Kirshenblatt-Gimblett's "Confusing Pleasures".
This project consists of 17 black and white photographs presented systematically every three pages throughout the book, which Witte de With in Rotterdam published on the occasion of the exhibition *On Translation: The Audience*. The images are taken from the New York Public Library collection – one of the largest image banks in the world – and were selected by Muntadas from key words like "audience", "spectators", "readers" or "listeners" and then reordered and inserted in a different context from their original one. The aim was to show that archives or libraries encode images and words according to a previously agreed cataloguing system which affects their parameters of presentation and interpretation.

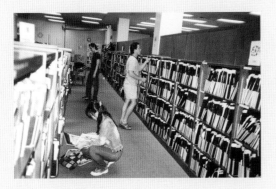

Muntadas
On Translation: The Audience

WITTE DE WITH, CENTER FOR CONTEMPORARY ART, ROTTERDAM

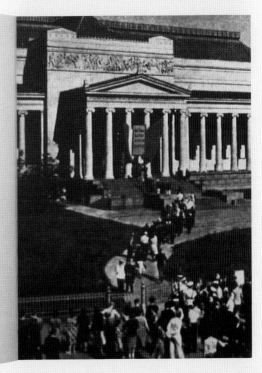

On Translation: The Publication Monique Verhulst

The series in what appeared *On Transla-tion: The Audience: The Publication* were literally meant as textbooks, so hardly any pictures were allowed. But Muntadas came one day to Rotterdam with a whole bunch of slides and pictures from the New York Public Library, and he convinced us of the necessity of having these images in the book. First Muntadas proposed several inserts, at certain moments of the book, each consisting of three images. They should always start on a right-hand page, followed by two images on a double-page spread. This would refer to the *On Translation: The Audience* project in Rotterdam in which cultural institutions had each shown a photographic triptych. Maybe this was too obvious to do, or it was much more than we could financially afford – I really cannot remember the reason why – but we ended up putting one image, full page, on every third page. This also evoked a certain rhythm, to ensure the images could not

be interpreted as mere illustrations to the text, that they were an independent item. Bartomeu Marí and I made a selection, out of the selection already made for the triptych pages, using the same key words as Muntadas did in the library: "audiences", "spectators", "readers", "listeners", "museum visitors", "waiting lines". So next to the written texts there was *On Translation: The Audience: The Picture Collection*. If I skim the publication now, I really would like for there to be a "picture book" with only images out of the "private archive" of Muntadas's picture collection – his choice, his own categories – made out of this amazingly large archive (the New York Public Library contains more than five million pictures!). No translations to other languages are needed, just pictures and audiences to look at them.

One could say of the art object what Alain Badiou says of the poem: the poem (in this case, the poetry of Mallarmé) does not demand that one interpret it, but that one enter its operation: 'The rule is simple: step into the poem, not to know what it is talking about, but to think what is happening there. Because the poem is an operation, it is also an event. The poem takes place.'⁵ Simply, unlike the poem, the object occupies a real place, a material and social space, definable and limited: however exclusive the gaze which seizes upon it and, in a sense, internalizes it, that gaze cannot completely ignore the more or less public space where the object (painting, sculpture, installation) takes place. Thus one cannot separate the reception of which it is the object from the social conditions of its exhibition, nor from the social effects it produces. What happens in the artistic operation always has more or less to do with the relations that it permits or elicits (and this 'more or less' remains an essential question for any theory of art; it is the basis on which art history is written). Because this operation cannot be the object of an exclusive appropriation, its reality is always situated somewhere between the sum of its determinants and social effects and the sheer visibility of its formal presence, somewhere between meaning and space.

Now, all this is shifting today, both in the domain of meaning and in that of space. We are told that the 'great narratives' are dead and that there are no more myths of the origin or of the future. Population movements, the development of communications, and globalization all affect the symbolization of the relations inscribed in space: in short, social meaning (the meaning of the relations between people) is weakened even as the spaces of communication, circulation, and consumption become more anonymous. It is no longer the time of the surreal, of a surplus meaning that reality hid from intelligence, entrusting it to intuition or augury; instead it is the time of de-realization which replaces the depths and meanders of life with the flat visibility of the copy or the simulacrum. Communication replaces language and spectacle replaces landscape.

In this same movement, art arrives at the crossroads; but it quickly looses track of both paths. In its struggle with space, it finds itself at grips with nothing but phantoms of reality, problemless images which break like waves over the world. In its role as a mediator it only intervenes between consumers who deny it any creative role, and particularly the role of a social creator.

5. Alain Badiou, *Petit manuel d'inesthétique* (Paris: Seuil, 1998).

Notes on *On Translation: The Picture Collection*
Andrea Frank

The development process for *On Translation: The Audience*, which was realised in Rotterdam, originated in the New York Picture Library. It was Muntadas who first introduced me to this amazing and strange archive of images in the heart of New York City. It contains thousands of images from magazines and other publications, pasted on standard-size heavy paper, with a shorthand written reference to a file indicating source and copyright. The subjective nature of this archive's filing and categorization scheme makes any search unpredictable, more like detective work. We pulled from rows and rows of green folders in alphabetical order, filled to bursting, according to our chosen keywords, and flipped fast through hundreds of images, which would leave stereoscopic impressions and memories in the mind, until we found the right pictures: people reading, cheering, viewing, libraries, museums, books, etc. The images can be checked out and taken home. The resulting photocopies became the raw material for the Rotterdam collages.

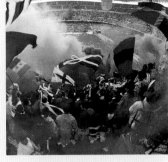
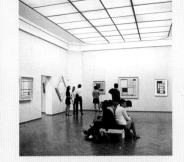
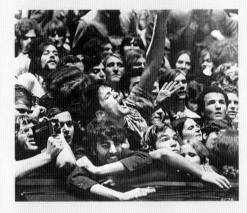

The Audience: The Web Site

1999

Muntadas
On Translation: The Audience
September 12 - November 7

current

The projects of Muntadas focus on the ever changing relationship between art and the mass media

exhibition

lectures & events

On Translation

http://www.wdw.nl/ENG/text/projects/munta199/fr_munt.htm

Rotterdam, The Netherlands
1999

Production and collaboration:
Ariadne Urlus

• Produced in association with Ariadne Urlus, this website was part of the work *On Translation: The Audience*. Simultaneous to the physical presence of the twelve interventions – the twelve panels – at the twelve institutions involved, this web presented them virtually in the context of their respective sites. It was therefore a transposition of the itinerary created by *On Translation: The Audience* to the context of Internet, where navigation and user behaviour are affected by various mediation factors and the same "filters". In this case, however, the confrontation took place between the interface architecture of the different institutions and the virtual, anonymous image of each triptych.

http://www.wdw.nl/ENG/text/projects/munta199/fr_munt.htm

Muntadas - On Translation: The Audience
September 12 - November 7 1999

For many years, the artist Muntadas (Barcelona, 1942) has explored the relations between mass media and art. The exhibition in Witte de With is devoted to three works, a new work titled *On Translation: The Audience* , a reinterpretation of the installation *Between the Frames* , and a reconstruction of the well-known video installation *The Board Room* .

The project *On Translation: The Audience* is a new work consisting of eleven large photographic triptychs each of which were shown in a cultural institution in Rotterdam for one month and are now brought together for the first time in Witte de With. You can follow the projects progress at On Translation.

On Trans-lation

http://www.wdw.nl/ENG/text/projects/munta199/fr_munt.htm

Muntadas - On Translation: The Audience
October 1998 - September 1999

The project *On Translation: The Audience* began in October 1998 when the first of eleven cultural institutions in Rotterdam exhibited a photographic triptych for a period of one month.
The project explores the exchanges within the cultural world. The colorful, mobile triptychs present these exchanges as a three-field system of translation between audience, institute and cultural expression. You can follow the projects progress at:

| 1 | 2 | 5 | 6 | 9 | 10 |
| 3 | 4 | 7 | 8 | 11 | 12 |

The Audience constitutes the latest project in the ongoing series *On Translation* . Focusing on various forms of international communication, the series included, among others, the projects *On Translation: The Pavilion* (Helsinki, 1995) which focused on simultaneous translation within international summit; *On Translation: The Games* (Atlanta, 1996) which examined the exchange of national values and symbols at the Olympic Games; *On Translation: The Internet Project* (documenta X, 1997) which developed the translation of one sentence through 23 different languages and *On Translation: The Bank* (New York, 1998) which dealt with the currency trade in the world of international finance.

Muntadas is especially interested in what he labels as "filters," physical wrappings of exchange which operate between audience and cultural artifact: cultural institutions, architecture, and the media. Contending that these filters greatly influence the shape and reception of the artifacts, Muntadas compares this influence to that of a translator, and views the process from completion of a work to its public presentation as similar to the process of translation. The large, mobile triptychs present this process of translation as a clash of forces in which filters (a concert hall, auditorium, soccer field) are flanked by those of audiences (applauding hands, a mouth, a searching eye) and cultural expressions (a book, a painting, a film).
The monthly exhibition of these triptychs in cultural institutions in Rotterdam was part of Muntadas' case study of the public's viewing behavior. Instead of selecting an exhibition space, the artist opted for showing the work in transit spaces, including museum entrance halls, theater lobbies, and stadium basements. In these spaces, the audience is conditioned to focus its attention to signs for the cash register, shop, cloak room, and favorite destinations. The triptychs seemed out of place. Signs of a more abstract sort, they pointed the visitor to the role of the institution rather than its amenities, to viewing art in general rather than to viewing individual art objects.
The exhibition of the assembled triptychs at Witte de With constitutes part two of Muntadas' project. By taking the works out of the anonymous lobbies and entrance halls and bringing them together in an exhibition space, Muntadas changes the relation between the artwork and its audience. The juxtaposition of a series of similar works and the attention-demanding space alter the triptychs' function and effect. They present the project, as it were, in a new translation.

Witte de With, center for contemporary art, Witte de Withstraat 50, 3012 BR, Rotterdam, http://www.wdw.nl, info@wdw.nl

Translating *On Translation: The Audience*
Ariadne Urlus

The preliminary explanation was amusing, but very disconcerting; only when I saw the works did I understand what it was about: ordinary objects can become art objects.
Anne

Before going I thought: "I'll bet this will be another silly outing!" But I thought the exhibition was really good, because I saw things I liked. What's more, I knew the parts of Rotterdam in the photographs very well. At all events, if I hadn't seen it at Ahoy, I would certainly have just walked by.
Patrick

This school project has been really special. Through an unconventional presentation of conventional images from the newspapers and TV, they've created art objects. All the works have something you can identify, though at times you had to look twice. I thought it was a really good exhibition, even though I had to look really closely at some works to understand them.
Latifa

The guided tour was the most interesting thing, because for me it was the first time I'd seen that kind of art. And just because it was the first time I thought: "How cool!" Anyway, just because it makes you react like that, I think it's great.
Selim

The guided tour was just neat. There are some very original things to see. First I thought that some of them didn't belong in a museum, but after the explanation I realised they did, that they are also part of the museum. And that was the idea! You really need a lot of imagination for that!
Hermon

I found it all very pretty and thought the works of art on show were amusing and entertaining. A shame we didn't have much time.
Good luck!
Greetings from Samantha

wereldmuseumRotterdam *Voorheen Museum voor Volkenkunde* English

○ Algemeen
○ Tentoonstellingen
○ Collectie
○ Voor kinderen
○ Rondleidingen
○ Onderwijs
○ Theater De Evenaar
○ Faciliteiten
○ Zaal huren?
○ Email

Welkom
bij het Wereldmuseum Rotterdam

In het Wereldmuseum Rotterdam staan ontmoetingen en cross culturele inspiratie centraal. Het museum prikkelt en verrast met eigentijdse en historische culturen van veraf en dichtbij. De bezoeker komt hiermee in contact via bijzondere tentoonstellingen en evenementen.

The descriptions in the exhibitions are also in english

On Translation: The Audience

Home Info Current Upcoming Publications Research **History** Kids @ Witte de With center for contemporary art

JavaScript error: Type 'javascript:' into Location for details

Those were some of the reactions from boys and girls between 13 and 14 years old after taking part in a visit to the exhibition *On Translation: The Audience* by Antoni Muntadas, which was held from 12 September to 7 November 1999 as part of the Witte de With center for contemporary art educational programme. That sample of opinions shows clearly and charmingly how a non-expert audience perceive a visit to Witte de With and a project as complex as *On Translation: The Audience*: as a pleasant outing, free, at first glance, from any implications. What happens after an exhibition is open to speculation; much of the way the audi-ence receive the work, how they interpret and assess it, is outside the creator's reach: his influence is limited to the work in itself. The institution undertakes to transmit it. The media also transmit it. And the space transmits it.

In general there is very little control over the final interpretation of the work by the audience. One particular aspect of the teacher's task is that, unlike the artist, you are in direct contact with the audi-ence, and you do not only follow the trans-mission process, you can guide it as well. With *On Translation: The Audience*, oddly enough, that phenomenon made the theme of the project, i.e. the influence

on the perception of art of the "filters" between art and audience, overlap with my function as transmitter. That is why this article is also based on the questions that are raised when one is faced with the unmasking of one's own functions. *On Translation: The Audience* revolves around who understands what, how and where.

The starting points are: the audience is not a stable value; it is a variable receiver with intentions that plays an active part in the perception of a cultural object. The circumstances in which we make contact with art and culture influence the way we perceive art and culture. The receiver, the

location, the architecture of the venue, the means of communication, even the length of the experience, are factors that influence the way a work is perceived and the meaning attributed to it.

In *On Translation: The Audience* those questions take the shape of an experiment that consists of two stages. Unlike scientific experiments, where there are controllable and verifiable conditions, what occupies the central place here is not the result but the investigation itself. In the period from October 1998 to October 1999, a mobile photographic triptych was mounted at a cultural institution in Rotterdam each month. The content

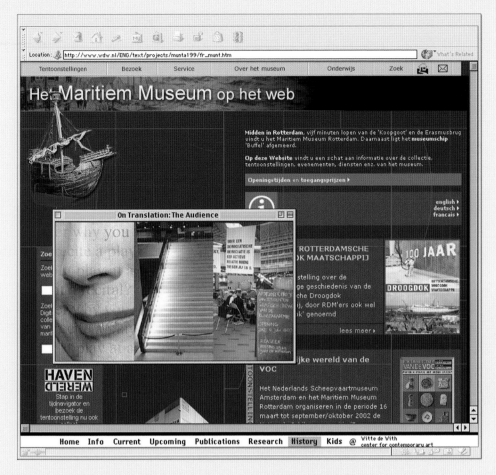

of the triptych changed according to the location. The location was always a "non-place", chosen with great care, which could be a transit area such as a vestibule, an entrance or a cloakroom. In that first phase, the triptychs were more reminiscent of the visual rhetoric of advertising hoardings and signposts than works of art; only the leaflets let the visitors know that the triptych they were passing was part of a contemporary art project. Nevertheless, its status was not defined: the images on the triptychs remained abstract.

A twelfth panel was added to the series of eleven and that total was presented as an "official" exhibition (stage two) at Witte de With from 11 September to 9 November 1999. On that occasion, the works took on another status. The proximity of works of that kind and the context of a recognisable exhibition space modified the function and effect of the triptychs. In this case the project was presented, so to speak, with a new interpretation.

And how to convey that complex process of factors that intervene in the meaning of the work to young people who are being exposed to contemporary art for the first time? We chose to make an experiment. The groups of students were

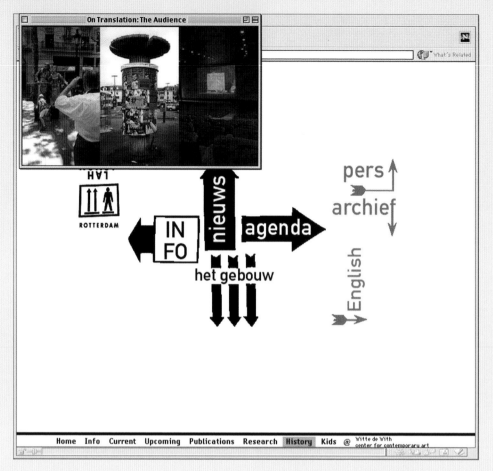

divided into two. One group was given an explanation of the ideas and assumptions behind the *On Translation: The Audience* project and they were guided in their perception during the visit to the exhibition, whilst the other one was not. They went into the room without knowing anything.

How did the two groups interrelate? On what points did their interpretations differ?

It turned out that as soon as they were faced with the works, the theme was revealed. The live interaction, among the works, allowed questions to be asked, such as: what do you think the creator meant by this work? How do you explain this work? How can there be two different explanations? Why are there different interpretations? What has been lost in the act of transmission? What has been gained?

Combined with the triptychs, those questions became starting points for discussions, which at times were very productive. In themselves the triptychs were always the starting point. The students recognised the language of the signs, the codes used and their ambiguous identity. They reacted to the conditions in which they were housed, i.e. within the context of an institution devoted to art. They

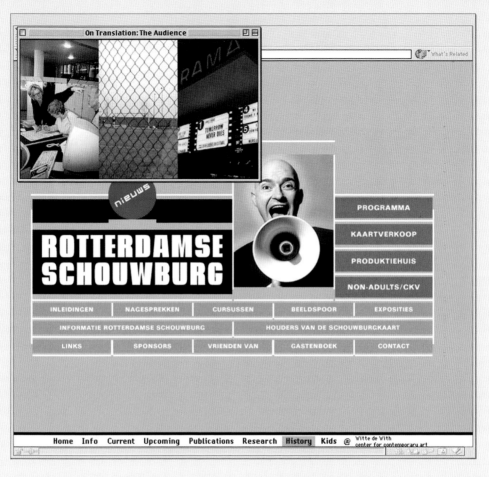

knew the images in the triptychs: (part of) a cultural institution, (part of) the audience and (part of) a work of art. They were able to establish relations between those "filters"; evidently there is a difference between popular culture and art, it is clear that the place where we see a work of art is important, and it is evident that listening to music at home is quite different from listening in an audience among a crowd of people. With no great effort, here and there they went on to talk about the different experiences provided by artistic events.

There were conversations about where the images came from and what it was that made them recognisable, and reference was also made to television programmes, advertisements, magazines, the Internet and images in the street. In a kind of cultural version of Trivial Pursuit, tests were carried out to see who was the first to recognise the three pieces and who first spotted the relation between them.

It may be that, for creators of meanings, this seems to lack implications. That is not the case. Relations are established. The students became involved actively in everything they said and, as conscious receivers, completed the communication process. The fact that the language used

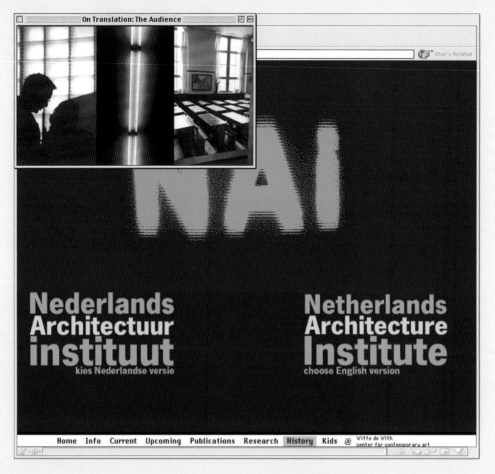

On Translation: The Audience

Nederlands
Architectuur
instituut
kies Nederlandse versie

Netherlands
Architecture
Institute
choose English version

Home Info Current Upcoming Publications Research History Kids @ Witte de With
center for contemporary art

was simple and far removed from art-world jargon is of no importance whatever. When, at the moment of conceiving the work, the artist imagines the audience, he is not usually thinking of a young or, to put it another way, a non-expert one. There is always a friction space between the audience and the art, between the artist and other people's interpretations. Whilst the audience in the know shares at least some of the aesthetic, professional and even institutional conventions with the artist and may thus realise the meaning not only of the work, but also of the relation between the work, the artist, the institution and its own role, the unini-tiated audience has a totally different frame of reference and relies on other criteria which are not derived from or bounded by the contemporary art world. An intrinsic factor of art education is the friction zone between the complexity of the work of art ("the artist's message") and the (im)possibility for the audience to make that message their own. More-over, more than one interpretation is possible.

For the non-expert art audience (that is, an audience which has not been condi-tioned and is unaware of the conven-tions), contemporary art is in a way so "unrecognisable" and diffuse in its form

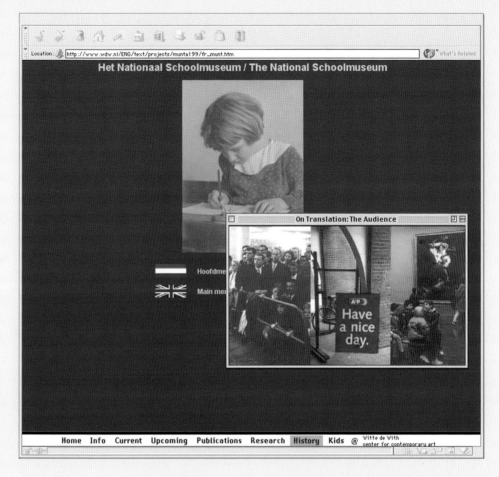

that not even within the context of an art institution (official exhibition spaces) do its members recognise or appreciate it as such immediately. At all events, that does not prevent young people from taking part in it. The crux of promoting interpretation skills in students (i.e. taking them by the hand and making them participants) also involves discovering their frame of reference and experiences and placing all that at the center of the dialogue. In this concept of art education, the entity in charge of the teaching (the school) ceases to be a transmitter of knowledge and becomes more of a component in the transmission process, a kind of chairperson. That turns the audience, however young they may be, into participants. It is evident that a space of that kind enables a wide range of personal interpretations.

El aplauso

1999

Casa de Moneda – Biblioteca Luis Ángel Arango, Santafé de Bogotá D.C., Colombia
August – October 1999

Direction, production and collaboration:
Bill Horrigan, Wexner Center for the Arts (Columbus (Ohio), Carolina Muñoz, Luis Ángel Parra, Luis Fernando Ramírez, José Roca, Gabriela Salamanca

• This video installation in the form of a triptych was shown on three adjacent screens. On the two side screens the images and sound of the applause of the audience at an unspecified event were oriented towards the central screen, where the audience clapping were shown front on. At regular fifteen or twenty second intervals, the image being shown on the central screen changed rapidly, in a kind of blink of the eye or subliminal snapshot, giving a glimpse of an image of overt violence, in black and white and with no sound. Those images, which tackled violence in all its categories, came from Colombia and other places around the world.

• • With other earlier projects, this work was part of the exhibition Muntadas: *Intersecciones*, which took a look at the processes of transformation and translation of violence into a media spectacle. The applause – understood as a social convention denoting consensus, satisfaction and acceptance – was approached as a metaphor for the immaterial identity of the audience, their alienation and complicity, represented here by the repetitive, monotonous gesture of clapping.

• • • Starting from an analysis of the local context of Colombia, a country in the grip of extreme violence, corruption and social inequality in the face of international incomprehension, passivity and indifference, in *On Translation: The Applause* Muntadas drew a portrait of the obscene morbidity with which the media translate and accept atrocities committed all over the world.

Shows *are* presented by the producers, managers, conductors, etc., through packaging and multimedia presentation to submerge the audience in a conscious/ unconscious state of leisure. Indoctrination and control come via entertainment, in the shape of games and competitions, and the seduction of the audience through monumental, spectacular shows is the ultimate success. The audience is then trapped and consumed.

Muntadas. "Notes on *Stadium*", in *Stadium*. Banff: Walter Phillips Art Gallery, The Banff Centre for the Arts, 1989

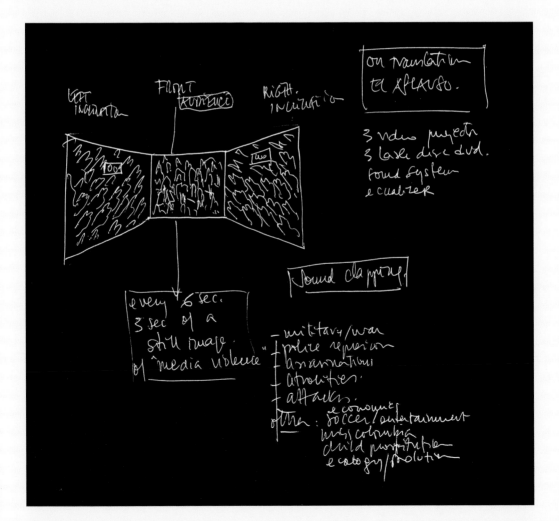

Muntadas: On Translation: El aplauso José Ignacio Roca

For artists who see us from outside, coming face to face with the "reality of Colombia" has always meant a conscious operation of resistance to what constitutes the stereotype of the country (drugs, violence), which – like all stereotypes – is an out of context exaggeration of real, unquestionable facts. Muntadas is not exactly a visiting artist, or at least he is one of a different kind. Since travelling is a constant, inseparable practice in his work, a reading of new contexts is inevitably part of it, and so it would be correct to say that his sensibility has been exercised in a sharp, deep reading of contexts which he is encountering for the first time. In other words, his work is based *precisely* on that constant operation of moving from one place to another which, as Eugeni Bonet recalls in his essay on Muntadas's work,[1] is one of the meanings of the word "translation".

On his first visit, with the selective vision supplied by his experience, Muntadas identified two contradictory aspects of our reality. First, that the situation in the main cities such as Bogotá and Medellín is "less serious" than was supposed; that life there goes on without the feeling of war or imminent danger that is assumed to exist from outside. Second, paradoxi-

cally, that the situation is also more serious than is thought outside – in other words, what is known about Colombia outside does not manage to express the tragedy of the country on its full scale; over thirty thousand people (mostly men between the ages of 15 and 30) have died in violent circumstances, insurgence pervades the whole territory, and the capital cities – as in the Middle Ages – are sheltering behind their barricades of soldiers defending the status quo. The rest of the country is at war, but that only reaches the capitals through the media.[2]

That has meant that the experience of the conflict people in a city like Bogotá have is not essentially different from what people outside might have, in the sense that there is no real, first-hand experience of the massacres, the attacks on the infrastructure and the sieges of towns; those events are not *lived* as local ones, but are *perceived* almost exclusively through the media, in particular television.

But even through the media there are obviously great differences between perceiving the Colombian war from outside and from inside, above and beyond the absence of context. One of the essential differences between the perception of

ON TRANSLATION : The Adapter
A project by **Muntadas** and the **Department for Public Appearances**

Presenting

Cesare Pietroiusti - The Human Adapter
A personalized introduction and exchange of ideas
for newcomers (and not) to the cultural life in NYC

Tues and Thur, 3 - 5 pm, from May 30 to July 6, 2000
At **Art in General**, 79 Walker Street, NYC, 4th fl.

Appointment by phone: 212- 219 04 73

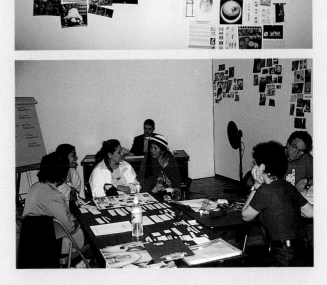

May 9. Gallery opens to the public. A kind of work routine sets in. At least one artist and Barbara are in attendance every day. I walk through the gallery. Muntadas is discussing the project with two Cuban artists; Silke is surfing the web in search of adapter-related images. Poster idea is further explored with thoughts of distributing it in a small box, stamped with: "Adapter?" Muntadas would like the paper to be as thin as that used for the usage instructions with medicines, to reference "both an ordering catalog and pharmaceutical instruction". Barbara calls the industry to discover that all related pharmaceutical info is classified. Within three weeks the gallery has been transformed into an oversize bulletin board half covered with adapter interpretations. The vastly varied responses - ranging from auto-biographical to narrative, conceptual to descriptive, whimsical to ideological - convey the broad cultural diversity of the participants.

May 30. At Muntadas's suggestion Italian artist Cesare Pietroiusti is incorporated in the project and sets up shop in the space as the "Human Adapter": a persona offering visitors a personalized introduction to NYC's cultural life. Much of the residency's spirit is embodied by a fluidity that readily welcomes new components. Friends and visitors come and go, compare their adapter versions and discuss those displayed on the walls. Encounter with a scientist whose interpretation uses math equations, an adapter that ironically remained opaque for much of the public. Reminds me of a very comic scene in Botho Strauss's play *Trilogie des Wiedersehens*, in which a depressed pharmacist confides to an artist that he feels as if his life is dissolv-

ing like an aspirin in a glass of water. To which the equally depressed artist angrily responds that not being a pharmacist but an artist, he can't relate to the feeling of the metaphor.

June 8. Gabriele arrives in NYC. Silke scans interpretations and experiments with ways of designing the poster. Much industriousness. Gallery has evolved into a social space where visitors engage with each other & the artists. The adapter concept prompts many conversations around such topics as the personal, societies in transition, globalization, technology or hybridity. A group of young students from a Chinatown high school visits the gallery. They are very excited about the adapter question. Most of them recently emigrated from China and have become translators of US culture for their non-English speaking parents. They make drawings that convert mountains, fields and boats into skyscrapers, stores and computers.

July 8. Closing day. A participant who has changed his mind about his interpretation comes back to switch it! Yet unrealized idea (lack of time and money): the manufacture of a "pill adapter" packaged for automatic dispensers. It would be available for a quarter at airports and other sites and provide travelers "instant adaptation" as they cross over from one place to another. "The great debates," wrote Deleuze, "are less important than the spaces of knowledge which make them possible." This is in a sense what the project illustrated for me. In the end the artists successfully engaged the public with a concept, and in the process of transforming it into images or words the participants became the project's co-artists, cultural critics, performers, authors or poets.

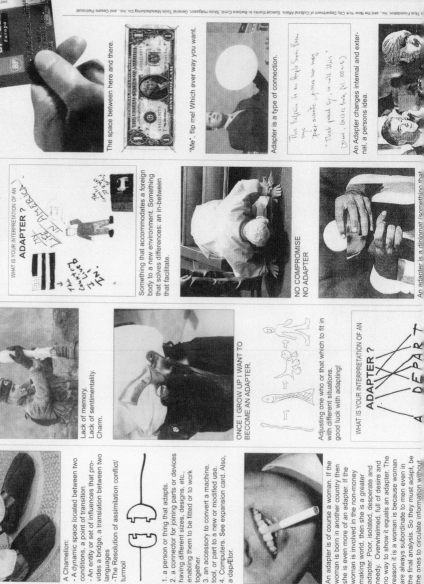

...Plus Foundation, Inc., and the New York City Department of Cultural Affairs. Special thanks to Barbara Cirrił, Saula Helgason, General Tools Manufacturing Co. Inc., and Cesare Pietroiusti

The space between here and there.

"Me", flip me! Which ever way you want.

Adapter is a type of connection.

That happens to an People Surre Peters say - Because of your own many
"That need by us will Whats" (Seurs Fustrs book fit 100's-6)

An Adapter changes internal and external, a persons idea.

Someone who can fit a square peg in a round hole + change everything.

WHAT IS YOUR INTERPRETATION OF AN ADAPTER?

Something that accommodates a foreign body to a new environment. Something that solves differences: an in-between that facilitate.

NO COMPROMISE
NO ADAPTER

An adapter is a diplomat (something that

Lack of memory.
Lack of sentimentality.
Charm.

ONCE I GROW UP I WANT TO BECOME AN ADAPTER.

Adjusting one who or that which to fit in with different situations.
good luck with adapting!

WHAT IS YOUR INTERPRETATION OF AN ADAPTER?

A DEPART

A Chamelion:
- A dynamic space located between two conditions, a point of transition
- An entity or set of influences that provides a bridge, a translation between two languages
-The Resolution of assimilation conflict/turmoil

1. a person or thing that adapts.
2. a connector for joining parts or devices having different sizes, designs, etc., enabling them to be fitted or to work together.
3. an accessory to convert a machine, tool, or part to a new or modified use.
4. Computers. See expansion card. Also, a dapÆtor.

An adapter is of course a woman. If the woman is born in another country then she is even more of an adapter. If the woman is involved in the non-money making world, then she is a greater adapter. Poor, isolated, desperate and needy. Overwhelmed, full of desire and no way to show it equals an adapter. The reason it is a woman is because woman are always subordinate to men even in the final analysis. So they must adapt, be the ones to circulate information without

Translate your own text or your favorite webpage.
Just type or paste in your text or the URL of a web page

English to French Translate

The ADAPTER is a temporary element in intercultural contacts.
The ADAPTER is a construction between not-compatible systems, persons or groups which are representing different hierarchies.
The ADAPTER is the mean or the tool which creates understanding and allows connections without injuring the identity of the participating persons, groups or systems.

Adapter means...?
- lack of identity?
- connector of electronics?
- compromising?

A mechanism that takes a signal from one system and makes it compatible with another.

WHAT IS YOUR INTERPRETATION OF AN ADAPTER?

Change language
life
foods

ON TRANSLATION : The Adapter A collaborative project by Muntadas (NYC) and the Department for Public Appearances (Germany). Art in General, New York, May/June 2000. Made possible by funding from the National Endowment for the A...

WHAT IS AN ADAPTER?

Ich verstehe ADAPTER als eine Hard-ware, die zwei verschiedene nicht pas-sende Steckverbindungen als ein Drittes verbinden kann. Im Softwarebereich wuerde diese Funktion ein Filter ueber-nehmen. Beiden Adapterfunktionen ist zu eigen, dass sie zwei unterschiedliche Prinzipien durch ein Drittes verbinden können. Ein Filter erzeugt eine Wahrneh-mungsfärbung, die das Dreierprinzip erst erlebbar macht. Im Sanskrit ist dies das Prinzip trikona, ein Dreieck/triangle.

ON TRANSLATION : The Adapter
A project by Muntadas and the Department for Public Appearances

Presenting
Cesare Pietroiusti - The Human Adapter
A personalized introduction and exchange of ideas for newcomers (and) old to the cultural life in NYC

Tues and Thur 3-4 5pm, from May 30 to July 30, 2000
At Art in General, 79 Walker Street, NYC, 4th fl.
Appointment by phone 212-219-04 73

The adapter is apt. The adapter is apter than others. The adapter is also ad-apt. The adapter is a virus (a-p-t) that snaps itself to anything through prefixes and suffixes.

An adapter is a fancy go-between.

Learned English
learned Dutch
forget Dutch
learned English
spoke English with a Dutch accent
learned German
spoke German with an English accent
spoke English with an English accent
spoke like a Dutch
speak English with an American accent
can not figure out when Dutch is Dutch
can not figure out when German is German
forgetting Dutch - forgetting German
adapting.

For me, the adapter is something or someone that makes it possible to some-thing or someone else to fit in a special situation, be it a plug, a foreign country, a society. This can be fulfilled either with sensitiveness and good feeling for the task or with violence and arbitrary decisions, for example some people have been adapted to kill others for money, for politi-cal or power reasons or some people have to adapt themselves to a situation where they are submitted to violence and arbitrary decisions.

Something or somebody that has the ability to serve as a liaison between two systems and make them compatible.

WHAT IS YOUR INTERPRETATION OF AN ADAPTER ?

An adapter is when a person can adapt to a certain environment or thing. For example, animals adapt to the environ-ment that they live in.

(S)'ADAPTER ?
c' a'(w)ADPTER .

An Adapter is like a covering to help adjust to new situations. A snake has a new skin for springtime, a cameleon a new colour to climb a tree. a woman a new dress for a party. But at heart still snakes cameleons and beautiful ladies.

Ich bin nicht sicher, aber es könnte im Sinne von Radiotechnik ein "Zwischen-stecker" sein. Ansonsten hat es auch mit "anpassen" zu tun. Richtig? Volle Punktzahl :-)?!

Dear John,
it's not you, it's me. I am just not a good adapter. I know you will find someone who really is and will really make you happy.
Sorry + Take Care

WHAT IS YOUR INTERPRETATION OF AN ADAPTER ?

The thingie that makes the other thingies work.

Something small which is doing miracle in changing from one to the other type.

The interface between one system and another. First thought – this is electrical (born in 1959), but more directly, what it seems we all do daily: shifting from one context of interaction (class, gender, visual/verbal are most pronounced for me) to another.

Il telefonino

2001

Torino, Italy
June 2001

Direction, production and collaboration:
a.titolo (Giorgina Bertolino, Sergio Bregante, Francesca Comisso, Nicoletta Leonardi, Lisa Parola and Luisa Perlo), Lab0ratorio 2 / Assessorato alla Cultura Regione Piamonte

• This is an edition of seven 50 x 70 cm triptychs showing photographs of different people talking on a mobile phone. In the centre of the composition is a complete image of the different individuals in the process of carrying out the action; on each side of the image a smaller detail showing their eyes and their mobile phone is reproduced.

•• Presented at Galería Visor in Valencia, this idea took shape in the workshop Muntadas was giving as part of the Lab0ratorio 2 project, an initiative of the artists' group a.titolo, held in Turin. The leitmotiv of this second number was a reflection on the concepts of public and private.

••• On Translation: il telefonino explored the unconscious mechanisms generated by a communication process - in this case the telephone - which is apparently private but which, because it takes place in an unprotected space, becomes a public act open to audiences of all kinds. The different expressions adopted by the users of the mobile phone - whose use was far higher in Italy than the European average at the time - , the attitudes of surprise, joy, anxiety, etc., symbolised by the movements of their eyes and their gestures, was in a way a subliminal translation to the public sphere of aspects related to their privacy and their personal lives.

Hello, Where Are You? Thoughts about
On Translation: Il telefonino Francesca Comisso

An *incipit* perhaps destined to disappear, the "hello, where are you?" puts the principle of movement and atopia at the origin of the conversation filtered by the mobile phone. The question of identity, with the traditional "who is it?", thus gives way to a topological interrogation. In the face of the ubiquity of the medium, it notifies a state in a place conjured up from the dissolution of a physical perimeter and therefore of the clear-cut separation between public and private. The *public/private* relationship was the subject of a workshop organised in Torino in 2001, in which Muntadas was invited as tutor of the group of *a.titolo* critics and curators to which I belong.[1]
The work on the mobile phone emerged that moment, thrown up by the importance of the conjunction of reality and commonplace: "They say the Italians, and Latin people in general, use the mobile phone all the time and everywhere." The real predisposition of Latin culture towards the public-social presentation of the private as an ostensible affirmation of one's own presence and the voyeuristic looking-glass attitude towards other people's privacy provide a magnificent script for a consideration

– both site-specific and time-specific
– of the effect of media technology on the redesign of social practices and the spaces where they are expressed. Whilst the traditional telephone was designed for individual and private use in sheltered spaces (at home, in the office, in closed booths around the city), with the use of the mobile phone the privacy of the conversation bursts into the public sphere and vice versa, taking shape within the confines of a permeable threshold which coincides with the body and its mental capacity to abstract itself. The person speaking, like the one listening, is intermittently present and absent from the context he or she is in. The conversation space with the mobile phone, therefore, can define an elastic interface between public and private – a "critical" space that refers to the concept of "between", which is so important in all Muntadas's artistic investigations. How is a space like this connoted? Two observations, among the many that emerge from this work, may help to sketch the profile. The first refers to the communicative arrangement, since it no longer takes place exclusively between two agents joined by the telephone line; it includes

interference from environmental back-ground noises, and contiguous "public" presences as voluntary or involuntary hearers/listeners. Due to those aspects of "interdiscursiveness" and dialogism, the semiologist Gian Paolo Caprettini talks about "mass neo-orality", conjuring up an image of the "universal square" as the place where "everyone's word is shaped and circulates, where stereotypes are perpetuated", where in the end the boundaries between I and the Other are redrawn.[2] The second consideration refers to the socio-behavioural sphere and revolves around the concept of being locatable, like a transgression of the time – as well as space – limits between public life and private life and the condition of being "on-line". In the early days of the mobile phone, being locatable was justified by emergency and applied to specific professional categories: doctors, politicians, businessmen. With the spread of the device, it has become one of the main management categories of interpersonal relations, to the point of becoming the very condition of their existence. To locate and be located at all times and in all places guarantees individuals their own belonging to a network of relations from which they draw security, recognition,

affirmation of their own being. However, that requirement of always being "on-line" tends to reinforce the modes and dynamics of the productive logic of efficiency and speed that reign supreme in the public-work sphere. Bursting into the private domain, that logic colonises its spaces, its times – where planning time tends to impose itself on living time – to the point of administering the very content of the communication. One example among many is the menu of pre-written messages in the variable range that goes from the pragmatic "the meeting has been cancelled" to "I love you". And so "between" emerges as a place for negotiation between public and private, the moving border from which practices of resistance or submission can be instituted. Muntadas demonstrates its capacity.

1. *LabOratorio 2-Proposte XVI, Pubblico-Privato*, organised by a.titolo, Torino 2001 (catalogue with texts by various authors, Edizioni Regione Piamonte, Torino). The *LabOratorio* project included a workshop for young artists, interdisciplinary lectures and an exhibition, organised around a particularly crucial subject in the cultural debate and contemporary art investigation.
2. G. P. Caprettini, *La comunicazione con il telefonino: una protesi che prolunga l'Io*, in R. Minore (ed.), *La piazza universale*, Rome: Cosmopoli 1998. See also G. P. Caprettini, *Ordine e disordine*, Rome: Meltemi 1997.

The Message

2001

?09fb3+Pn6/9oADAMBA
RTN2KTfQA4moHIXoOae
ayGA8sDbj5fUmm7lPK5
PboaftGA5BG2gBSwB5F
Hv608BVYqo5NKAjrgFq

Rome, Italy - New York, USA
16 May 2001

Production, collaboration and acknowledgements:
Claudia Cannizzaro, Internet

• This was a message of about eight pages in whose "subject" the words *atto politico* could be read; the artist Claudia Cannizzaro had sent it to Muntadas during the presidential elections held in Italy in 2001. As often happens with messages on the Internet, the text that arrived in New York was illegible; later Muntadas discovered that it was an ironic image of the propaganda used by Silvio Berlusconi's election machine, but he never managed to decipher it.

The paradox was the transformation undergone by an item of information which had been sent with a precise intention and meaning, but, on arrival at its destination, turned out to be indecipherable. The notion of translation – in this case the impossibility of it – therefore alludes to the different forms of encrypting internaut messages, which are due to technical errors and computer viruses, or to the deliberate concealment of the meaning as a strategy for transmitting secret messages.

The work aimed to raise questions about the forms of surveillance, censorship and interference which arise in the communicative processes used on the Internet, and thus to question in what sense technology is democratic.

Subject: Fwd:l*f* atto politico
Date: Sat, 10 Nov 2001 11:33:38 -0500
From: Claudia Cannizzaro <cadalui@yahoo.com>
To: Antoni Muntadas

Note: forwarded message attached.

/9j/4AAQSkZJRgABAQEBLAEsAAD/2wBDABALDA4MChAODQ4SERATGCgaGBYWGDEjJR0oOjM9
PDkzODdASFxOQERXRTc4UG1RV19iZ2hnPk1xeXBkeFxlZ2P/2wBDARESEhgVGC8aGi9jQjhC
Y2NjY2NjY2NjY2NjY2NjY2NjY2NjY2NjY2NjY2NjY2NjY2NjY2NjY2NjY2NjY2NjY2P/wAAR
CAEdApMDASIAAhEBAxEB/8QAHwAAAQUBAQEBAQEAAAAAAAAAAAECAwQFBgcICQoL/8QAtRAA
AgEDAwIEAwUFBAQAAAF9AQIDAAQRBRIhMUEGE1FhByJxFDKBkaEIIOKxwRVS0fAkM2JyggkK
FhcYGRolJicoKSo0NTY3ODk6Q0RFRkdISUpTVFVWV1hZWmNkZWZnaGlqc3R1dnd4eXqDhIWG
h4iJipKTlJWWl5iZmqKjpKWmp6ipqrKztLW2t7i5usLDxMXGx8jJytLT1NXW19jZ2uHi4+Tl
5ufo6erx8vP09fb3+Pn6/8QAHwEAAwEBAQEBAQEBAQAAAAAAAAECAwQFBgcICQoL/8QAtREA
AgECBAQDBACFBAQAAQJ3AAECAxEEBSExBhJBUQdhcRMiMoEIFEKRobHBCSMzUvAVYnLRChYk
NOEl8RcYGRomJygpKjU2Nzg5OkNERUZHSElKU1RVVldYWVpjZGVmZ2hpanN0dXZ3eHl6goOE
hYaHiImKkpOUlZaXmJmaoqOkpaanqKmqsrO0tba3uLm6wsPExcbHyMnK0tPU1dbX2Nna4uPk
5ebn6Onq8vP09fb3+Pn6/9oADAMBAAIRAxEAPwDtxS0inlqRi01JTC46ZGfSgB9LUYbb/Pr
zQCHynzD39ayGA8sDbj5fUmm71PK5wOPrTgg+7zt65J60pGORnaBjvVqQA0bG0jGaMMo3jJR
eGPvTRgqw5Hv608BVYqo5NKAjrgF9e5xjNAEYCdCjrk1FI6GUP/AAAgcetTfu9u05I65I60
xkV3BXhgGmgGGGPtdw/P0p2UBDsMGnGNMNchuce1PKqgDMnPpigCLKg7/l0RVj/ALxP8qQb
N2Gzntx0pwwyVyHas9PajQBCijMajHQT0jBy8mMejZ0qBCijMajHOTa28f8IPoWEh8/iI+FE4+k
B2jnJprshXdzSYf16Ob2jnJA/OOOSy6AU9x27ryHWEuaNhp 7oynEhqPw4NDRNvG0jnjgcUoiIJOWA6NzzmI
YuxXwxw3pjijCqzAkknpOqTyuck8jjnpSCE5PJYHt3FK4wBVYyAcnq3GDVuxmkTbsU/nxVcQ
bV4HXkkjmkAQr+7kBx1Ipp2dwNlRT+1Uba6DDYGDMVH1qQ+nX5FMBzzTAkpwAh2Ah2Dbp
B2jnJprshXdzSYf16Ob2jnJA/OOOSy6AU9x67ycnb6AU9x67yBS9a0qBCijMajHOTa28f8ZRIJMYJ4p315+bDjHbG
jLI53bSCB0xkUuZIBHkjLbXyCOMRkUimNCQNx5xg6ijMfQnk9iOKcqohOSScbT2qbiEBUZV
cjHJBpAY3y Fzxycj8Bp4jjAIB9zng0m2JwQrduSOtO4hBsCpcPEDnOOAVzHtDEnbnGQKNsYUR
k7j645P/ANAnbWIGAqjt70rjI2KnD5IB9B1oYxnEhGPw4NDRNvvG0jnjgcUoiITIJOWA6Nzzmm1
YuxXwxw3pjijCqzAkknpOqTyuck8jjnpSCE5PJYHt3FK4wBVYyAcnq3GDVuxmkTbsU/nxVcQ
bV4HXkkjmkAQr+7kBx1Ipp2dwNlRT+1Uba6DDYGDMVH1qQ+nX5FMBzzTAkpwAh2Ah2Dbp
jLI53bSCB0xkUuZIBHkjLbXyCOMRkUimNCQNx5xg6ijMfQnk9iOKcqohOSScbT2qbiEBUZV
cjHJBpAY3y Fzxycj8Bp4jjAIB9zng0m2JwQrduSOtO4hBsCpcPEDnOOAVzHtDEnbnGQKNsYUR
k7j645P/ANAnbWIGAqjt70rjI2KnD5IB9B1oYxnEhGPw4NDRNvvG0jnjgcUoiITIJOWA6Nzzmm1
YuxXwxw3pjijCqzAkknpOqTyuck8jjnpSCE5PJYHt3FK4wBVYyAcnq3GDVmxmkTbsU/nxVcQ
bV4HXkkjmkAQr+7kBx1Ipp2dwNlRT+1Uba6DDYGDMVH1qQ+nX5FMBzzTAkpwAh2Ah2Dbp
y2BQA6kzUbSAdSB9TShsjjn6UAPzSbaetAx6g6AOBzQcd6aVepAHV=xm
0831KSo3H0rNk82RlkPLHrhqkaKXcSC3P+3mmGBo1UjOc8/PyazbuIaIGKs569DlqDHINh5y
fU9aNkjK7EE4/vNS7HYITvJ7AtxSEIIHd2DcEdg2aJVkIQFcKOmGpdr+Ywben0fIppV2RQVZ
eeoamAgR8OAuU6ctTvK+VNoYsfU05YnUttRnX1Jqtc391YgXMx3+hbNPUCcxll+YsCCOu05p
cOJkbywB6KaxT4r0/awCzqeenQ1UPjEhwYbMfJ70WY7HTJANsxMeTjgMeRSeW7eWpU+289q5
ceNXOWazDFj3Y0n/AAAm71Qr2m4D/AGzTswsdQYyA4VGAHXB4oMJUnyNAT/cNYZ5yL+e3h
Uj+Fs1pWGtadqVx5VqZA4/vcZosxFryMAZ4/vcZosxFryMAZ4/vcZosxFryMAZ4/vcZosxFryMAZ4/
oQ5wOhbj60AVzbtskLKeD2PFO8gl4yygAj+E9akKtttkDB1weQjcUSREeXlCoPdH5NAyEwEK6
qoIzySeaXyCssexSWx/Gad5ThZNqlh/eLc0oTk5k2h3OOQ7f1oEMEA2SFlYHPQH5amihYXcW9
QMHI2nP503YCJWYSDB+6DkVLbbBluYw0ZTPTa2f8AIpoDWVRThSCnYqigxRRmgBNoopc0UAR
xnKj6U4ms2O7bylIweKfHe5+8G+uKTdtxLUuu6xoXcgKO5rJ0+XztTmY90yPmz39PSqN7c3t
3cSohTyIzk5UkADuafociC61KyQ7dn8AI59+/hU8wr6lrVb2SN/sOAIJXLsrAY+vaqEeel3Tw
mTa5yOA0vLe5pmqTINUkBMJYsMZU5HT866AyEN/Sk5Lqc92Y+nXbKSxs2yY+nXk9VMtvOH8knbl3BKn/wDX
2rT1C5NnbF0UvITtRRRjJNYjmuzet1oOOo4JNYtxm4AxsMFpFpPruOOOoA4JNYtxm4AxsMFpNpruoA4JNYtxm
fXsjOfM4/4bmnRnBA9hRuruC4BKy4/uB1KkenP8+XNIuHTTt0j/AHZ6kfiGUtHCCYhycbwcfp0qs43+
0oFY1V8u4hWVRguoJ9qy9WuXgWuXgGp2e3Ryl5GXdSOPz6fWrOlSr9hhClRKLw14UcdaytWiL62YXkhHr1/n
fOxB6Dr6/SpumW72GGRWt3LGX2zYP95b/1t5lhWcxnjLgHH2dW2K2W3+6Lx0w6nP6mq
LqMo2wABgeSRzx270hNW1Nu5lWKFpPz+RuOOOAJNYzteXsmf8ASaSDDh
QF/z6Vd15oxbwqyRkF/
4yR2NSaUyiyIo87zyG3frQVIHvYoxovd2Eyh3nwOdjKGBfbUMiPGs2WwRnRnBH3frWbrcnmRxD
ZH8cHOCTT6A9qgnsJAuj0dsfRuVJx+ZosCdnYYXd5PcSNHHBeGeJScDYg+b8aiZL62KYkuv5+9g
H8P/AK9K9eSS3S3bh+A7Vs3Sgy0nA2+7+8Sjl5BZIu7zerOlSr9hhClRKLw14UcdaytWiL62YXkhHr1/n
LdEjUmQ8DC5x4qpo6BpmyEKmP8Ahk3Hr/kIQ6lh9cMZvNvNuXYE2+fqKACAbgeSRzx270hNW1Nu
AAe3FT6fe3EMyi8MzITjDoPl/HrWtamJbwFVFCD5RwUZmtKpvys5ysJyswLJBcr+fqKKAtaa2Yw2
c9elJ5YJIDjd3zTY2O0j3wY3WO0jLJ0QdVeR2eJ9yDJ5GP5UJFrUtjBXv+b1FQrLErGI7ic4JxUFl
lLcgphi7HJ5OO1PADScd+TUt2CxMMXMjJACoCMdTjrSNJGo43jHoKjXhmH+etI74OtCbY7D5bg

198

New Urgency to Debate on Electronic Message Encryption

Pub

Continued From First Business Page

restricted the export of strong encryption products by American firms.

Over time, however, the administration's two-pronged encryption initiative failed. Companies and consumers said they would not use a product that had government access built in, and argued that criminals surely would not; the trove of escrowed keys, they argued, would itself become a prime target of hackers and spies.

Also, encryption companies were able to show that foreign competitors were already producing strong encryption products that rendered any export ban useless. By the end of the Clinton administration, the Clipper proposal was dead and the export controls were largely lifted.

To experts like Dorothy E. Denning, a professor of computer science at Georgetown University who

A fear that the hijackers may have cloaked their communications.

supported the Clinton administration's key escrow efforts, the issue was properly settled and should not be reopened.

"We had all those debates a few years ago at a time when we could rationally debate it — the consensus really emerged," said Professor Denning, "that regulating encryption wasn't the right thing to do."

But Senator Gregg argued that the issue should, in fact, be reopened. "This is an attempt to find a functional approach to this that both sides can agree with," he said.

He is recommending that Con-

gress create a "quasi-judicial" body appointed by the Supreme Court that would handle subpoenas for encryption keys to avoid one of the objections to the original Clinton administration plan. But he also acknowledged that criminals and terrorists would find alternatives to any escrowed system.

"Nothing's ever perfect," he said. "If you don't try, you're never going to accomplish it. If you do try, you've at least got some opportunity for accomplishing it."

For Mr. Zimmermann and many other programmers who have brought encryption products to market, the Sept. 11 attacks brought reflection on the balance between the good uses of encryption and the bad.

"Did I reexamine the question? Of course I did," he said. "But after some reflection, the conclusion is still the same."

"I have no regrets," said Mr. Zimmermann, whose product was distributed free of charge via the Inter-

net. "I did this for human rights 10 years ago, and today every human rights group uses it. And I feel very good about that."

A newspaper article last week suggested that Mr. Zimmermann felt guilty about P.G.P., but he said the account, which appeared in The Washington Post, misrepresented his views; he had only said that he felt bad that his technology might have been used for evil ends, "the way that the Boeing engineers felt bad that their airplanes were used" to commit the attacks, he said.

Last week a group of 150 civil liberties organizations from across the political spectrum urged lawmakers to consider with caution any measures that might reduce the rights of citizens. The coalition stressed what, in a statement, it called the "need to consider proposals calmly and deliberately with a determination not to erode the liberties and freedoms that are at the core of the American way of life."

MUTUAL FUNDS

On Translation: The Message Claudia Cannizzaro

Technology develops fast, and it's hard for us to keep up with it.

I received my baptism of internet amusement just a couple of years ago. Since then, weird messages have gone in and out of my electronic mail box. It does happen sometimes that, rather than simplifying communication, email, magic in its miraculous appearance in a matter of seconds in somebody else's mail box, can either get us either into trouble or just into an embarrassing situation.

Don't rely too much on what you believe you've just sent.

Months ago, or maybe a year or so, I attempted to share my worries about the critical Italian political situation, on the verge once again of a banana republic, with Muntadas. I therefore sent to him one of the many funny and bitter slogans cir-

culating at that time against Berlusconi's candidature as Italian prime minister.

I was in Italy at the time, and the electronic message I sent to Muntadas in New York got irrevocably transformed into a cryptic series of symbols...if it really had navigated on the rough ocean for days, getting soaked to the bone.

Was it censure? A sign of fate?

Had the D.I.G.O.S. (Italian C.I.A.) turned the joke back on us? We both wondered...

Indeed, it took us a few days to clarify what I had sent and what Muntadas had received. As a matter of fact the *atto politico* [political act], a joke about Berlusconi's promises, became a perfect metaphor for the "politicalese" universal language of politics...

...Untranslatable...

yejwpc4lcll4w4M/slbzc10fo0vBNDqyCw1XvXcJell11GW1V10.lml1pp.E10k.lgJg......+
wNij8KeganKNbSpqNyZLATu9wJI5z/COMc9senershv/ADLwyXCzRmJgkDxAAHtkjk9x+Nb+
1SMYBFNMSf3F/K1ZMNTkNMge21mwkgsrmxgkBWdZX3Rk44C5JPWnnSrptPhhkgbH9peY8ZH8
G88/TFbusQzT2wFuV3qwZCTjkGntvlZSzAL3x2olJWBXuc62jSoZ5YrIBxqKvGVUA+VxyPQd
asXVlcy2+vAQNuuGBhHd/lA4rZwXO7PTvmkRCzZckAf7VRzFWOf1ewupbmF2heaI2vlBURXK
tn0J4+tbUEctvaQw5ZnVArZbJ6VIUK5JY5z60CN0XOSxPvSbAcqvjCADPXnpTmiJO3JOO4NM
CSrHlW+YnoeakKMQFDHdxzmkAhUswGDt9c0FGz1+VenvSOZc7ccDvmneWWZdzEKKAEAOS/P0
zSKsj5bhSOme9GwkllZvpuoXzGbLZGPU0wBVaNMsxLN+GKCXQYwxz79KFDhSXPJOOOoo8p1T
qzZ9TQAjo642YGevOcVEkZ8wjd09DipdrsmAfm+vSozD++2iQ/gaaEKzFiFYEAd80oaQEnOV
Hb1pzRYZRzj1zTpIm35DDYB1A60AN3EEtkn29aApf52yD2zQItx3bmx6E0KpOSdw9MmgBVVl
BLHJJ7VBLJNb8QxM7N3zwKmG8DLE8nGB2pQJIk7tntnOKAKZmu2QhYyWI5AAx+tZV0hDN5MR
hf8Aiw4wfwrekhZ4/lyrN6HkVSl0YSth7qYj0GBn8aaAhsDc61a7Jp2MMbbWVcDdx0J61al0
uxjx+6jhUDh0Ow/mDU8ECWca29vEQmck+p9Sab5DtOHk5I6E8gfSi4GUkEto5l0++lMfXy5k
LL+dSR3yCXzp4GtZcY81P3kbexA6VrsZOqlhjtnH4VEbZLjJdCjf3gdp/Si4FCzvls4yks8T
W5PyPEf9WPQjr+NSahp7yRpd2TYuByjqc5B/mDTZPD9vPuebcSSRggEiq40O+skH2K/mRR0Q
NkD8DTAhnZn0a8mhTZL5DR3FuWztH94ZrItLbVLnQfLh0+CSAgkS4G/+daVxoetXEZ3XUZLg
hj0bB7HFRxeGNZij+zrqnlxY+6rtimmBY9jVUtfCRKNteBWTBI5JPH86xNHkXS9SsL1p0KTE
iTB+6DxzWpL40C26QxTsZS2XkYcEe1PuPBMRVVtbqQOOS0mCp/IU7oQ3xfJbajf6bHFcxlG3
KXByFyR1rNV2F7Y21yyFbWcL5it2yO47Vu3vhtbi5tLiPy4xCB5o2/fPHSnXegrc3lvNbxxw
xxOC6MuN/I4ouhmUjWF34nvJL6eN4o+Ig+SG/KrJ/saS9TyoZRIucPGhYf0rQ1Xwxb3xjnsz
9juR/dHyn603SPDN1Z363t5qDSvGP1VCcH657UAc7qMSXWqXCQSL5cEZOXO3JHbnvWjpEbXe
lQyKGO3KHA9P8irieDIriSaW+u5Wlkct+6wBz65FXdD8Pf2Wk8csizI7AoeQV/zxTA5rxBB5
S23UZfH8qk12zt7K1WZAqTbsKRwT+Fb+v+H5NUigS3uDGY2JPmMT+VVIPCE8lyk+o6ibgoch
dpIP1zQBRu4ANImuNoDtCCxxgnik0i2WbSI2ZFP3yM84rotT0y5u7GW3SSAb1wDsYY/WodN0
i6stNW1LwOQGG75h1pAcz4fg+0QyvtUkSYyfpUF3E91f3Soc+Qp9uldPo2hXelW8kRkhl3tu
ByRg4+lZsfgy4kMklzeDe7E/uz6+uRRcY23xd6HLOQP9WQ2PUA0eH7ZpdLjb3bv7lpad4fvr
TSrqy8+3ZZs7W+bjIqrYeGtcszGkepxpCjZ2Atg+vFMRQ0eHzNZvU4+U+vvVS/E15dXcsJAj
tRg544HH866nT9Au7XUr6HNzGGcA7Ni9D75BvVK38EqY3e6vH85iT+76H65FABp8T3MwnWXCI
7F8cgZ571JJaMn31VeP4nArS0LRTp9m0F0Y5sN1MzWBWnHDHGf3cSL9FFICrZvvSQrnaX44x
ngVNUrn2qvcsUjUoPmJwKzceo7jweadVMXTbsNHj2HWl+1sE3eWB7E8mo5WLmRboqutyCwDI
yD1I/WlN0gUHDEHvijlY+ZE9FQi5j3FTnI5IxSfaoigf5gp6cdaOVhdE9Gai+0RfMAckdsU3
7RGAGYlQx4JHFHKwuifNGai89CzABjt6kDimm4j2gqS+egWjlYXRNmjNRedHkjJDDsRTBdR7
VJDDccAEUcrC5PmlzVZ7nY0i+UxKDP8A9ahrsBVPln5u1PlfYLlgGlzVX7TJlgIQuOcu1H2y
QxrshO4nGSflFHI+wuZFrFHI+wuZFrNJmqwupPnBiDED/AJZ//Xpn2ib9yW24ZucdTRyMOZE8lxGr+VvA
cjP0HrVcX3mkP5Ssnc9Tx7fjV8WMBYuY8swwTnrQ9jAzZ2YONvBxxVqCOncqfbYo081CMZwF
PGab9rUZ82MDnCkcjj3q8j3q8l8jAmMRj5elKLGABQIxgcinyR2D3iibyOM7ftAXHbHSirb2FuzEm
IEmio9kiuZl2ikpa2EZEiBPMlKrKm/PmKcOvtVyQ51C3P+w1SNZwNJvaNSxOc1IY1Mgcj514
B9M1gqbRo5Ipee8dnM6BQyykDj3qaGSX7TJDKwbChgQMVKYIjGU2DaxyR6mnBFEhcD5iME+w
qlCV9xXRQAjk0wPKgwuTgcd6rG3dLfCnGRk57VqmGPyfK2fJ6frVe6TcCOmeKl0m/uHzFC3U
mYgAooAOAasDc/3gV9OajWMJt2EruHY0gctIR0x0waUItKwpO7uSJuUlnPfGKDfuT7uST2zUJ
c4Z/TtT4yQScn8TVWJJUEmPlHzY9f1p7Rt9zcSevBqIMVQuCcn1NSc+WfmOeORRZgBVuFAJ9
89acUJwobC+tJuOwDJ602QkMEBx15oAcASd2SMe9IPMkY/wgdCaYxbf94jjoKduJycnjpiiz
AVFdQzueScYA6UZdFz8xz2zTUcvuJ9SB7Ypq7u7E59e1FmA91cLlRgn1PSovLbziN3PtxT5H
KQBskk+p6VApaR87iOe1NiJ3J3VufMR6+tGZM4VsqB3700ds5NDSHeVGBtB59aLMCTeSdwJA
9KUbpCWIIx07VFyz/eIHpQJGGTk/KelFmBNm4G5u0eB6Uwl0XJ3En8aakpk3E9s4pI2YA5JP
1oswHbpAmVByfXtTmD42AnPqOM1G8zRISMnI9el03sYwQcE9SKdmApaTcEWT7/8A16CspcKD
hRzk96aZGJAzz6imvKwkCZzjPPrRZgIsrs+7lfanCZ2iFYEdF6fhULllc4b5cj5e1KZD6na
DjFRqK5IJpCrMV57D0pPO1RT95vryRUayM5fPRentSeY653Nu+XIJHSnqK5N5sgjLKGOffp7
9Ka0khUDn6iozKyB2ySQMinbmaNXDbWJxkUtQuO8+T5VKsR6jv8AjStJMHVOijueQah3uEXD
YLAgkUhlKFQM89cnrzT1C5IzzM+4FlX07UqzSSNjawI5C9B9KikkdZDhiFB+72o8wiTvjPTN
LUC7aO8trNvG0g8KfSroHHNZt1Kz3BB6AlRWoK1j5jQAUYpRThTGM20bCafSOwIwlLtp1FADd
oo2AU7NFADQtLtpaQmgA20mKTcaQsaQDsCjimbjSbyigAc1nTzpIygDeA2OPWrc7HYfoapKA
VUY4z61EmthCtIu912EAcEA8/lSbwsa/Ljv1wak4EpUDAIxwajBHloQMEkDOai6ARnUyH5SD
jPz0blZVJViM4x1FKyjzmyMkjOT2ppP7lCckehNK6FYeSPM6YG3op603CiOP5Np3H5h3pyko
x2kjjsaZgCNCAQS3XNPmQWFADNL8m7uMnpQSPKQfMMnoxwBS7vmlyM4GQCaQ/wDHsrEkgH7u
eKfMgsKhVXcsjDA/gpPlMSZjByeqcmnRx+ZK7AlMDop600YkCJgKQ2Nw6000Fh24F5Pk3ADH
ztz+VMLosaDaTg8hjj9Kkl2xyurLvBXuajYBbdG5I4+Ung09AHllVpF2Mvy5xTdwWOLEYXPf
ODTgBum25GOODTcKkcRVcN65ouFh24BpCI/xemhlKxko3B/i5WlO3fIWXdld3J6UYzDGzEsB
j5SeDRdABYF5FIbHX5Dn86RiFSH5QuXHQ4IqRAGeVVJUdMA1ECGEW1dhBzkGhNAbIp1MToKf
WiKClopKADFFJmigD//Z
--------------41EE7A695900

--0-1312467219-990020958=:41381--
--0-1182791027-990022356=:79677--

The Bookstore

2001

London, UK - New York, USA
2001

Production, collaboration and acknowledgements:
Nayda Collazo-Llorens, Borders Bookstores,
Andrea Frank, Ediciones Moisés Pérez
de Albéniz

• An edition of nine numbered boxes and three artist's proofs, each consisting of thirty-three 32 x 32 cm photographs reproducing images of nomenclatures from the bibliographical classification used in bookshops in London at the start of the project and in New York later on.

• • *On Translation: The Bookstore* was presented in the form of a photographic composition in eight columns of four elements each as part of the *Muntadas* exhibition, held at Galería Moisés Pérez de Albéniz in Pamplona, which was also showing *On Translation: The Negotiating Table* (1998), *On Translation: The Applause* (1999) and five silk screens from the *Meetings* series.

• • • The work proposes a walk around a generic bookshop, laid out in a series of categories which aim to define and systematise the subjects dealt with by the books in it as objectively as possible. Those categories, however, become a subjective ordering in which the subjects, disciplines and contents are "translated" according to the particular criterion of the person organising them.
The metaphorical sense of the idea aims to shed doubt on the supposed universality that is the aim of classifying devices and their capacity to establish stereotyped hierarchies and topologies.

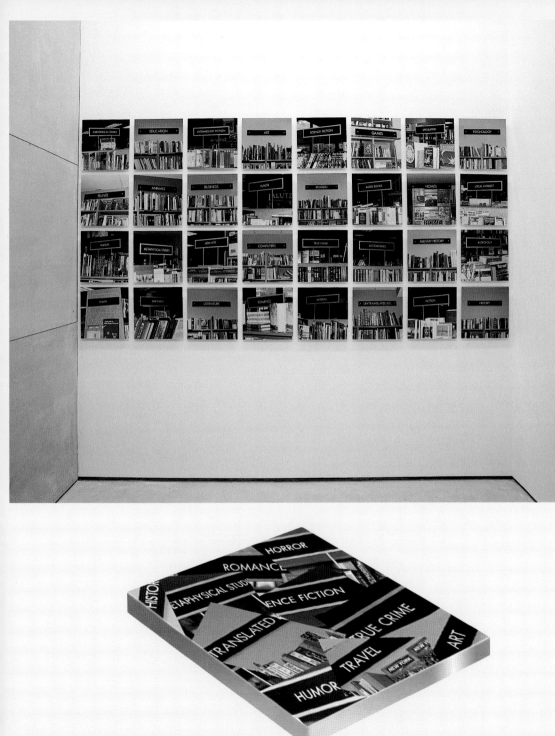

On Translation: The Bookstore Nayda Collazo-Llorens

I collaborated with Muntadas on the work *On Translation: The Bookstore*. I witnessed how it developed from an idea to a finished piece. We visited various bookstores. Trying not to look too suspicious, we spent a few days photographing the spaces, the signs. The editing process became a particularly interesting one when we discussed not only the terms used in the signs, but how they are used in reference to marketing, culture, and some kind of code system. We were curious to see so many kinds of classification: new fiction, non-fiction, western fiction, science fiction, new non-fiction, etc. We discussed how ideas and cultures are divided and segregated, and how this is particularly true in a big franchised US bookstore. Eventually, content became form. We decided on the right medium for the project, the size and format, and the way the work should be displayed.

As a team, we worked with the photographer who printed the final photographs with which the edition was produced and assembled.

Petit et Grand

2002

Paris, France
12 January – 2 March 2002

Direction, production and collaboration:
Gilberte Fustemberg, Nicolas Germain,
Dario Grossi, Caroline Maestrali,
Gabrielle Maubrie, Victor Lee

• The work consisted of finding and compiling a set of different kinds of elements related to popular culture – book and record covers, film posters, food labels, city signs, newspaper headlines, songs, advertisements, etc. – that contained the words *petit* and *grand* (*large* and *small*, *big* and *little*, etc.). They were presented at Galerie Gabrielle Maubrie in Paris looking like ordered and carefully juxtaposed compositions and accompanied by a video in which the image refers to the concept of *grand* and the sound to that of *petit*.

• • Starting from the widespread use of the words *petit* and *grand* in French, the show examined the nature of certain linguistic habits which usually conceal strategies and resources that go beyond the mere verbal cliché. For example, the words *petit* and *grand* not only determine the dimensions of the noun that follows them and place it in a hierarchy; they also mask different attitudes (persuasion, paternalism, false modesty, scorn, etc.) by the people applying them and according to the context in which they are used. The idea of translation is associated here with a certain notion of anthropological investigation in which the small could be linked to the notion of private and the large to the notion of public.

petit geste / grand geste

petit service / grand service

petit con / grand con

petit plaisir / grand plaisir

petit maître / grand maître

petit écran / grand écran

petit film / grand film

petit collectionneur / grand collectionneur

petit bourgeois / grand bourgeois

petite dame / grande dame

petit cru / grand cru

petit verre / grand verre

petite table / grande table

petite faim / grande faim

petit hôtel / grand hôtel

petit palais / Grand Palais

petite ville / grande ville

petits travaux / grands travaux

petite folie / grande folie

petite entreprise / grande entreprise

petit capital / grand capital

petit discours / grand discours

On Translation: Petit et Grand Nicolas Germain

In 1997, talking to Sylvie Zavatta, who at the time was director of the Basse-Normandie Regional Contemporary Art Collection (FRAC), I found out that she was intending to invite Antoni Muntadas for an exhibition at FRAC the following year. Seduced by Antoni's work, I asked Sylvie for more details about the project and I learned that he wanted to work with students from an art school to mount his exhibition *Home, Where is Home?*
With the students I had to analyse and sift through the installations in order to be ready to start work. We therefore carried out together, over a period of several months, a search for documents, work with photography and sound, a task of reference, investigation and filing. The work groups took shape naturally according to each one's interests and investigations. Some of them turned to the sound element, others followed the more documentary, sociological, linguistic or cinematic trails (that last one brought in René Prédal and his students from Caen University).
I was in contact with Muntadas as often as possible to assess the evolution of the work until the installation of the exhibition. At first I did all I could to allow the students to step back from his work, so that they could act according to their own vision of things. I wanted them to commit themselves as if the investigations were their own. Then the meetings with the artist became more and more frequent and the work more and more precise. We really shared his project and had the feeling that we could make a genuine contribution to it.
We have stayed in contact (thanks to e-mail, as Muntadas is always travelling!) and he has proposed a new association in 2001 for his exhibition *On Translation: Petit et Grand* in Paris. I have therefore been delighted to enter his universe again. I have taken charge of the sound, as that is my favourite tool. Then came a chain of discussions by e-mail and meetings in Paris. Impregnated now with a common work method which had been established during our first experience and which, I think, works pretty well, I was soon able to find my marks again and to launch myself more easily into the production.

207

For the *Petits* and the *Grands*
Gilberte Fustemberg

When Muntadas told me of his intention to create a project around the words *petit* and *grand*, I must admit that at first I was taken aback. What interest could those insignificant words possibly arouse? What gauntlet was Muntadas throwing down?

Then those little nothing words began to run through my (little?) head and, as I am fairly broadminded, I began to keep my eyes and ears wide open and in the end I could see that a large number of things and behaviors were concealed behind those apparently banal words.

Indeed, those little all-purpose, almost invisible, words – there doesn't seem to be anything big about them (like our little chats, our little stories and our little errands) – can end up clinging to our spirit (to great spirits?)... "Little", there are all kinds of little things – to do with childhood, of course – beginning with little babies, little bruises and little cuddles, signs of a tender affection (come on, my little darling, my little love). Sweet little words, intimate and warm, words of friendship – words from the heart that are also bandied around by grown-ups. "Well, my little sweetheart, would you like to have a little drink and then, if you feel like it, we could go for a little stroll." Could that "little" be rather seductive by any chance? ...But it may be more so in the kitchen where the "littles" seem to be aimed at producing their biggest effects ("I've cooked you one of those little dishes with a little sauce and an amusing little wine... you'll see, I've taken care of all the little details").

Do we French have a special affection for everything "little"? We might wonder, when we talk about cunning little things and little rascals but big hunks or big slobs. However, "little" as in "stupid little twit" tends to take you down a peg or two, while great is simply grand. We only have to think of our great classics, our great thinkers, our great chefs, our Great Library, our TGV, our Grands Boulevards and our Grand Palais or our great lords or quite simply the great and good in general (not to be confused, of course, with the petty bourgeoisie or the petty bureaucrats...)

Through novels, films and songs, many *petits* and *grands* have fed our French imagination. Who does not quiver at the name of *Le Petit Prince* ["The Little Prince"], *Le petit chose*, *La petite Fadette*, *Les petites filles modèles* or *Le Grand Meaulnes*, ["The Wanderer"], or *Le Grand Livre des Voyages*? And while we are on the subject, might you by any chance have read *La grande histoire de la petite 2 CV*, or *Petit traité des grandes vertus* ["A Short Treatise on the Great Virtues"]? "Is a big one a little one?" they ask in Africa to underscore an obvious argument. No, of course not... Big can't be little... but, thinking about it, can't little be big? Doesn't a request for a small favor often conceal a request for a big one? And don't one's little lapses and the little surprises life sometimes has in store turn out to be big lapses and big surprises when looked at from someone else's point of view? An amusing little

DOSTOÏEVSKI
LE PETIT HÉROS

NOUVELLE TRADUITE DU RUSSE PAR ANDRÉ MARKOWICZ

GENEVIÈVE DORMANN
La petite main

ANDRÉ
COMTE-SPONVILLE
PETIT TRAITÉ
DES GRANDES
VERTUS

POLITESSE
FIDÉLITÉ
PRUDENCE
COURAGE
JUSTICE
GÉNÉROSITÉ

PURETÉ
DOUCEUR
BONNE FOI

Dai Sijie
Balzac et la Petite
Tailleuse chinoise

folio

David Lodge
Un tout
petit monde

Préface de Umberto Eco
Traduit de l'anglais
par Maurice et Yvonne Couturier
Rivages poche / Bibliothèque étrangère

Maupassant
La Petite Roque
et autres nouvelles
Édition d'André Fermigier

folio classique

wine may be concealing a great one and a little gesture may reveal a grand one.

A matter of false modesty or insecurity? So how to find one's way through the jumble of all those littles and bigs, which try in turn to be strategic, political, convincing, persuasive, pejorative, paternalistic, charming – even perverse. For example, can you tell me why we say *se payer une petite folie* – to allow oneself a little extravagance – but *avoir la folie des grandeurs* – to have delusions of grandeur; *goûter aux petits plaisirs de la vie* – to enjoy life's little pleasures – but *éprouver une grande joie* – to be filled with great joy? And why is breakfast always small – *le petit déjeuner* – even if accompanied by a *grand crème* – a large white coffee?

Will a dictionary enlighten you on the subject? Maybe, but beware. Which dictionary will you be consulting? The *Petit Larousse Illustré*, one of the *Petits Classiques Larousse* or the *Grand Larousse* in 10 volumes, or even the *Petit Larousse grand format*?

This project may enable you to discover the magic of those two little (big?) words, to create, with a little luck, your own associations and to supply your own meanings, to the great displeasure of dictionaries!

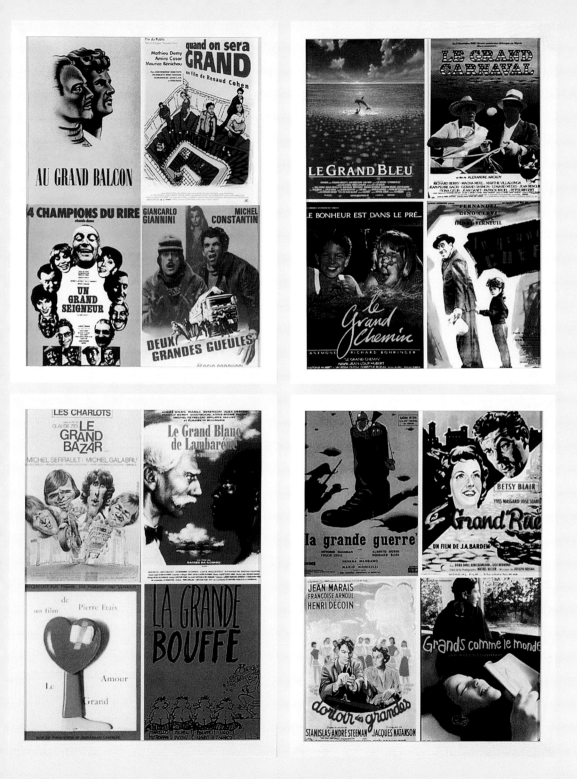

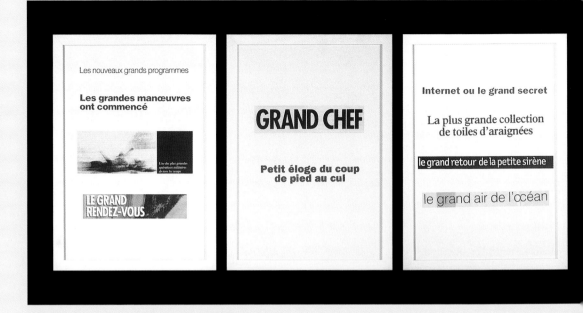

On Translation: Petit et Grand Caroline Maestrali

I had been in New York for a month when Muntadas talked to me about his project *On Translation: Petit et Grand* for the Galerie Gabrielle Maubrie. He asked me to help him by gathering any iconography on the two words I might come across. Amusing to see me embark on that research in French, as it had been a month since I discovered total immersion in a foreign language and the difficulties that follow from it at all levels. My mastery of the foreign languages I speak is school level. Things and ideas become different in translation. I no longer use the phrase "a little kiss".

Muntadas told me about his encounter with *petit* and *grand*. *Un petit T-shirt* does not mean the same thing to Muntadas and to me. He expects to see a T-shirt in a small size, whereas I just buy a T-shirt for all occasions.

I began my research in New York and finished it in France. Although it is easier in France, you often find that particular use of the two adjectives abroad: on the signs of French shops, Le Petit Bistrot du Nord, or in the specialities offered by a French *pâtisserie*, *petites douceurs* – little sweets. In France you are constantly coming across the *petit troquet*, the little bar, where you sit down to read about Petit Poucet – Tom Thumb – as you sip a *petit café*, while your *petite-nièce* gives you a *petit câlin* – a little cuddle. I prefer the word *petit* and the expressions it is used in: *petit rien* – sweet nothings, *petit coucou*, *petite chose* – little thing, *petit câlin*...

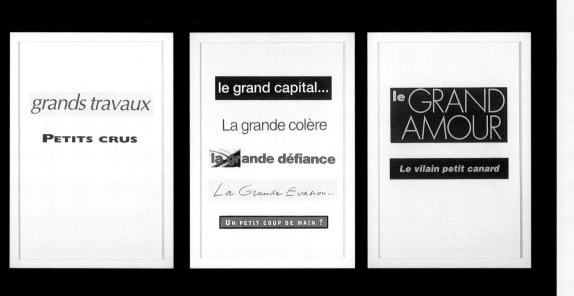

If we are talking about translation, we have to refer to the singularities of culture. In the context of the French language, the concepts of grand and petit are phenomena of representation so deeply rooted that they have become opaque for the very people who use them.

Muntadas, project notes

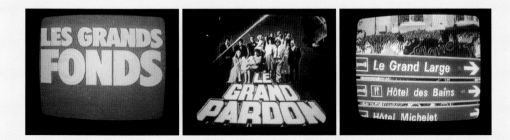

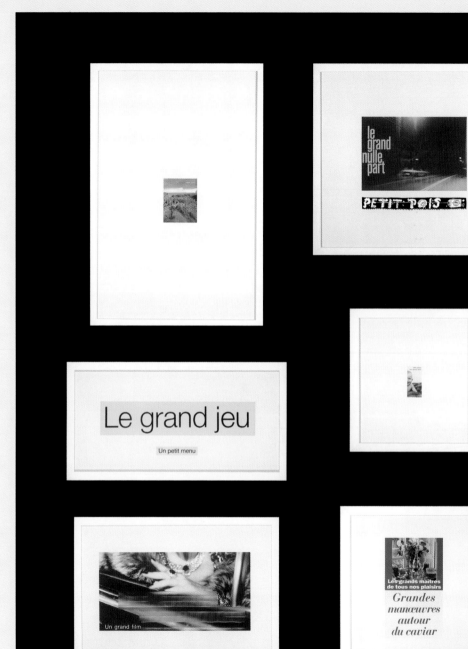

Envie de voir grand ?

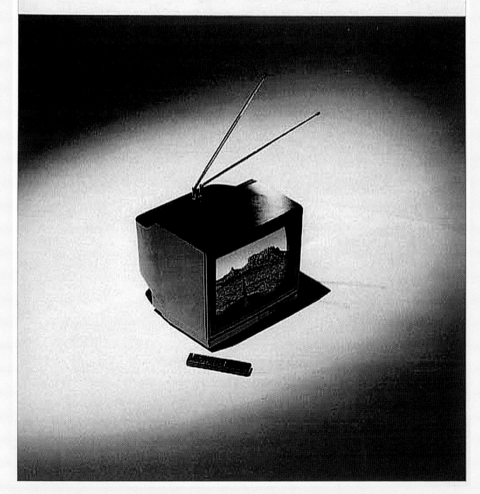

Comemorações urbanas

**1998
2002**

COMEMORAÇÕES URBANAS

LARGO DO GLICÉRIO

VIADUTO DO GLICÉRIO
1979

VIADUTO GOVERNADOR
ROBERTO ABREU SODRÉ
2000

OLAVO SETÚBAL
PREFEITO MUNICIPAL
1975 ▪ 1979

CELSO PITTA
PREFEITO MUNICIPAL
1997 ▪ 2000

**Sâo Paulo, Brasil
November 1998 - March 2002**

Direction, production and collaboration:
Nelson Brissac, Luciano Chalita, Andreia
Moassab, Paula Santoro, Una Arquitectos

• This project was structured in four sections. The first consisted of manufacturing ten bronze plaques and installing them at different points around the Zona Leste district of the city of Sâo Paulo. Their formal appearance, deliberately stereotyped and official, imitated the appearance of the commemorative plaques that pay tribute to an important historical event or situation. The plaques in *On Translation: Comemoraçoes urbanas* followed the same compositional layout – place, date of inauguration, and the name and post of the person who decided to carry out the intervention – , but unlike them they celebrated town planning decisions taken over the last fifty years in that part of the city that have led to disasters and blunders that have determined its present state of disuse, degradation and loss of identity.

The second section was an edition of ten postcards, each reproducing the image of the plaque in the exact place where it was installed, together with a detail enlarged so that the contents could be read. On the back of each postcard, a paragraph adds information about the "urban disaster" the plaque commemorates.

The third section was a presentation in Sesc Belezinho, the headquarters of *Artecidade*. On a large-scale plan of Zona Leste, drawn on the floor, ten luminous pedestals of different heights were placed, each at one of the locations where the commemorative plaques had been installed. On each pedestal there was a reproduction of the postcard image with a text explaining the architectural "commemorated" in each case. On one of the walls of the exhibition space, a text written by Muntadas and Paula Santoro – an architect who helped with the documentation – explained the intention of the project.

Lastly a website was created, www.artecidade.org.br, which allowed users to follow the dynamic of the concept, have access to all the material (images, locations, texts, etc.) and, most of all, by means of filling in a questionnaire, include new town planning operations anywhere in the world in order to uncover the processes and contexts that led to their implementation.

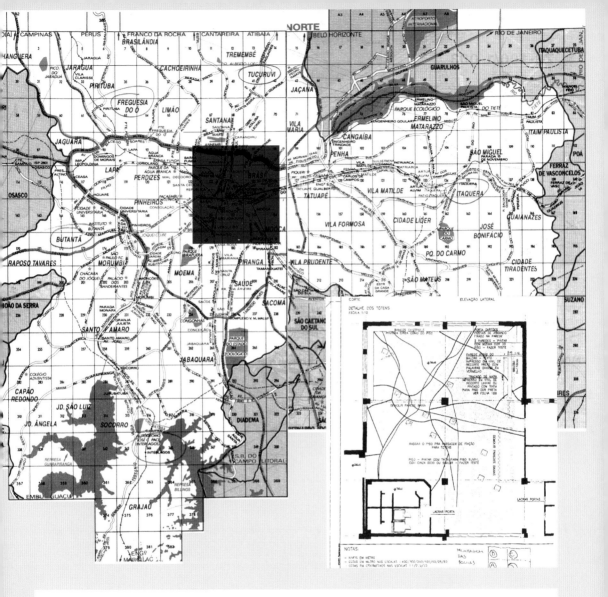

• • *On Translation: Comemoraçôes urbanas* was Muntadas' project for the fourth number of Artecidade, an international event held in Sâo Paulo that brought together ideas by architects and artists. On this occasion the leitmotiv - apart from the specific area of Zona Leste in the Brazilian city - was the new layouts in the big cities that are a by-product of globalisation.

• • • The work did not set out to make an exhaustive inventory of the constant restructuring of Zona Leste, but to highlight some decisions that heightened or brought about its present discontinuity and social precariousness. In that way, the plaques installed at different points around the city could be regarded as monuments in the negative sense, "counter-monuments" promoted by the savage capitalism of today, which ironically celebrate the disorder, the aggression and the imbalance of the city.

Comemoraçoes urbanas

Placas comemorativas são elementos que servem para celebrar, homenagear um feito ou uma situação histórica importante.

O projeto, concebido como uma série de «intervenções modestas», propõe a fabricação e colocação de uma série de placas comemorativas às grandes e importantes decisões, planos, construções e obras urbanísticas dos últimos 50 anos na Zona Leste de São Paulo. As decisões político-urbanísticas e econômicas em foco são as que fundamentalmente determinaram as atuais situações de desuso, ruína, transformação e perda de identidade de certas áreas, levando aos fracassos urbanos e à precariedade social.

No desenvolvimento urbano característico de São Paulo a «cultura do carro», que fomenta a agressividade urbana, está no núcleo das situações de ordem/desordem na cidade. Estas «necessidades interessadas» criam estruturas hoje subutilizadas, como pátios de carga ligados ao sistema ferroviário. Também convertem os espaços em zonas de «não-espaço», em fragmentos conseqüentes de implantação e superposição de viadutos e vias expressas que orientaram a reestruturação urbana da Zona Leste a fim de suprir a crescente demanda de fluxos. Estes são monumentos em sentido negativo, ou os «contra-monumentos» do capitalismo selvagem da época contemporânea.

Os locais elencados são exemplares dessas dinâmicas. A descontinuidade do tecido urbano e das atividades nele desenvolvidas, provocadas ou acentuadas por construções como, por exemplo, do metrô, da Av. Radial Leste e Parque D. Pedro II pode ser entendida como verdadeiro «desastre urbano» engendrados por esta dinâmica. Também o padrão de expansão horizontal

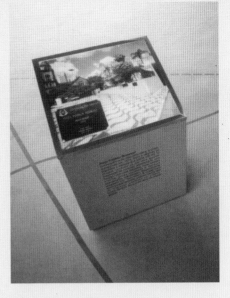

da metrópole tem produzido periferias desequipadas e distantes do centro urbano, implicando grandes gastos para a implantação de infra-estruturas básicas, como é o caso dos grandes conjuntos habitacionais Cidade Tiradentes e Fazenda da Juta.

O trabalho não pretende dar conta de todos os processos conseqüentes das constantes reestruturações da Zona Leste, apenas aponta alguns que são exemplares do padrão metropolitano de urbanização e fomenta a discussão sobre estes processos e outras dinâmicas que acontecem em diversos lugares do mundo podendo ser apresentadas e discutidas no site **www.artecidade.org.br**.

Plaza Franklin Roosevelt
The purpose of the square, which was inaugurated in 1970 and is the product of a planned roadwork, was to organise the traffic passing below it. The project took the shape of a large impermeable cement construction with no defined functions or uses, whose segregating effects have created underused residual zones and deserted areas, often occupied by the homeless. It is used mainly as a car park though, due to the lack of public spaces in the city, it is sometimes used for recreation by some groups.
Text for the postcard: The project for the impermeable cement square has created underused, deserted residual areas, often occupied by the homeless.

Muntadas em colaboração com Paula Santoro

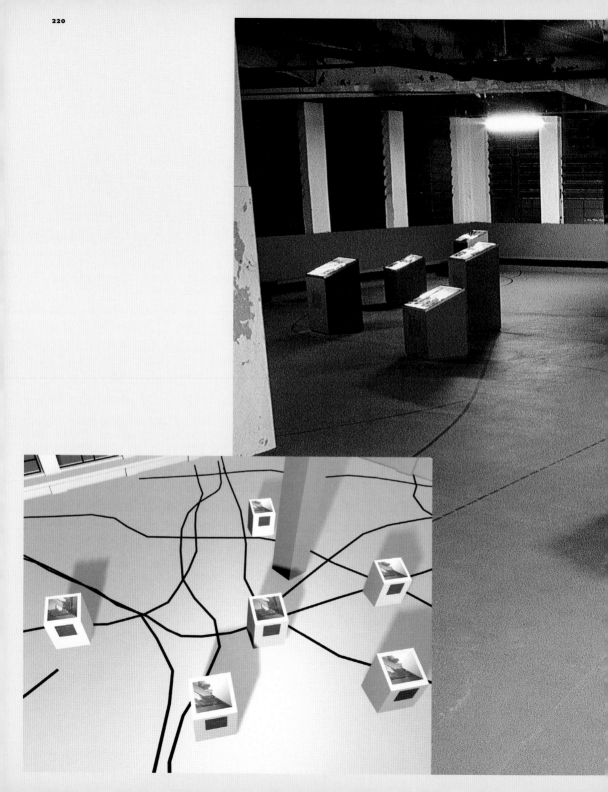

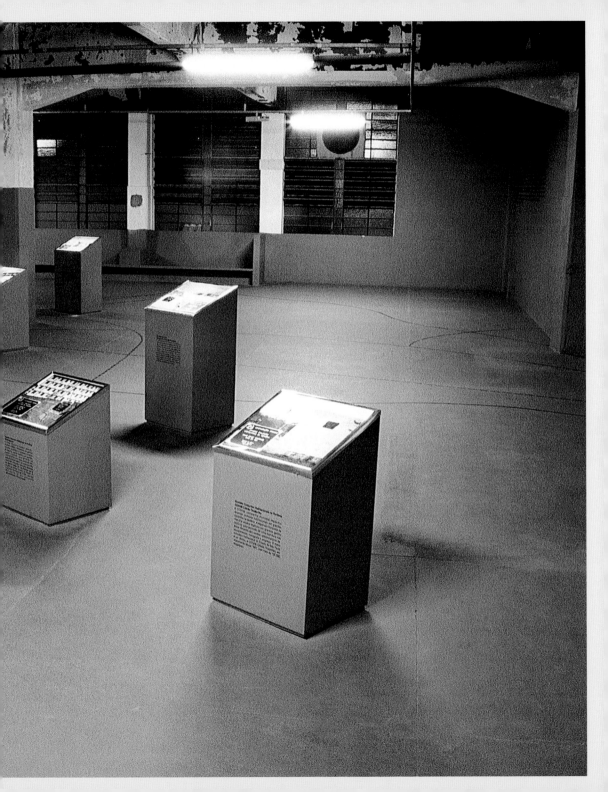

Personal Impressions. *On Translation: Comemorações urbanas* Paula Santoro

I met Muntadas years ago, when the Artecidade project was just being outlined. He simply asked the reason for certain "urban disasters". His eye had lighted on the apathy of São Paulo towards important issues of the big city. I cannot say that he became aware of our urban problems just because he was a foreigner.

We tried to understand which decisions had determined the disuse, the ruin, the transformation and loss of identity of certain areas and buildings in the city, which in turn brought town-planning failures and social precariousness. We waded through the heap of papers with measures taken by mayors and secretaries to find out who had signed a particular one. We were often uncertain about which decision had triggered off certain processes. At all times we mistrusted our own claims. But if there were doubts about the decision, I cannot say the same about the authorship, since we could hardly be unsure about who had signed: our old acquaintances.

The diagnosis of disaster on each plaque showed us that the glory or the slip-up was in the details: it is not the isolated sealing of a valley bottom that causes floods, but the number of sealings done; or it is not that a square is made entirely of cement that necessarily makes it a bad square, but the spatial layout, with spaces cut off and difficult to use, which certainly takes them far from projects for public squares. So I learned to look at the problems of the city by trying to distance myself from common sense and look for the origin of the problems, and, at times, in indignation, I still felt like writing to Muntadas and remarking: look how absurd what they are doing now is! That is why I believe that the project has possibilities for continuity. In any part of the world decisions of this kind are taken, and the Internet enables us to continue that conversation, at any time, whenever we want.

Although the plaques "commemorate" political, town-planning and economic decisions that led to disasters, no politician has made a statement so far.

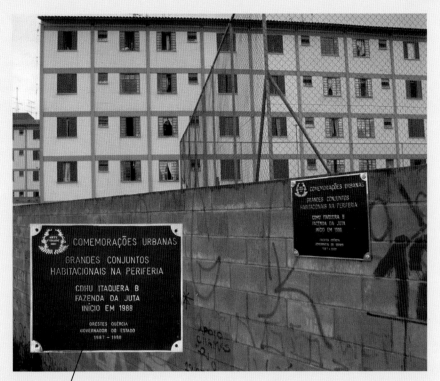

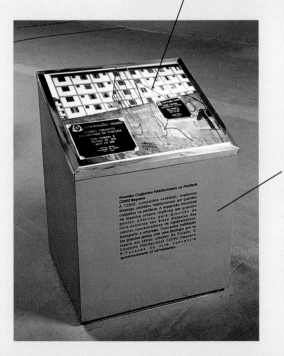

**Large housing estates on the periphery
CDHU Itaquera**

The state-owned company CDHU, Companhia de Desenvolvimento Habitacional e Urbano [Housing and Urban Development Company], has built a number of housing units in large-scale town planning operations on the periphery. Horizontal urban sprawl involves major public expenditure to provide infrastructures for areas far from the centres where facilities, transport and jobs are concentrated. It creates disadvantaged agglomerations of a typology that is repeated in different cities over the country. The CDHU Itaquera B/Fazenda da Juta housing estate has about 22,000 inhabitants.

Text for the postcard: Horizontal urban sprawl involves major public expenditure in areas far from the centres, with no facilities, transport or jobs.

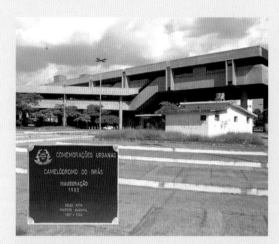

Camelódromo do Brás

In 1997 the town council decided to organise large precincts, the so-called *camelódromos*, to accommodate the street vendors (known as *camelôs*) *en masse* and thus take them off the streets and squares of the city. The largest of those *camelódromos*, with 1,936 stalls, was opened in 1998 next to Brás metro station, a zone with little traffic and few customers. That measure reveals a mistaken policy for reorganising the space of the informal economy.

Text for the postcard: The introduction of large precincts for street vendors in zones with little traffic and few customers reveals a mistaken policy for reorganising the space of the informal economy.

Parque Dom Pedro II

It is difficult to imagine it as a park, since the systematic installation of viaducts has successively fragmented it: in 1938 it was the Rangel Pestana viaduct; in 1969, the Diário Popular viaduct; later a metro line was run through it, and in the early nineties the Parque Dom Pedro II terminal was installed and refurbished in 1996. The municipal policy of occupying public space with traffic is justified by the growing need to enlarge the road network to the detriment of urban environmental issues.

Text for the postcard: The municipal policy of occupying public space with traffic is justified by the growing traffic requirements to the detriment of urban environmental issues.

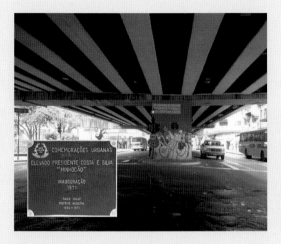

Terraplén Presidente Costa e Silva "Minhocão"

The "Minhocão" was part of a road plan designed to remove congestion from the city centre. The work segregated established urban areas as a result of a bad town planning project which caused the loss of local quality of life and the degradation and devaluation of the environment. In this zone buses are not allowed to circulate, since the project gives priority to the use of the car to the detriment of public transport. This is an example of how individual traffic problems often take priority over urban issues related to the environment and quality of life.

Text for the postcard: This is an example of how individual traffic problems often take priority over urban issues related to the environment and quality of life.

Light vehicle on tyres Fura-Fila

In an attempt to find solutions to city traffic and public transport problems, in 1988 a transport system with exclusive lanes for specially designed vehicles, the *Fura-Fila*, was introduced. This was a local solution, only for an isolated track, which has still not been integrated into the other systems. Moreover, the fact that work was brought to a standstill on several occasions in 2000 has led to its present state of neglect and has added it to the list of unfinished constructions scattered around the city.

Text for the postcard: After work on the *Fura-Fila* was brought to a standstill on several occasions and generally neglected in 2000, it is now on the list of unfinished constructions scattered around the city.

Largo do Glicério

From 1979 to the present day (2000) the frequent superimpositions of roads, with elevated highways to meet the demands of traffic flow, has brought about the fragmentation of the area, the transformation of its uses and the loss of its identity. The spaces left over, generally beneath the viaducts, are huge pockets of poverty: they are occupied by a marginal population, a little further on by low income groups and by institutions providing assistance and work for the whole sector, as is the case of the cooperatives engaged in collecting paper.

Text for the postcard: The frequent superimpositions of roads to absorb the demands of traffic flow have created residual spaces which are now huge pockets of poverty.

Channelling of rivers
Channelling of the Aricanduva river

The channelling of the Aricanduva river is an example of the policy of occupying valleys and channelling rivers to construct avenues. That is interesting for public power because it combines the removal of precarious housing from these areas with the creation of new avenues that increase the value of the environment. Applying this policy intensely in the long-term make the ground impermeable, increases the speed of the run-off and takes the problem of flooding down river.

Text for the postcard: Systematically making the valleys impermeable takes the problem of flooding down river.

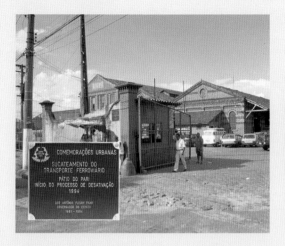

Dismantling rail transport
Closing down of Pátio do Pari

The running down of the rail transport system dates back to 1929, when railway lines and junctions were taken out of use. From the sixties the dominant federal policy was to replace the railway with the road network. That policy brought about the dismantling of large railway areas and structures, which meant that central locations well equipped with infrastructures were deserted, as is the case of Pátio do Pari which, since 1994, has only been used as a warehouse.

Text for the postcard: The replacement of the railway with the road network brought about the dismantling of large railway areas and structures in well equipped central locations.

Large housing estates on the periphery
COHAB Cidade Tiradentes

The municipal entity COHAB, Companhia Metropolitana de Habitaçao [Metropolitan Housing Company], has built a number of housing estates in large-scale town planning operations on the periphery. Horizontal urban sprawl involves major public expenditure to provide infrastructures for areas far from the centres where facilities, transport and jobs are concentrated. An example of this is the largest housing estate in São Paulo, COHAB Cidade Tiradentes, which has been developed since 1981 and has over 130,000 inhabitants.

Text for the postcard: Horizontal urban sprawl involves major public expenditure in areas far from the centres, with no facilities, transport or jobs.

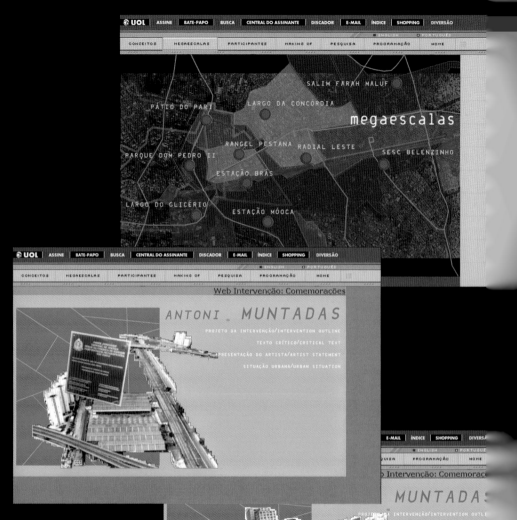

Sicherheitsvorschriften

1970
2002

1970 - 2002

Direction, production and collaboration:
Pep Aubert, Caterina Borelli, Hans D. Christ,
Iris Dressler, Antoni Miralda

• This work in progress was launched in the seventies as a result of the many plane journeys made by Muntadas for professional engagements. And so it begins with a collection of airline safety regulations amounting to two thousand documents.
The collection enables us to observe the forms of semiological evolution, the transformations in corporate design and, more significantly, the appropriations made by each airline of a standard code, established by consensus by an official body which looks out for the passengers' safety, but which, nevertheless, ends up as a particular interpretation where commercial interests live alongside, and sometimes take priority over, information as important as codes whose aim must be to watch out for physical integrity and the preservation of life.

Safety Information

CONSIGNES DE SÉCURITÉ
SICHERHEITSANWEISUNGEN
ISTRUZIONI DE EMERGENZA
INSTRUCÕES DE SEGURANÇA
INFORMACIÓN DE SEGURIDAD

A310

PLEASE DO NOT REMOVE CARD FROM AIRPLANE.
PRIÈRE DE LAISSER CETTE CARTE À BORD.
BITTE DIESE KARTE AN BORD LASSEN.
SI PREGA DI LASCIARE QUESTO CARTONCINO A BORDO.
FAVOR DEIXAR ESTE CARTÃO A BORDO.
ROGAMOS DEJAR ESTA CARTILLA A BORDO.

PAN AM.

TAKE-OFF AND LANDING
DÉCOLLAGE ET ATTERRISSAGE
START UND LANDUNG
DECOLLO E ATTERRAGIO
DESCOLAGEM E ATERRISSAGEM
DESPEGUE Y ATERRIZAJE

THE SMOKING OF PIPES AND
CIGARS IS PROHIBITED
IL EST RECOMMANDÉ DE S'ABSENTIR
DE FUMER LA PIPE ET LE CIGARE
DAS RAUCHEN VON PFEIFFEN UND
ZIGARREN IST VERBOTEN
VIETATO FUMARE PIPA O SIGARI
E PROIBIDO FUMAR CACHIMBO E CHARUTO
PROHIBIDO FUMAR PIPAS Y PUROS

NO SMOKING
NE PAS FUMER
NICHT RAUCHEN
NON FUMARE
NÃO FUMAR
NO FUMAR

OXYGEN
OXYGÈNE
SAUERSTOFF
OSSIGENO
OXIGÊNIO
OXIGENO

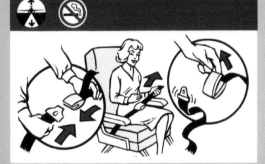

FASTEN SEAT BELT
NO SMOKING

PLEASE COMPLY WITH ALL
SAFETY SIGNS AND PLACARDS

VEUILLEZ RESPECTER TOUS LES
AVIS ET TOUS LES PANNEAUX DE
SÉCURITÉ.

BITTE ACTEN SIE AUF ALLE
SICHERHEITSHINWEISE.

VI PREGHIAMO DI OSSERVARE
TUTTI I SENALI DI SIGUREZZA.

OBSERVE TUDO OS SINAIS DE
SEGURANÇA.

OBSERVE TODAS LAS SEÑALES Y
TODOS LOS AVISOS DE SEGURIDAD.

©1990 Pan American World Airways

922-318319

How can ordinances established by an official body and whose primary goal is to watch out for people's safety at moments of maximum danger to their lives be interpreted in such different ways?

Muntadas, project notes

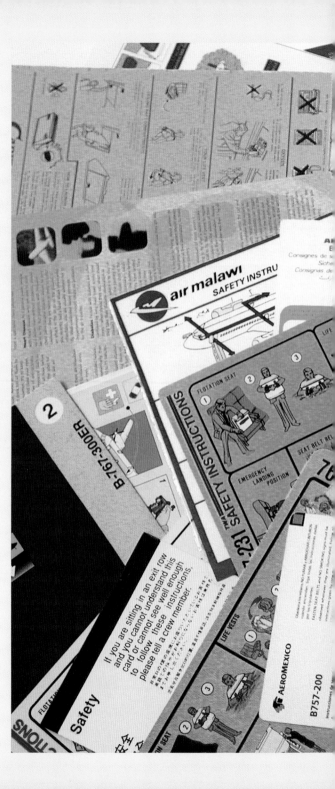

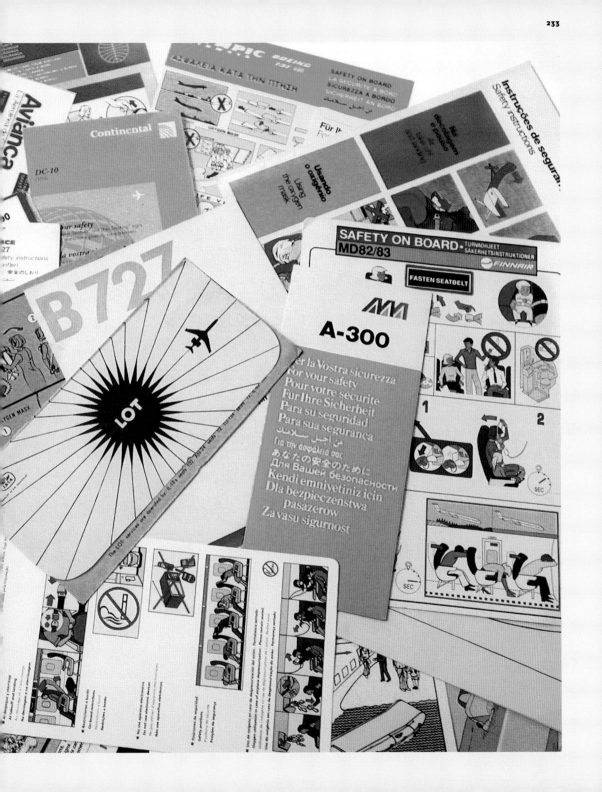

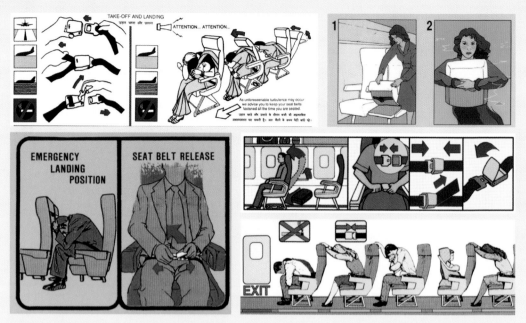

Thoughts about *On Translation: Sicherheitsvorschriften* Hans D. Christ, Iris Dressler

To turn the work *On Translation: Sicher-heitsvorschriften* into the language of words – specifically this text, in this case – is a very special task, because so far the work only exists in the shape of a concept and a collection of safety regulations amassed over twenty years. The work uses the graphic safety leaflets found in the seat pocket in front of passengers on aeroplanes. Muntadas analyses three different scenarios referring to safety on board: "Fastening/unfastening your seat belt", "Placing the oxygen mask" and "Leaving the aircraft by the safety chute".

Once examined in more detail, the invitation, rather unusual at first sight, to write a text about a work of art or an "artefact" which is difficult to conceptualise seems to be consistent with the methodology used in *On Translation*, since it deals with the importance of interpretation in art. The text we are presenting anticipates, in a kind of conclusion in reverse, the personal artistic translation and interpretation Muntadas proposes of a set of specific images, to do with a particular group of people.

First of all, *On Translation: Sicher-heitsvorschriften* refers to a means of transport which, with the Internet, is one of the main instruments of globalised world trade. It is a means of transport which can only exist in highly developed economies, and so it implies economic dependencies and exclusions. Air services have one of the most rigid forms of control and supervision of journeys, as we can see even in the architectural concepts of airports which, like fortresses, organise, channel and regulate mass movements in the most effective way. And so the

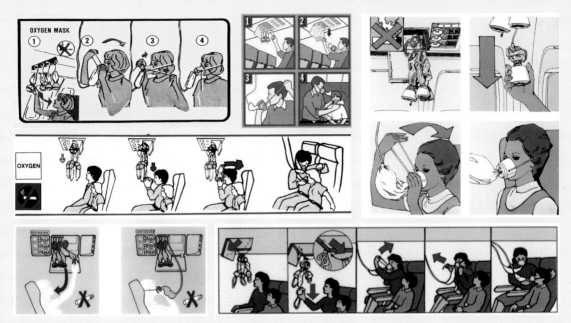

plane may be regarded as a yardstick, like one of those "archetypes" or "displays of power" which Muntadas is constantly confronting.

The safety measures in force on any airline are characterised in turn because they define, as rules and on the basis of international conventions, the standards of the individual model of behaviour, specifically in the event of an emergency. In that way they condition the process of filtering public or official information, a process Muntadas illustrates time and again in his project *On Translation*. In this case there is also a process of transformation of language into image, since the safety regulations are above all graphic stories presenting situations which have to be understood immediately by anyone. However, we have to wonder: who is that "anyone" who is part of the scene in this case? How is his relation to the plane shown from the point of view of optimisation of his chances of survival in the event of a disaster?

On Translation: Sicherheitsvorschriften is presented first of all as an essay about the individual's voluntary connection with the plane: the belt that links him to the seat or the mask which, like an umbilical cord, provides him with oxygen from inside the plane. Apparently individual elements of personal protection are suggested, though in the end that is externally conditioned. In counterpoint the graphic scenes that represent the escape often show a jolly crowd shooting out of the plane looking as if they have escaped from a mechanically conditioned sacrifice, as if they had been saved from an imperious need characterised by the slogan "to be is to be mobile".

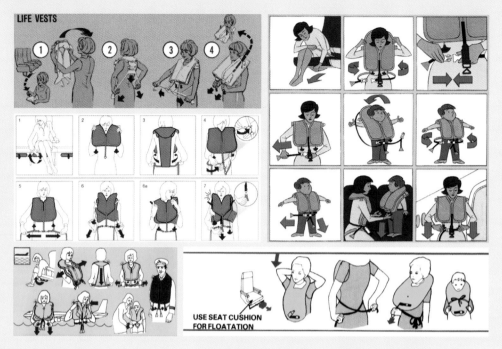

LIFE VESTS

USE SEAT CUSHION
FOR FLOATATION

Parallel to the representation of the travellers as beings intimately linked to the machine, the pictograms, the computer graphics and the series of photographs of the safety devices also provide mirror images of socio-political inclusions and exclusions. The standards of "Western civilisation" reign in the representations of the people. These attributes stand out despite the graphic limitations, although everyone has to identify with the images, including non-Western sectors of the population, who in this case are not only blotted out *de facto* as travellers, but seem to be also eliminated from the right to safety and rescue. Even on Malaysian Airlines, the woman, to some extent presented in a folkloric way, has been adjusted to Western parameters. Indeed, the greatest degree of individualisation of the passengers is to be found in the consecutive series of photographs provided by American Airlines, and the highest level of depersonalisation can be seen in the eyeless figures supplied by the Colombian airline, where the portrait of the passenger with the oxygen mask suggests a member of the secret service. It is striking that in safety regulations the example of the mother fitting the oxygen mask on to her child is so recurrent. Besides the idea of the minimum family unit, which is suggested here as a normative family structure, the normative gender construction: Woman = Mother = Care also stands out. For its part, Gruppo Italia presents a type of computer-generated woman with the sexual features of Lara Croft. On the Yemeni and Malaysian airlines too, the task of putting on the masks is women's business, although in this case their sexual characteristics are reduced to a minimum graphic expression.

On the other hand, with the title "Leaving the aircraft" the motif of "last man on board" is very evocative; as he emerges from the hatchway he is shown as a gentlemanly construction of the generous male attitude, in perfect harmony with the rule "women and children first". Obviously, this first brief incursion into the search for ways of reading the supposedly neutral safety regulations of international airlines is too short. These graphic stories suggest new groupings in series, fields of relations, assignations and contexts. Only between the lines does what is used in this work as an example take place: the inculcation of constitutive patterns of inclusion and exclusion which, at the moment of transfer, cover the space that mediates between the universal message and the individual receiver.

Warning

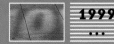

1999
...

Various devices in different places
1999 – in process

Direction, production and collaboration:
Sylvie Boulanger, Elisabeth Chardon,
Olivier Kaeser, Jean-Paul Felley, Centre
pour l'image contemporaine / attitudes /
Le Temps, Ginebra, Suiza; White Box, Nueva
York, Estados Unidos; CNEAI, Chatou,
Francia; Base, Florencia, Italia; Cabanyal,
Valencia, España; Galería Chaves,
Porto Alegre, Brasil

• Starting from the typical procedures of media communication, *On Translation: Warning* is the generic title of a series of works whose aim is to incite the audience to commitment and participation and to question and show up the forms of manipulation and mediation found in informative processes. The thread of the work was the phrase *Warning: Perception requires involvement*, translated (more or less literally, according to the case) into other languages. The phrase has become a kind of slogan that constructs a visual paradox that goes beyond the strict sphere of exhibition spaces and their protection mechanisms to take its place in a broad spectrum of different situations, locations and contexts.

• • Although this work was first formulated on the poster for the exhibition *On Translation: The Audience*, at Witte de With in Rotterdam, the specific project entitled *On Translation: Warning* was launched in the context of the *Muntadas, Warning* exhibition, held simultaneously at the Centre pour l'image contemporaine, the Musée d'art et d'histoire and the *attitudes* group, all in Geneva. The show was a collection of earlier projects by the artist – *On Translation: The Applause* (1999); *Media Architecture Installations* (1999); *La siesta* (1995); *Architectur, Räume, Gesten* (1991); *Portrait* (1994); *Portraits* (1995) – , as well as a retrospective of his video work and three special projects.
The three special projects consisted of the publication of a small sticker with the phase *Warning: Perception requires involvement*, which was distributed arbitrarily and placed at random on different elements of urban furniture in the city (traffic lights, notice boards advertising hoardings); the placing of the same phrase *in situ* on the outside of the windows of the ground floor of the Centre pour

l'image contemporaine, so that the interior of the exhibition room could be seen through the letters, and at night it became a kind of light box; and lastly, a full, independent page placed in the Swiss newspaper *Le Temps*, with the usual format for advertisements in the press and a composition formed by the phrase that structured the project written in white on a red rectangle and translated into eight languages (French, German, Arabic, Italian, Spanish, English, Portuguese and Russian).
On Translation: Warning has been recontextualised and presented at the White Box Gallery in New York, the CNEAI in Paris, Base in Florence, the Cabanyal district of Valencia and Galería Chaves in Porto Alegre, adopting the local language in each case.

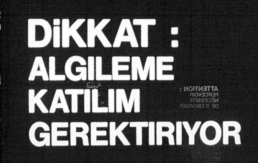

DiKKAT :
ALGILEME
KATILIM
GEREKTIRIYOR

ACHTUNG :
WAHRNEHMUNG
ERFORDERT
EINSATZ

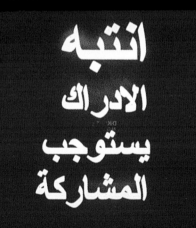

ATTENTION :
PERCEVOIR
NÉCESSITE
DE S'ENGAGER

انتبه
الادراك
يستوجب
المشاركة

The Man Who Was Worth 15 Minutes Sylvie Boulanger

She was quite sure that a chronology of the pieces of advice would give the pointers to Muntadas's work. The way in which, unbeknown to everyone, he proposed a possible meeting, confirming by a genuine design of exchanges – I can't work out what this means the fundamental importance of what could be produced or destroyed by a power relation – or this: a power relationship / a powerful relationship/relative powers?

"This one is worth 15 minutes," he had said to her as he put her out of the taxi just outside the bookseller's window. The man who was worth 15 minutes was not there. Even if he had been, she would doubtless never have known which of the two was worth 15 minutes to the other. The most likely answer, knowing the artist's acumen, was that the relationship could not have generated a profit much higher than one given "a 15-minute value".

She thought that time was counted. Obviously counted, like public space and like the time of collective action or individual involvement. She thought one could act on the perception of thingsÉ but how to turn it to good account other than by drawing the successive contours of those utopian negotiation spaces where there was no power relation or capture of the individual: really public spaces where each person's involvement could be practised in a polysemy destroyed by marketing and power? It still remains to be able to live there, and what came next proved that she was still not there.

"We'll have dinner with X and then we'll go drinking with XX." Fortunately she had been running that morning in Barcelona, which made her 30 minutes late arriving at the rendezvous. Healthy disobedience. Impossible to work in a city without having visited it running in the morning. A necessary appropriation, even if an illusory one. Thirty minutes late then, after an almost sleepless night and 10 kilometres on her legs. The need to be alone had just about been mastered. At all events the feeling came along systematically as soon as work with the other began. But there, against all expectations, it survived and grew. A desire to run away swept over her: it would force her to escape twice during the day, on made-up pretexts.

The whole day she was dogged by a feeling of working under obligation, driven by an interest in objects and information, but no response, just a work environment, goals, planning for a series of meetings. At no time the ease of an interaction that feeds on itself through the sterile energy of exchange, that chummy revival of the stupid pleasure of the retort that draws its strength from the utterance, that comfort of being among people from the same milieu as ourselves, art, where each person needs the other, the extreme ease of dependence where the dreamed proof masks one's perception of reality.

She was as if alone, with the other. She was just beginning to understand her limits and the issues that followed from them when exhaustion descended upon her. But she had understood that however difficult it might be, that position would correspond to the highest level of exchange. They got drunk with XX.

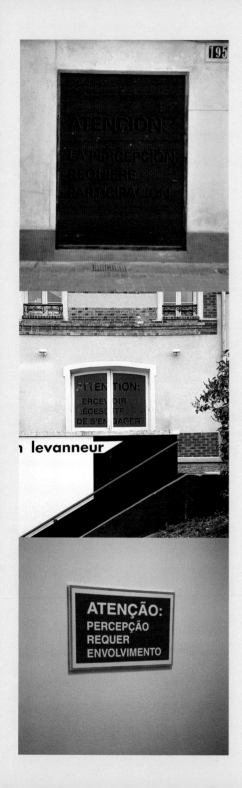

An artistic concept presented in a cultural space, let us say a protected one, like a gallery, a museum, an art school, is not, in fact, exposed to the same pressures of, among others, space, climate, light, sound, itinerary, as the ones designed for an urban site which is by definition open. The relation with the audience is also totally different. In the first case, it is an audience one seeks out, in the second case, an audience one finds. However, the audience is fundamental in both situations; they represent the element that makes it possible to complete the circuit.

Muntadas. "Marseille/Givors: de la Commande publique à l'intervention temporair", interview with Sylvie Amar, *Art el Mégalopole RN86*. Paris: Mardaga, 1989

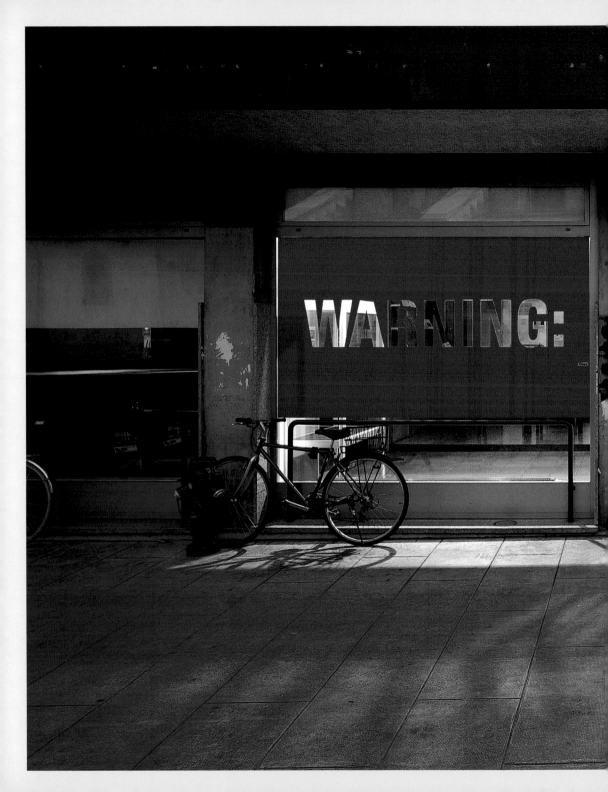

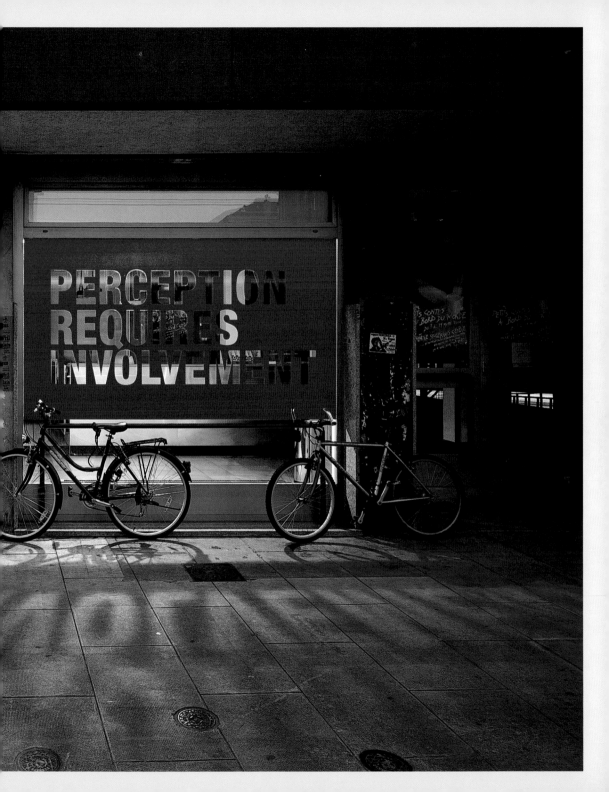

Muntadas. On Translation: The Sticker
Olivier Kaeser & Jean-Paul Felley

When we asked Muntadas to do a project in Geneva, we had imagined a happening that would erupt in a number of places. Together, we had therefore set up the components of this Geneva event: first a lecture, then three simultaneous exhibitions.[1] Installed in a display case at the Centre pour l'image contemporaine, the large format slogan *Warning: Perception requires involvement* could be seen from the street by day and by night. Simultaneously, the same slogan appeared on a full-colour page in the Swiss daily *Le Temps*, in eight languages, and on a small sticker. The sticker, with a run of 4,000 copies, intruded into people's lives by post – included in the *attitudes* mailshot – and then appeared on road signs, advertising hoardings, cash dispensing machines and other elements of urban furniture. Everyone appropriated the phrase by sticking it onto everyday objects, either to "transmit" it to others by choosing supports such as the bodywork of their cars or scooters, or opting for a more personal kind of injunction by sticking it onto a briefcase, a scanner, a desk drawer or the cover of a file. Little by little, a number of people thus managed to impose sustained attention on themselves to keep up the commitment necessary for perception of their environment. Muntadas is totally involved in the implementation of a project, whether it

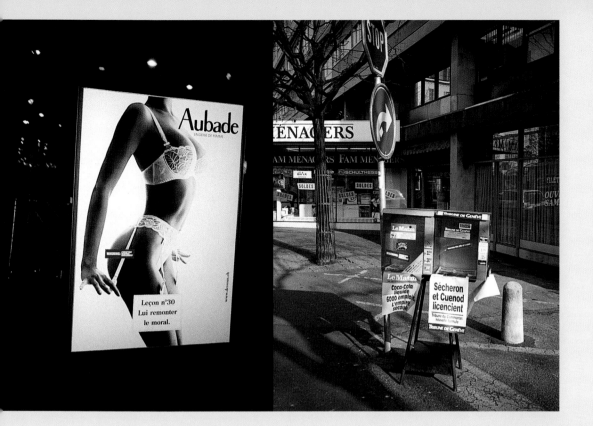

takes the shape of a multimedia installa-
tion, a CD-ROM, a workshop or a simple
sticker. If his work is still as surprising as
ever today, it is because it questions the
operation of several elements that go to
make up the present: the media, adver-
tising, the economy, political statements.
With *Warning*, however, he is touching a
more global but also more intimate chord
in our life, since it is a matter of our
capacity to perceive people and things.
In a way, that sticker acts as an antidote

to a number of evils that rot our every-
day lives: tiredness, habit, automatic
gestures, stress, etc. He appeals to our
capacity – and especially to our will – to
open up our senses and our intellect in
order to catch what is happening around
us. In a nutshell, the *Warning* sticker
successfully incites us to become sensors
of reality.

1. Exhibitions from 29 January to 19 March 2000 at
attitudes, the Centre pour l'Image Contemporaine Saint-
Gervais Genève and the Musée d'Art et d'Histoire.

On Translation: Warning Elisabeth Chardon

Since its creation in March 1998, not counting certain photographic operations which are clearly closer to art than to journalism, *Le Temps* has opened its pages to fifteen or so artists' interventions. It accommodated a series done by young artists from Geneva in the summer of 1998, in the following year, it allowed the Relax group from Bienne to organise a parody of a survey; in 2000 it took part in the Geneva stage of Muntadas' *On Translation* project, and, in 2001-2002, in the framework of a partnership with *attitudes*, it offered a series of artists who have had an exhibition at that contemporary arts space in Geneva a chance to see an unpublished work printed full page. Indeed, few of them have really worked with the support like the Spanish artist. Muntadas' intervention in *Le Temps* on Saturday 29 January 2000, opposite an article on the lottery and casinos in French-speaking Switzerland, had a header, like the other pages of the daily. It was the term "Translation". Below, eight red rectangles spelling out the same slogan in eight different languages: in Spanish, "Atención: percepción requiere participación". By choosing a daily, Muntadas was intervening in the basic support of mediation. A perfect on-site work. Every day journalists relay, translate raw information. They capture an event, or its interpretation by a press agency, and tell it to the readers. Muntadas' phrase thus sounded like a golden rule for the good journalist. For the good reader too.

Through its declension in eight languages, it also conjured up the diversity of the world the media are supposed to report. What a headache for those translations! Among the contributors to *Le Temps*, at the School of Translation and Interpretation in Geneva, a whole multilingual network had been set in motion. In particular, I remember discussions about the translation into Arabic: asking several people made me aware of the cultural and linguistic differences of the Arab world. Setting up the operation itself thus turned out to be rich in meaning.

Except for the first series, the artists' interventions that appeared in *Le Temps* have always been linked to a current event – an exhibition – reported in an article on the "culture" pages the same day. It was not a matter of making the work published explicit, but of providing clear clues for the reader by talking, not simply about the work that could be seen on the pages, but more broadly about the artist's research.

And so, returning to those four years of experiments, I realise that Muntadas' intervention was particularly interesting because it was a piece of a rich jigsaw puzzle which included not only different exhibitions in Geneva, but also all the pieces of *On Translation* networked through Internet. And most of all because Muntadas' proposal only really made sense if it appeared in a general interest daily.

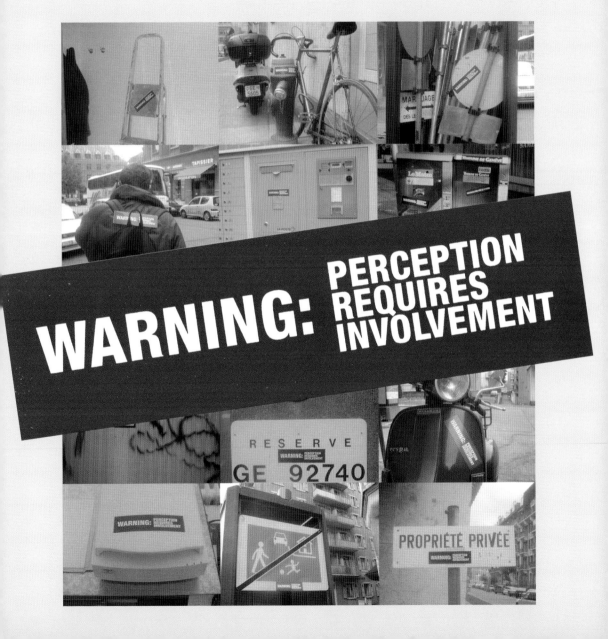

WARNING: PERCEPTION REQUIRES INVOLVEMENT

Traduction

ATTENTION:
LA PERCEPTION
DEMANDE
L'ENGAGEMENT

ACHTUNG:
WAHRNEHMUNG
ERFORDERT
EINSATZ

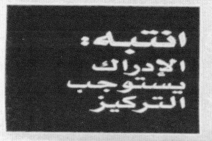
انتبه:
الإدراك
يستوجب
التركيز

ATTENZIONE:
LA PERCEZIONE
RICHIEDE
COINVOLGIMENTO

ATENCION:
PERCEPCION
REQUIERE
PARTICIPACION

WARNING:
PERCEPTION
REQUIRES
INVOLVEMENT

ATENÇÃO:
A PERCEPÇÃO
REQUER
EMPENHO

ВНИМАНЕ:
восприятие
требует
участия

Remerciements aux traducteurs, notamment ceux de l'École de traduction et d'interprétation de Genève, et aux collaborateurs du Temps.

SUISSE ROMANDE • La Loterie romande programme le fiasco du réseau de casinos d'intérêt public dont elle rêvait en ignorant les maisons de jeu existantes. Un conflit se prépare

En heurtant les intérêts des casinos privés, la Romande des jeux court à l'échec

Patrice Guénat, directeur de la Romande des jeux, pendant la conférence de presse. LAUSANNE, DÉCEMBRE 2000

Pierre Dubois, ici au centre avec Jacqueline Maurer, en a appelé à l'union des cantons.

Laurent Busslinger

Six casinos romands, fraternellement rassemblés derrière un réseau de casinos qu'ils convoitaient. Patiemment préparé depuis qu'ils rêvaient de peupler un public en 1993 le retour des grands jeux d'argent en Suisse, ce rêve de la Romande des jeux – qui n'aura jamais que des misères aux cantons existent? (Le Temps du 25 janvier) – a volé en éclat hier à Lausanne. Un échec ironiquement devenu évident lors de la conférence de presse qui aurait dû sceller la solidité de ce bloc, car Pierre Dubois, président de la Romande des Jeux S.A. a ouvert en instant ironie: «Seule l'union des cantons évitera les décisions imposées par la Berne fédérale.»

Une union romande qui aurait dû se faire sur le pré d'un grand casino (casino A) à Lausanne, complété par quatre Kursaals (casino B) à La Chaux-de-Fonds,

Yverdon, Fribourg, et Sion. Pour Patrice Guénat (directeur de la Romande des jeux) ces implantations tiennent compte des besoins de populations respectifs, garantissant que le casino A, le consoler d'État Gérard Ramseyer a déjà pris position en faveur d'un casino A. En Valais, son collègue Wilhelm Schnyder plaide pour une maison de quatre casinos, dont un de la catégorie A. Et Jacqueline Maurer elle-même, pourtant présidente de la Conférence romande de la loterie et des jeux...

Résistances

L'ennui, c'est que ce réseau ne tient pas compte des casinos existants de Genève, Montreux, Saxon et Courrendlin, et oublie de même tous les autres projets

privés qui ont déjà surgi ici et là (voir l'infographie ci-dessous). À Genève, qui ne pourrait prétendre selon ce scénario et en fonction des restrictions fédérales qu'à un casino B, le conseiller...

Un refus à risques

Dans ce contexte, le conflit international est programmé...

Seule conclusion pour la Suisse romande...

L'importance économique des casinos

La Romande des jeux prévoit des investissements de 50 millions de francs.

La Romande des jeux prévoit d'être partout locataire de collectivités publiques...

Lausanne: Château d'Orchy. Concession A visée (Grand casino)...

Fribourg: Site à trouver...

Sion: Sous-le-Scex (bâtiment à construire). Concession B...

Les casinos de Suisse romande

Courrendlin
■ Casino «B»
Casinos existants privés
● Casino «A»
● Casino «B»
● réclamant de devenir «A»

La Chaux-de-Fonds
Yverdon
Fribourg
Lausanne
Montreux
Divonne (F)
Evian (F)
Genève
Annemasse (F)
Saxon
Martigny

sous. Produit des jeux: 20 millions. Emplois-sexe: 50. Autres: 50.

Casinos privés existants:

Courrendlin: 33 machines à sous, 1 boule. 2 millions de produit des jeux. 6 employés aux jeux, 25 au total.

Saxon: 200 machines à sous, boule. 25 millions de produit des jeux. 40 employés aux jeux, 65 au total. Un Casino A (demande) signifierait 12 millions d'investissement.

Genève: 109 machines à sous, boule. 17 millions de produit des jeux. 38 employés aux jeux, 53 au total. Licence A demandée.

Montreux: 200 machines à sous, boule. 21 millions de produit des jeux. 60 employés aux jeux, 90 au total. Un Casino A (demande) signifierait 30 millions d'investissement.

Autres projets privés connus:

Martigny: Licence A souhaitée. 12 millions d'investissement pour la construction.
Zermatt: Licence B souhaitée. 5 à 7 millions d'investissement.
Crans-Montana: plusieurs projets de Casinos B. 6 à 8 millions d'investissement.
Fribourg: Casino B concurrent ce celui de la Romande des jeux.

L. B.

GENÈVE • Les agriculteurs opposés à la loi contre la spéculation

La Chambre genevoise d'agriculture (CGA) s'opposera à la loi contre la spéculation foncière soumise aux électeurs genevois le 12 mars prochain...

VAUD • Pas d'opposition au restaurant du glacier des Diablerets

Le projet de restaurant du glacier des Diablerets, élaboré par l'architecte Mario Botta, n'a suscité aucune opposition lors de la mise à l'enquête...

JURA • Joseph Voyame remplacé à l'Assemblée interjurassienne

Remplacer un siège de la trempe de Joseph Voyame à l'Assemblée interjurassienne constituait une mission délicate pour le gouvernement jurassien...

VALAIS • Débâcle de Loèche-les-Bains: la société Parkhaus a été mise en faillite

Le couperet est tombé pour une des sociétés endettées de Loèche-les-Bains: Parkhaus SA a été mise en faillite...

SUISSE ROMANDE • La réorganisation des bureaux de poste est jugée préoccupante

La restructuration du réseau des bureaux de poste préoccupe la Conférence des gouvernements de Suisse Occidentale...

CANTONS • Les camionneurs français annoncent un blocage des frontières

Les camionneurs français entendent à nouveau bloquer les voies de passage aux frontières. Lundi matin, le poste frontière de l'autoroute à Bâle-Saint-Louis, pourrait bien être à nouveau bloqué...

VALAIS • L'enquête a débouché sur 34 interpellations

Bande de jeunes démantelée à Sion

Une bande de jeunes actifs en ville de Sion a été démantelée après une enquête qui a débouché sur 34 interpellations et deux arrestations...

ATS

SUISSE ROMANDE • Droit de regard des parlements

Accord sur la HES de Suisse occidentale

Les six cantons romands ont signé un protocole d'accord concernant le contrôle parlementaire de la HES de Suisse occidentale...

ATS

The Interview

2002

Birmingham, Alabama, USA
2002

Production, collaboration and acknowledgements:
Caterina Borelli, CNN

• This work goes back to a thirty-minute interview with Pablo Poliaschenko, a Russian-English translator during the Cold War, on a CNN programme. In the form of a direct testimony, the document illustrates the role of the translator in a historically compromised situation, in which his task goes far beyond the purely linguistic sphere and he becomes a repository of a range of ideological and media positions. Pablo Poliaschenko's experiences, anecdotes and thoughts not only show the impossibility of any kind of translation being objective; they are a parallel chronicle to the successive and sometimes contradictory official discourses, a kind of voice-over that tells the ins and outs of events which are fundamental to recent contemporary history.

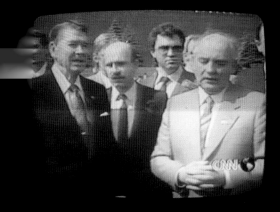

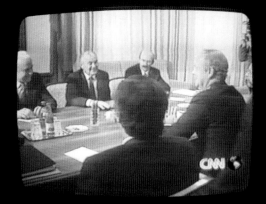

Translating News Caterina Borelli

It is September 2002, and I have just finished working on the coverage of the anniversary of September 11, 2001. I am Italian, working for an Italian TV company, and I have been living here in New York for more than twenty years. In the structure that creates information, the correspondent is the translator of a foreign reality to the home audience.
My colleague, an Italian foreign desk journalist, coming from Italy on a specific assignment, is the translator of the US reality – of its political, financial, cultural, relevance – into our Italian reality. I myself, as producer, am employed to provide the information necessary to give the audience an exact interpretation of what is happening. I am the interpreter for the translator.
I have often found myself in a situation where I provided information that the correspondent found too remote or too irrelevant to the Italian reality. Yes, it's important to the US, but because it is not in the news in Italy we will not cover it. Some stories cannot be translated. Some stories are not "sexy" enough. The relation between the current administration and Enron is not «sexy». We don't cover it anymore. After all these years I am too detached from the Italian reality, and can no longer distinguish what is news for Italy. I interpret with a US "key"; I have lost my knowledge of the Italian. Could there be news without interpretation? News is not what is happening in a place at a certain moment, but the relevance that fact will have in another place. Its interpretation. There is no kidnapping of a child in an upstate town, without this kidnapping taking its place

in an epidemic of kidnapping, and "We need stronger laws". There is no contract awarded to a US oil company in a foreign country without mention of the omission of the fact that the President was a major shareholder of that company. It appears that there is no news but its interpretation. News exists only in its translation, in its tailoring to a specific audience.
On September 12, president Bush is talking at the UN to push for an armed invasion of Iraq. He chooses strong words; his English is aggressive. As he likes to say: "Make no mistakes" in understanding the meaning of his speech. In the booths the translators work hard to disentangle the many languages of the General Assembly. In Italian his speech sounds mellower: could it be that in English he is pushing for war while in Italian he is only suggesting it? Could he be making war in English but not in Italian?

In the following days, we watch with interest what our Prime Minister Silvio Berlusconi will say in his address to the UN. In the News Department we all tune in the live feed and watch. Room after room resounds with the echo. As he starts all of us turn, in unison, puzzled: he is talking in English. He has chosen to address the General Assembly directly, without the mediation of the translator. We all notice – it is more than a simple choice, it is a sign. However many languages are defined as official at the UN, English is the one of the power brokers. By speaking English, Mr Berlusconi intends to place himself as a peer at the table of the decision makers, to be considered a politician at a world level,

doesn't want to miss the boat, wants a piece of the pie. More so in the following days, when Mr Berlusconi, this time in the role of Foreign Minister, travels to Camp David to meet with Bush. At the end of the private talks, they come out to meet the press and answer a few questions. This time we see them each with their own translator. But at a certain moment our Foreign-Minister-cum-Prime-Minister cannot resist, takes over and again speaks English to declare that: "The US flag does not only represents the US nation but is a symbol of freedom throughout the world". In Italian *interprete* and *traduttore* can be used synonymously. Usually the interpreter works live, as in these diplomatic situations, while a translator works in writing. It is unavoidable for a live translator to interpret. Languages are so rich, many words could convey a meaning, although giving it different nuances. Mr Berlusconi wanted to make sure nobody would interpret his word. These days, war is spoken in English.

I had always thought that translation could be decisive in major political decisions. Listening to the Poliaschenko's interview, I realised that in the translator's hands there are far reaching possible interpretations and that we never fully realise that.

Muntadas, project notes

L'Affiche

2002

Paris, France
28 March 2002

Production, collaboration and acknowledgements:
Catherine Auclaire, Sergio Bregante, Benoît Fougeirol, Jean-Christophe Nothias, Joan Olivar, *La Page*, Analia Segal

• *On Translation: L'Affiche* was an intervention in the first number of the newspaper *La Page*. It consisted of the production of the back of the page, where a composition of the phrase *Attention: La perception requiert l'implication* was printed, written in white on a red rectangle and translated into the eleven languages of the member countries of the European Community at the time (French, German, Spanish, Dutch, Portuguese, Greek, English, Italian, Danish, Finnish and Swedish). The lower rectangle of the right column was left empty, with no text of any kind inside it.

• • This work appeared in the first number of the newspaper *La Page*, the product of an initiative by a group of independent journalists and which, as the name indicates, has only one page. On the front the first number had different founding texts and writings with thoughts about Europe; on the back there is an illustration, which will be commissioned from a different artist for each number.
On Translation: L'Affiche retrieved one of the fundamental elements of *On Translation: Warning*, adapting it to a publication that wrote about the idea of European identity. The call to action, commitment and participation was therefore done in the eleven languages of the member countries of the European Union, whilst the empty rectangle left a space free for the minority languages and the languages of the countries that would be joining in the future.

On Translation: L'Affiche Joan Olivar

Several years ago, I recall Muntadas had mentioned he was contemplating a project on what was then and still is my job: simultaneous interpreting. A few months later, he asked me for material on sound equipment and interpretation booths. Shortly after, *On Translation: The Pavilion* emerged as the opening piece in a long series.

The project followed its course, extending beyond the initial context of international meetings and negotiations, and gradually straying from its reference to translation, in the literal sense of a transfer from one language into another. Until the theme of multilingualism reappeared in one of the series' most recent avatars, *On Translation: l'Affiche*.

Muntadas relates the function of (inter)mediation in the process of communication to that of a filter or an adapter, implying its potentially distorting and manipulative nature, because of all the information that is lost, fabricated or transformed. In my view, however, an interpreter who equally operates "in between" is more of a "facilitator". No matter how imperfect live performances may be, their purpose is to keep the dialogue flowing.

In contributing to the poster Muntadas produced for the first issue of *La Page*, a "European ideas daily", I acted as a "facilitator", and not a translator. The core sentence originally termed in English, *Warning: Perception requires involvement*, had already been translated into the local language(s) of the various places it had passed through. My task now was to "facilitate" its translation into the exotic languages of the Union: i.e. Greek, Dutch, Danish, Swedish, and Finnish, so as to configure a European-specific series. Chance would have it that I had been assigned

to a plenary session of the Economic and Social Committee in Brussels, in all eleven languages of the Community, which is quite unusual for an interpreter who only covers three languages. It was sheer coincidence that only two days after Muntadas had called me, I would have native speakers at hand, in each of those languages, to complete the linguistic picture of the current European Union: an unexpected stroke of luck I couldn't waste. The point of *La Page* being to reflect on an alternative Europe, the project is most appropriate. By illustrating language multiplicity, it stresses the cultural diversity of Europe however much effort the Union puts into blurring differences, in the well-known name of harmonization.

After explaining the origin of the sentence and the purpose of the publication, I managed to "involve" my colleagues who accepted the challenge and so became party to Muntadas' whole project. The oral version an interpreter produces in conveying a message in real time is transient, by essence, unlike the written text of a translation that remains. More so when it is to be published. Hence interpreters took the task at heart: joining their efforts in each booth, they devoted their time off that whole morning to finding as concise a translation as would match the English version. Be this an opportunity to thank the interpreters of the Ecosoc Committee plenary held on March, 20, 2002, for their kind "involvement".

On Translation: L'Affiche was published a week later in the first issue of *La Page*, and I was mentioned in the credits. My name, however, was misspelled, John: "You're translated/in disguise…", said Muntadas. Simple misprint or conscious interpretation?

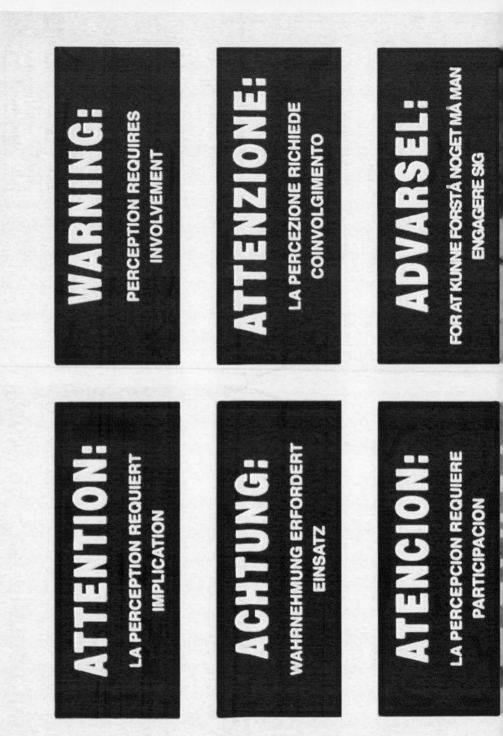

WARNING:
PERCEPTION REQUIRES INVOLVEMENT

ATTENZIONE:
LA PERCEZIONE RICHIEDE COINVOLGIMENTO

ADVARSEL:
FOR AT KUNNE FORSTÅ NOGET MÅ MAN ENGAGERE SIG

ATTENTION:
LA PERCEPTION REQUIERT IMPLICATION

ACHTUNG:
WAHRNEHMUNG ERFORDERT EINSATZ

ATENCION:
LA PERCEPCIÓN REQUIERE PARTICIPACIÓN

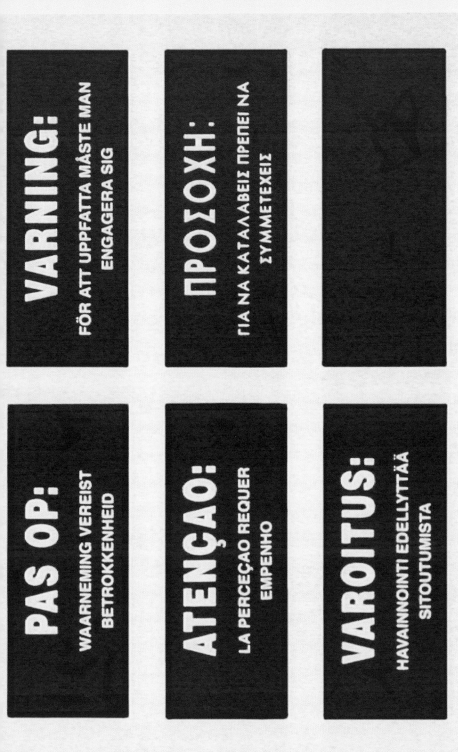

VARNING:

FÖR ATT UPPFATTA MÅSTE MAN ENGAGERA SIG

ΠΡΟΣΟΧΗ:

ΓΙΑ ΝΑ ΚΑΤΑΛΑΒΕΙΣ ΠΡΕΠΕΙ ΝΑ ΣΥΜΜΕΤΕΧΕΙΣ

PAS OP:

WAARNEMING VEREIST BETROKKENHEID

ATENÇAO:

LA PERCEÇAO REQUER EMPENHO

VAROITUS:

HAVAINNOINTI EDELLYTTÄÄ SITOUTUMISTA

"On translation : l'affiche ", Antoni Muntadas pour Le Pages n°1 du jeudi 28 mars 2002
Rennes Université & Sérgio Bregantini et James Oliver

Warning: Danger of Thinking Jean-Christophe Nothias

It was about eleven at night in that month of March 2002 when Muntadas picked up his telephone. A transatlantic conversation. I did not agree with some of the translations that appeared in his *Warning*. I wanted to get that straight with him in person. Here, at *La Page*, we were caught up in an adventure of another kind. A European daily of ideas, a single page, with an original work on one side and writings on the other. An encounter between non-conformist art-ists, journalists and intellectuals during a national presidential election. Every day a strong idea with a summary in four languages. Benoît, the poster director, had insisted that Muntadas should do the first number. Knowing nothing about contemporary art, I took advantage of my ignorance to approach the artists with a certain carelessness; my contacts with them thus took a rather amusing turn. I wondered whether Muntadas had originally thought of his *Warning* in English or Spanish. Where had he started from? I wondered who had suggested the French translation to him. I won-dered whether all the words covered the same area. A few days earlier, working on the first main text for *La Page*, André Glucksmann had talked to me about blindness, the absence of perception, the very kind that Chekov talks about in *The Cherry Orchard*. All the characters are fighting to get hold of the ownership of the grandfather's cherry orchard. When one of them eventually wins his case, it is no longer there. The muffled noise that can be heard all through the play is the sound of the axes chopping down the cherry trees. Absence of percep-tion! Blind individual awareness. For a newspaper that aims to be involved in a political analysis of the future of our European political space, the capacity to raise awareness was central. But for a publication like *La Page*, there is no question of getting into involvement in the militant sense. In *involvement* there is the idea – a beautiful one by the way – of entering the wheel: *in volvere*. We debated. Muntadas told me: "Okay, let's keep *implication* rather than *engagement* in the French version. But you will never get satisfaction out of a linguistic head-ache like that. Each person understands and translates differently." Muntadas is right. That is precisely where percep-tion starts up again. His *Warning* acts as a trap, as a call to the severity that heightens perception. Time has passed. The discussion has gone on. Awareness has been raised. The semantic particle accelerator is in place.

No, no. Too Much Information...! Sergio Bregante

No, no. Too much information...!
To talk about a project in particular is more problematic and less satisfactory than to refer to the joint work experience in broader terms.

But in this case it is also complicated to decide when, or where, one project ends and the next one begins.

In a way, the La Page project had begun almost two years before with the installation of a *Warning* in the window of a gallery in New York. Before that, it had been presented in Geneva in the form of a window and a sticker.

Warning NY: a text made up of four words and a window. The letters were cut out against the red background. The window was still a window, but now with a message, this time for the Chelsea public.

La Page France: the back cover of the magazine in poster format and the same Warning message, but this time repeated in each language of the European Union. The totally symmetrical diagram of red tablets on a white background in two columns of six; all the white letters but one, the last, which, with just the red background and no text, broke the symmetry and wrote a new, wordless message that referred to all the other unofficial languages in the European Union.

The projects are not finished, they are just not continuing. But we still think about them.

Photos of people talking on mobile phones, museum spaces, photos of balconies.
No, no. Too much information...!
That photo was never taken. But the phrase stayed with me for the rest of the journey. Another way of collaborating, exchanging and sharing public and private information.

The Edition

2000
...

New York, USA

2000 - in process

Production, collaboration and acknowledgements:
Pilar Vázquez, Penguin, Pelikan,
Artemídia Rocco, Metis, Gustavo Gili,
Rowohlt, Ediçoes 70, Parco, Il Saggiatore

• This work in process consists of a collection of different editions of John Berger's *Ways of Seeing*, published in different years and languages.
The concept focuses on a book in which text and image are inseparable, thus showing to what extent the successive editions alter the message and produce shifts of meaning, as they are the result of different publishing decisions and appear in different contexts. The publisher is therefore a translator who modifies the original using particular mechanisms (typography, format, illustrations) and creates unforeseen paradoxes for the readers.

Dear John Berger.

I don´t know if you remember, but we met briefly at Juan Muñoz´s opening at the Tate Modern more than a year ago.

I mentioned to you then, my interests in exploring – as part of my on-going series On Translation- the fact of your book <u>Ways of Seeing</u> having been translated into different languages and diverse editions with different layouts. As I mentioned then I have been collecting the different editions in the different languages. This project is tentatively being called On Translation: The Edition.

Personally, I find interesting the relationship between text, image, design and layout of the book with the different publishing decisions that have made each of the books in the various versions "look" slightly different.

On Translation tries to think and discuss the way translation, transcription and interpretation are not just text and reading but are also a part of our cultural understanding.

I hope that we can meet and talk about these issues and maybe eventually interview you. Pilar Vasquez, has been following and discussing with me about this matter and I have been talking with her about being the "translator" for this project.

I don´t know, maybe you have already thought about <u>Ways of Seeing</u> and its different editions and you have some comments to share with me. I hope that I have been clear enough so that you understand what I am talking about.

I look forward to hearing from you and hope that we can meet again in person. Maybe Pilar could also join us.

All the best,
Muntadas

The Symbol

2002

New York, USA
June 2002

Production, collaboration and acknowledgements:
Joan Brigham, Ton Granero, *Transversal*

• Placed in no. 18 of the contemporary culture magazine *Transversal*: a double page spread with a composition in black and white of nineteen images taken by Muntadas in New York from different milieus (advertisements, the media, concerts, placards, etc.) where the American flag plays a central role. In each row of photographs there is a box with a black background on which the words *símbol, solidaritat, patriotisme, paradoxa* and *marxandatge* could be read successively.

• • *On Translation: The Symbol* was Muntadas' reaction to the situation that arose after the events of 11 September 2001. The work was presented for the first time at the conference entitled "Culture and the knowledge society: present and prospects for the future", held on April 10, 2002 as part of the *Cultura XXI* season at Palau de la Virreina (Barcelona), with the sociologist and writer Manuel Castells. In this first approach, eighty slides were shown, among them the photographs Muntadas had taken in New York, alternating with words that introduced an element for thought. Later the work was reformulated to make up Muntadas' contribution to the special number of *Transversal* devoted to 11 September, which was a collection of different texts analysing the events in New York and Washington and a series of works by artists on the subject.

The work aims to show the reiterative and omnipresent use of the American flag during the long process of media representation and information after the terrorist attacks on the Twin Towers and the Pentagon. The symbolic significance of the icon and its unmistakably populist translation are made relative by the inclusion of a series of words which question the paradoxical sense of that generic, exacerbated call to patriotic feelings and values.

Thoughts on *The Flag Project* Robert Atkins

One message from Al Quaeda to Americans: Let 10 billion flags bloom in the USA. The stars and stripes are – and remain a year later – ubiquitous, planted on surfaces ranging from worsted wool lapels to the stainless-steel sides of every New York subway car, a dubious use of my tax dollars in a city bankrupted by 9/11. Nor is everyone's motives for displaying the flag patriotically pure: an Israeli associate and a Pakistani cab-driver friend feel similary pressured to display the flag to prove that they are loyal Americans in the face of President Bush's jingoism.

What a reminder of the importance of symbols and their complex, contradictory characters. The cross, after all, can represent everything from liberationist theology to the Klu Klux Klan. Yet only 15 years ago American artists – not schmaltzy pop musicians like Elton John – created the emblems that continue to stand for the ongoing AIDS crisis: the Red Ribbon, the AIDS Quilt, and Silence = Death. In a virtualizing, information age, new symbols can function as newly developed public space and discourse. But genuine symbols aren't produced on demand; they reflect the hard-won inspiration and energy of their creators. Undoubtedly, every generation gets those it deserves.

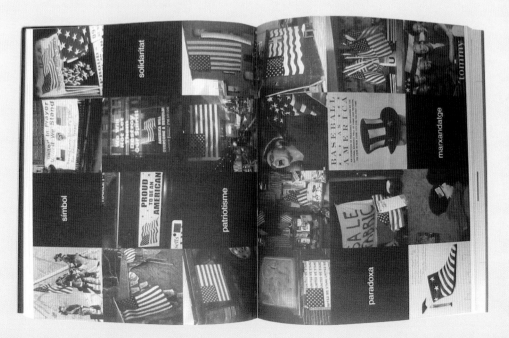

Rally Round the Flag Boys like Sheep Joan Brigham

After Sept 11 American flags seemed to
be everywhere, more appeared each day.
Most were in New York, but in Boston
there were also very many, perhaps
because two of the hijacked airliners took
off from there. The flags were on car wind-
shields, bumpers, aerials, hung from win-
dows and bridges, across whole building
fronts, draped as bunting over rounded
windows, on baby carriages and even from
the handlebars of tricycles. Ach display
was the a reason to respond in the most
conventional way open to most people and
it represented an assertion of solidarity of
being American and under siege. The flags
as a cultural phenomenon reflect two
opposing views: the under siege mental-
ity understandably exhibited the symbol
of our national identity, but the interpre-
tation of that identity was reactionary,
the defense of the flag at any cost even
if it severely undermined our devotion to
liberty and freedom: to me, the historic
imperative was quickly replaced by its
opposite as the flags continued to go up.
I felt empty, and so did my friends: with-
out an intellectually formed response to
what it meant, our minds were numbed.
Gradually, as the weeks worn on, it was

clear why the US was hated and the *faux
naiveté* and the whimpering innocence
were understood as elaborate denial
and one very dangerous. The checklist is
easy to write: our arrogant international
posture, our practice of financial bribery,
our disrespect for alternative opinions,
our blanket disregard for international
treaties, our flaunting of the most vulgar
popular culture the world has seen, and
the hopeless materialism of our culture:
The most devastating is the lack of intel-
ligent leadership: Michael Fried wrote
"where are the Democrats?", but I would
reply "where are the Americans?" Not
only is the cowboy metaphor apt, so is
the hustler, the swindler, the fantasist,
and the trickster. Our elected president is
a kind of modern-day King Ubu believing
that anything and everything is possible
because he wills it. Greed rules. Display-
ing the flags is sentimentalized behavior,
to those who know exactly what they
stand for, historically, their presence
among us is a devastating miscarriage
of patriotism. I am furious that the
symbol of our national identity is being
used to counter those values it was
created to inspire.

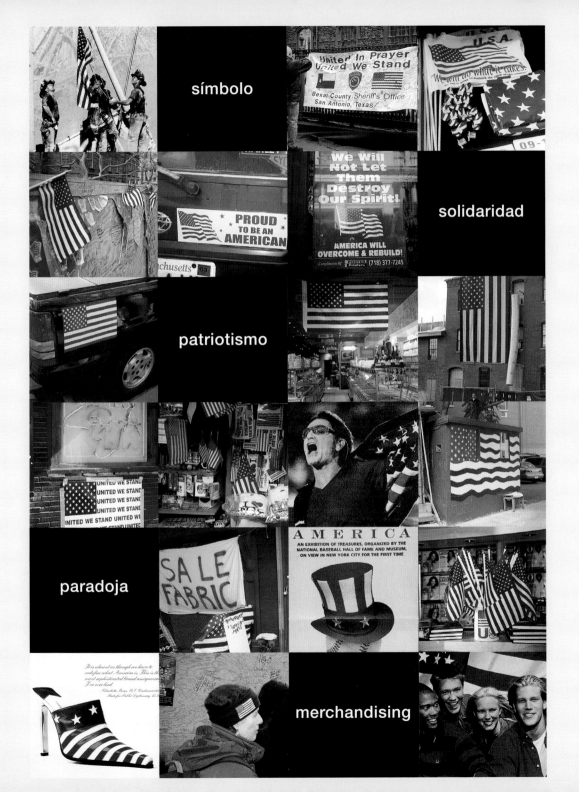

Die Stadt

 1999
...

7th Media and Architecture Biennial, Graz, Austria, 1999 - in process

Direction, production and collaboration:
**Charlotte Pöchhacker, Le Fresnoy
(Tourcoing, France), Mediateca
"la Caixa" (Barcelona, Spain)**

• This project was first sketched out when Muntadas was invited to the *Media and Architecture Biennial* organised in Graz (1999). The initial approach consisted of the projection onto the architecture of the Biennial headquarters, of a set of slides with texts in the form of questions written in French, English, German and Spanish about the generic concept of city. As a complement to the work, Muntadas gave a talk with Bartomeu Marí, director of Witte de With in Rotterdam.
The outcome of the successive visits to Graz is the project *On Translation: Die Stadt*, a kind of continuation of an earlier work, *Marseille: mythes et stéréotypes* (1992) - a screen for a film, a film for a screen -, where the cinematic presentation device was a mobile element located in different parts of the city. This is therefore a work that takes Graz as a model or prototype which can be extended to other similar cities in the rest of Europe such as Lille and Barcelona, where the intense migration processes and monumental town planning operations have brought about notable transformations in the experience the users - the residents - have of them.

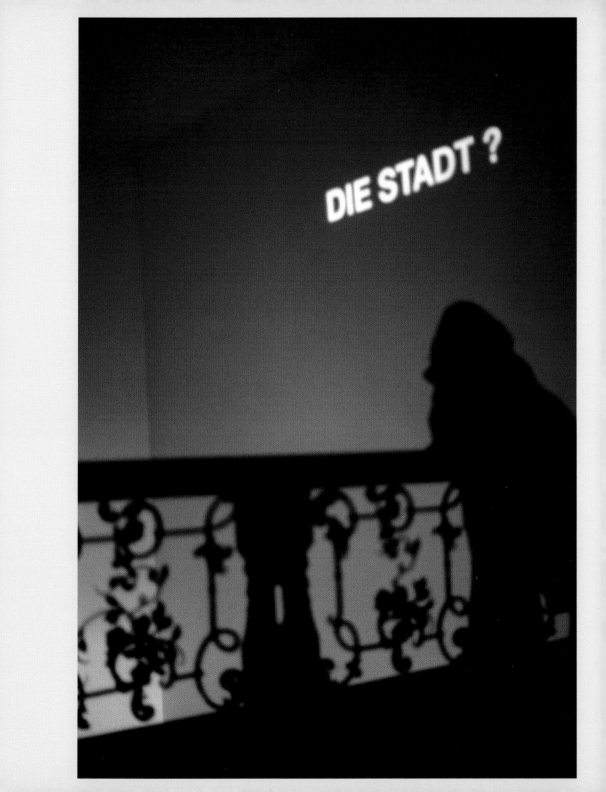

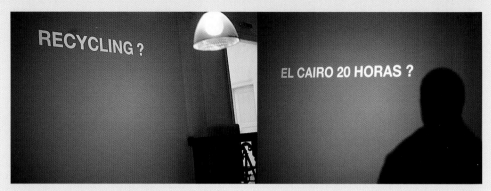

On Translation: Die Stadt Charlotte Pöchhacker

In search of an understanding of the contemporary production of the cultural space, the project On Translation: The City investigates cultural events in the context of the politics of public space throughout Europe.

Spectacle?
The starting point for On Translation: *Die Stadt* is a slide installation produced as part of the *Pragmatics On Public Spheres* at the 1999 Graz Media and Architecture Biennial, which analysed the relations between cultural organisations and the mechanisms that shape public opinion.

Politics?
Briefly phrased questions about the situation of cities follow one another in a constant cadence. The regular rhythm of the clicks that indicate the change of slide insists on apprehension, conscious perception and communication in the observer.

Who defines the rules?
A pertinent question and a project still in progress.

Citizens?
Muntadas analyses how the policies of public space are implemented, perceived and represented, beginning locally, with the specific examples of Graz, Lille and Barcelona. The interviews with the city representatives, the architects and town planners, examine global issues such as the politics of identity, immigration, the economy, globalisation and its effects on the local city context. In each particular place, Muntadas looked for a translator for the specialised questions of everyday life.

Cadre de vie?
In Graz there is a Greek taxi driver who, after spending many years in Paris carrying on his usual activity, knows the city day to day in its most diverse expressions. The specifically personal context of this translator, his experience of dislocation and the contrast between his everyday experiences and the specialised perspectives of the city reveal the inherent tension in the translation phenomenon, the transfer from one code to another.

On parle?
The point is to make people think about the specific situation of cities from different perspectives and to invite users of the city and culture to spark a discussion about the question. So it is a matter of showing the range of possibilities for cultural translation and transcription that characterises a society which

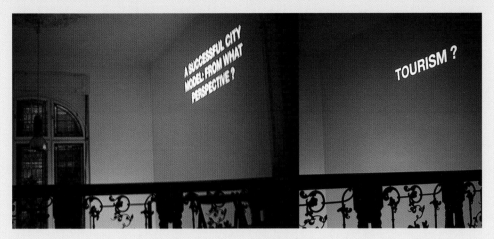

is structured as a collective made up of individuals. A society which therefore has different opinions that come into conflict and confrontation with one another and which, precisely because of that infinite range of voices, makes it possible to develop associations and creative processes in the city.

Public spheres?

Starting from the first formulation of *On Translation: Die Stadt* in the protected space of a cultural institution, the continuation of the project aims to intervene directly in the city. An essential element of *On Translation: Die Stadt* and the characteristic criterion of Muntadas' works is simultaneous translation in a series of media which act in the most diverse spheres of the public space and therefore encourage the most varied forms of analysis, participation and interaction between the observer and the artistic expression.

Is public space dead?

A mobile screen, a temporary intervention in the different urban contexts of Graz, Lille and Barcelona, as a public expression which is set in the everyday life of the city and, in the open, indefinite context of public space, looks for some direct communication with the broad

spectrum of public opinion. The mobile and temporary intervention in public space is, at the same time, an up-to-date response to the question of the potential of contemporary art in that space.

The city moves with us?

The extension of *On Translation: Die Stadt* on the Internet is proposed as a collaborative global analysis and corresponds to the open structural conception that characterises many of Muntadas' works. From three specific urban situations, Graz, Lille and Barcelona, visitors are invited to contribute to the website with their points of view.

A successful city model: from what perspective?

On Translation: Die Stadt is a long-term process that analyses the different public spheres, lays out the possibilities of artistic intervention in public space and reflects the diversity of cultural contexts of European cities.

La imatge

2002
2003

Barcelona, Spain
29 November 2002 - February 2003

Direction, production and collaboration:
Claudia Cannizzaro, Marta García Haro,
Rosa Pera, Olga Rodríguez, Luis Vilardell

• This is an anonymous image, silhouetted in white on a blue background – like architects' blueprints –
and applied to different formats (advertising hoardings in Barcelona city centre, postcards, T-shirts,
press advertisements, china plates, etc.), which refers to an archetypal decision situation occurring
in a generic space and typologically in accordance with the setting where is is taking place.

• • *On Translation: La imatge* is part of the exhibition *Muntadas. On Translation: Museum*, held at the
Museu d'Art Contemporani de Barcelona (MACBA) where, apart from this work, earlier ones such as
Emisión/Recepción (1974-2002), *The Board Room* (1987), *On Translation: La mesa de negociación* (1998),
On Translation: El aplauso (1999) and *On Translation: The Bookstore* (2002). There is also a version
applied to the Barcelona context of the exhibition *On Translation: The Audience* (1998-1999), and an
interpretation by MACBA of the complete series of projects done under the title *On Translation*, which
is presented as *On Translation: Museum*.

• • • This idea is related to *Meetings*, a series of silk screens reproducing discussion spaces where
events take place referring in stereotypes to consumer strategies, marketing campaigns or institu-
tional stances.
Like those works, *On Translation: La imatge* uses photographic material taken directly from the
media, but presented in such a way that the formal values – gloss, textures and definition – have
been eliminated to highlight its nature as a visual X-ray of an archetypal decision situation.
Lastly, as an essential, specific part of this project we should mention that it is not only presented
in the museum precinct itself, but also applied and located in other contexts and formats, always
unexpectedly and anonymously, with the aim of outlining questions and links of all kinds among
the audience.

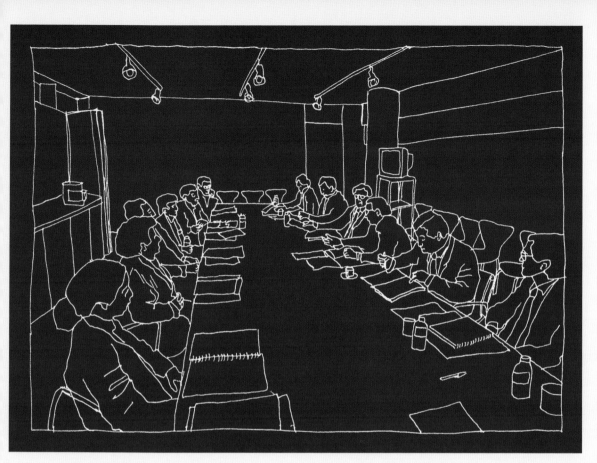

On Translation: La imatge *confronts the fact that one image is read differently depending on the medium and the context where it is presented. Working on CEE Project each of the 12 elements/ carpets was presented in public spaces in each of the countries of the CEE. Public space but with different institutional background: a museum, an opera house, a library, an art residence program, a corporate lobby... the use of a carpet - the consideration that the carpet can be perceived as an art object but also on the tradition of a carpet as applied arts, was confronting different reactions from the audience. From the ritual of seeing an object in a museum to the use of a carpet as a functional object.*

Muntadas, project notes

Operation: Muntadas. *On Translation: La imatge*
Rosa Pera

Coinciding with the presentation of the exhibition *Muntadas. On Translation: Museum* at MACBA, we have *On Translation: La imatge*. As is usually the case with Muntadas' projects, this is not just a visit to the exhibition; we become involved in a whole operation.

As soon as we enter the doors of the museum, *La imatge* appears: in exhibition territory but occupying a transit space, it catches our eye. We may walk more slowly, we may even stop, and whilst we are looking at it we may gradually formulate some question or other. Perhaps we can trace its presence in some corner of our memory. It is a large-scale image and because of its location – we are in the Museum – and its striking verticality we immediately identify its representative role.

It may also happen that we pass by and do not even notice that it is *La imatge* that seems to be looking at us out of the corner of its eye as we troop past. But almost certainly we shall stop at some time or other, since entering into a conversation with *La imatge* is just a matter of time and context, which means waiting for its rhythm, as we shall see.

On Translation: La imatge is a work in process connected to the different versions of *On Translation*, now revised – and therefore translated – for the first time in its entirety, with the *Meetings*

series, making up a situation in which it is difficult to speak of work, author, even exhibition or museum, if we allow ourselves to be carried away by *La imatge* and its circulation in public space. It is equally dubious to identify ourselves as spectators, whether we come across it on our way around the city or decide, having recognised it, to go out to meet it. In that case, we would have to inquire into the codes that give it movement. Though we can approach the issue by adopting a certain "drifting attitude", we shall soon discover that it is not necessary "to renounce, for a longer or shorter time, the reasons for travelling or acting we know, generally, in our relations, works and entertainments," as Guy Debord says in his *Théorie de la dérive*.[1] Because we encounter *La imatge* in places that belong to the everyday life of many people in the city, where we normally relate, work and spend out leisure time. And so by (apparent) chance we may run into it while waiting on the metro platform or at the traffic light that allows us to walk on; as we leaf through the newspaper or on a free postcard, at the cinema or in a bar... where we happen to be standing next to someone wearing it somewhere on their person. When we reach that point we may sense that it is encouraging us to become something more than spectators: for "the work" to function we have to activate it

with our participation, by reading it or circulating it every time it crosses our path. It is, then, a matter of "bringing it into play".[2]

And we do so, whether consciously or not, without modifying our usual activity, though we are now integrated into the "formless" process.

On the occasion of the exhibition *L'Informe: Mode d'emploi*, Yve-Alain Bois and Rosalind Krauss break down the term *informe*, mentioning one of the versions proposed by Georges Bataille an *opération de glissement*,[3] in other words, a "slipping operation" (somewhat removed from any subject, substance or concept, as Krauss and Bois point out), which slips away by scattering itself, without being constrained to concepts such as "form" and "content". As they also remark, those are not what Bataille is interested in; rather what *l'opération* makes it possible for neither of them to stay in place. Since, what are the form and content of *On Translation: La imatge*? And what is its place? There is no simple answer to those questions. Although visible and tangible through the presence of a specific – albeit ambiguous – image, we are essentially talking about a process work.

Deploying horizontally, Muntadas' idea is structured through a network of situations where each context (with all its players and components) adds new ele-

ments to the experience of perception. *La imatge*, also housed in a series of objects and "vehicles" (T-shirts, postcards, china plates, signs on urban furniture, postal labels, advertisements in the press, etc.), is released both from the verticality which dooms it to be stared at and the association with its author (the artist's name does not appear anywhere), while being transported from the status of "work" to the condition of "text". A text, as Barthes said, which "can be read without the guarantee of its father. [...] The Text, even though only because it is frequently 'illegible', draws the work (if the work allows) out of its consumption and assumes it as game, work, production, practice. All that means that the Text states the demand to abolish (or at least reduce) the distance between writing and reading, though not through a heightened projection of the reader onto the work, but through the link between the two at the heart of a single meaningful practice."[4]

Moreover, if La imatge inhabits different devices, they in turn are situated – and move – in different places, in the shelter of the different registers in which public space is diversified, whether in the media or the urban dimension, through advertising space, commercial space, etc. Those are territories which also point us out as users and consumers. But that consideration is far from diverting our mission as both read-

ers and writers of a text. On the contrary, it heightens it, as Michel de Certeau points out when he writes "...because it is the "exorbitant" focus of contemporary culture and its consumption: reading. From TV to newspapers, from advertising to all sorts of mercantile epiphanies, our society is characterised by a cancerous growth of vision, measuring everything by its ability to show or be shown and transmuting communication into a visual journey [...]. The economy itself, transformed into a "semiocracy", encourages a hypertrophic development of reading. Thus, for the binary set production-consumption, one would substitute its more general equivalent: writing-reading. Reading (an image or a text), moreover, seems to constitute the maximal development of the passivity assumed to characterise the consumer, who is conceived of as a voyeur (whether troglodytic or itinerant) in a "show biz society". In reality, the activity of reading has on the contrary all the characteristics of a silent production: the drift across the page, the metamorphosis of the text effected by the wandering eyes of the reader, the improvisation and expectation of meanings inferred from a few words, leaps over written spaces in an ephemeral dance. [...] The thin film of writing becomes a movement of strata, a play of spaces. A different world (the reader's) slips into the author's place."[5]

And that is the very air we have been breathing since the beginning of the operation *On Translation: La imatge*, when Muntadas proposed it to the Museum, as the artist has mentioned on more than one occasion, as a rumour. Since then scattering it has meant activity and putting agents from quite different fields in touch, all of them (marketing, industrial, advertising professionals, museum staff and board, photographers, designers, etc.) involved in the same process. During its development, *translated* by the dynamic of the project itself, we are all acting as producers and consumers now, as actors and spectators, whilst we are accomplices in the operation of giving the X-ray of the Museum a panoramic dimension. In circulation,[6] whether inside or outside the building, *La imatge* continues to print suspension points... like all rumours...

1. Guy Debord, 'Théorie de la dérive', published in *L'Internationale situationniste*, no. 2, December 1958.
2. We are referring to the word "play" in its full sense, as Barthes does, alluding to all its meanings (playing a game, operating and playing a musical instrument, ideas also expressed in other languages such as French (*jouer*) or Spanish (*jugar*). Roland Barthes, "De l'Oeuvre au Texte", *Revue Esthétique* 3 (1971), pp. 225-232.
3. Yve-Alain Bois, "La valeur d'usage de l'informe", in Yve-Alain Bois and Rosalind Krauss, *L'Informe: Mode d'emploi*. Paris: Ed. Centre Georges Pompidou, 1996, p.11.
4. Roland Barthes, op. cit., p. 172.
5. Michel de Certeau, "General Introduction to the Practice of Everyday Life" [1980], in Ben Highmore (ed.). *The Everyday Life Reader*. London: Routledge, 2002, p. 1971. From the original source: Michel de Certeau..
The Practice of Everyday Life (transl. Steven Rendall. Berkeley, California: University of California Press, 1984, pp. xi-xxiv.
6. We insist, with Barthes, on the circular meaning of the term.

portaveu parlamentari del PSC-PSOE, Joaquim Nadal, l'"anuncia-da reforma de l'Estatut d'Autono-mia suposa "treure del Parlament

Aquestes rèpliques sembla que allunyen Artur Mas del seu objec-tiu que el nou Estatut proposat tin-gui el "consens" de tots els partits

nou Estatut per a Catalunya és "ab-solutament legítima" i "admissi-ble", però va considerar que ara "no és prioritària". *Àngela Rodríguez*

titud ferma davant l'augment d'embarassos no desitjats, els avortaments i les "malalties de transmissió sexual ". (Metro)

25 anys de la tornada de Josep Tarradellas

Barcelona. Avui es commemora el 25è aniversari del retorn del presi-dent de la Generalitat a l'exili, Josep Tarradellas. Enmig d'una rebuda multitudinària, Tarradellas va pro-nunciar des del balcó del Saló de Sant Jordi del Palau de la Generali-tat la cèlebre frase: "Ciutadans de Catalunya, ja sóc aquí". Aquest mo-ment va simbolitzar la recuperació de l'autogovern català. (Metro)

Mestres marroquins no poden fer classe

Barcelona. La crisi entre Espanya i el Marroc està paralitzant l'apli-cació d'un conveni en virtut del qual 15 docents marroquins tenien previst venir a ensenyar llengua i cultura àrabs a menors d'aquesta nacionalitat que viuen a Catalu-nya, segons va dir a COM Ràdio representants de la Generalitat i de l'entitat Ibn Batuta. (Metro)

Es reforça la vacuna de la meningitis C

Barcelona. El govern de la Gene-ralitat va acordar ahir iniciar, a través de les escoles, una campa-nya de reforç de la vacunació con-tra la meningitis C per a gairebé 340.000 alumnes d'entre 11 i 19 anys. La vacuna es subministrarà a través dels centres educatius als alumnes d'entre sisè de primària i segon de batxillerat. (Efe)

Un tornado danya 20 masies al Solsonès

Lladurs. Una vintena de masies de la localitat de Lladurs (Solsonès) i els boscos d'aquest municipi van quedar molt danyats per un tor-nado que dilluns a la tarda va as-solar la zona, on es va desencade-nar una espectacular tempesta. El tornado es va emportar teulades de cases i d'explotacions i arbres sencers dels boscos. (Agències)

Els pagesos protesten contra Medi Ambient

Barcelona. Uns 200 pagesos i ra-maders, convocats per Unió de Pa-gesos, es van manifestar ahir da-vant de la Conselleria de Medi Am-bient per protestar contra la polí-tica "fiscalitzadora" d'aquest de-partament. UP considera que Me-di Ambient "exigeix molts controls als nostres productes que els es-trangers no han de complir". (Efe)

El Govern unifica els correus electrònics

Barcelona. El govern de la Gene-ralitat unificarà en *@catalonia.net* totes les adreces de correu electrò-nic destinades a l'ús dels ciuta-dans, dintre de la posada en mar-xa del portal *www.cat365.net.* A més, totes les adreces de correu de la Ge-neralitat s'adaptaran a *@gencat.net.* que coincideix amb la nova web oficial del Govern. (EP)

Con su libro 'Superadas', ¿pre-tende hacernos pensar sobre la realidad?
No quiero enseñar ni comunicar nada. No tengo ninguna intención con mi trabajo. Quiero dinero. Lo que no quita que me esfuerce por hacerlo lo mejor que puedo.

Crear opinión pero no sentar cátedra, ¿no?
Cada uno que haga lo que quie-ra; no soy buena para dar conse-jos, ni me siento en el podio de de-finir a las mujeres. Siempre digo que me bajen de ahí porque no soy socióloga ni psicóloga.

¿Recurre al humor para anali-zar asuntos serios?
El humor desdramatiza mucho. Permite hablar de cosas que de otra manera son muy aburridas... Con humor es más fácil sufrir. Si sufres y lo cuentas con humor, te escu-chan, resulta más agradable para el que lo hace y para el que lo lee.

¿Cómo logra que las mujeres se identifiquen con su humor?
Debe de ser por lo que dicen los hombres: que somos todas igua-les. Las relaciones humanas son iguales en todos lados y la gente sufre o es feliz por lo mismo.

¿Los hombres también se sienten identificados?
Les sirve como manual de ins-trucciones de las mujeres. Yo ha-blo desde las mujeres, son mi blan-co favorito. Ellos me dicen que así son su mujer, su madre... Pero tienen menos autocrítica para po-der decir: así soy yo. Les cuesta más reconocerse. *Elisabeth G. Iborra*

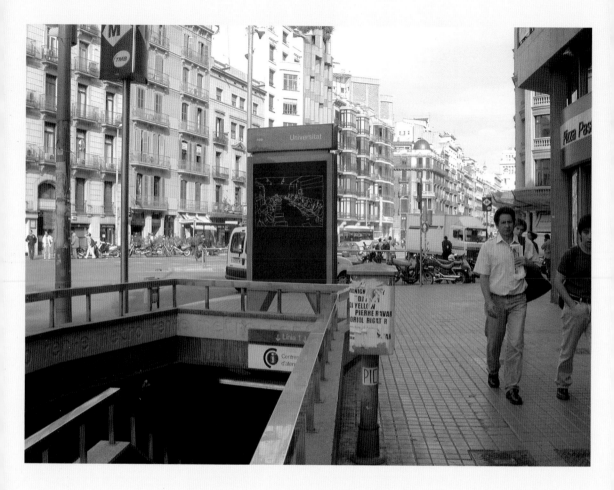

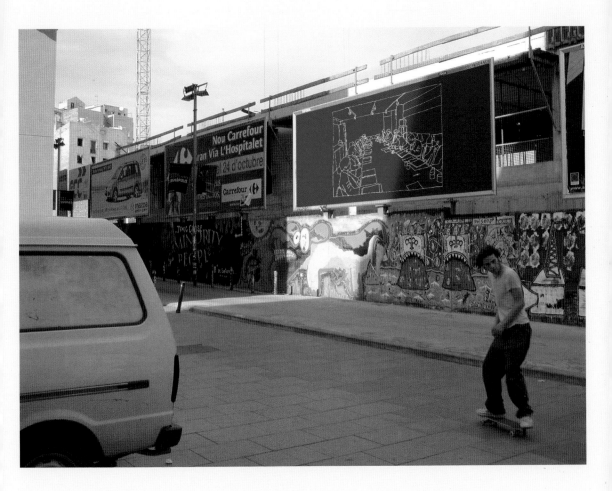

Bibliographic references on Muntadas

ALONSO, Rodrigo. "Esto no es un aviso publicitario. Un ensayo sobre la obra de Muntadas en video e Internet", in Jorge LA FERLA (ed.). *Contaminaciones: del videoarte al multimedia*. Buenos Aires: Centro Cultural Ricardo Rojas, Oficina de Publicaciones del CBC, Universidad de Buenos Aires, 1997.

AMAR, Sylvie. "Marseille/Givors: de la commande publique à l'intervention temporaire", interview with Muntadas in Alain CHARRE and Jacky VIEUX, *Art et Mégalopole RN86*. Liege: Mardaga, 1989.

AMAR, Sylvie. "Time for Dialogue", in *Art Press*, no. 177, April 1992.

ANTOLIN RATO, Mariano. "La exposicion de Muntadas", *Cuadernos del Norte*, Oviedo, 1985.

ARNALDO, Javier. "Iconografias de los contextos: Antoni Muntadas", *Cuadernos Hispanoamericanos*, no. 608, Madrid, 2001.

ATKINS, Robert. "Meditación sobre el arte y la vida en el 'Paisaje de los Media'", in *Des/Apariciones*. Barcelona: Centre d'Art Santa Mónica, 1996 [exh. cat.].

AUGATIS, Daina. "Note on Mass Events", *Stadium*. Banff (Canada): Walter Phillips Art Gallery; The Banff Centre for the Arts, 1989 [exh. brochure].

BATTISTOZZI, Ana María. "Entre Camaras y microfonos", *Clarin (Suplemento Cultura)*, Buenos Aires, September 18, 1997.

BELLOUR, Raymond. "L'art de la démonstration". Rennes: Festival des Arts Electroniques, 1988.

BELLOUR, Raymond. "L'entre-Image Photo, Cinema, Video", *La Différence*, no. 190, Paris.

BLANCH, Maria Teresa. "Muntadas, Ideological Statement", *Artefactum*, November – December 1984.

BIRNIE DANZKER, Jo-Anne. "Reading Between the Lines", *Centerfold*, no. 5, Toronto, July 1979.

BONET, Eugeni. "Background/Foreground. Un trayecto por la obra de Muntadas", in *Híbridos*. Madrid: Museo Nacional Centro de Arte Reina Sofía, 1988 [exh. cat.].

BONET, Eugeni. "Muntadas. Segundo intento", in *Muntadas: Trabajos Recientes*. Valencia: IVAM Centre del Carme, 1992 [exh. cat.].

BONET, Eugeni. "Muntadas: Seguimiento del proyecto [v 2.0]", in *Intersecciones*. Santa Fé de Bogotá: Biblioteca Luis Ángel Arango, 1999 [exh. cat.].

BOSMA, Josephine. "A De-caffeinated Experience of Net-art", in *Telepolis, Magazin der Netzkultur*, heise.de/tp/english/inhalt/sa/6552/1.html.

BOUGLE, Frederic. "Art Caught Whole in its Frame; the Reification of Methods", *From*, no. 2, Rotterdam, April 2000, p. 15-29.

CIRICI, Alexandre. "Antoni Muntadas i l'art táctil", *Serra d'Or*, no. 143, Barcelona, October 15, 1971.

CIRICI, Alexandre. "Cadaqués Canal Local", *Serra d'Or*, no. 182, Barcelona, November 15, 1974. Reprinted in *Brumaria*, no. 1, 2002.

CIRICI, Alexandre. "L'environament invisible d'Antoni Muntadas", *Serra d'Or*, Barcelona, October 1979.

CIRICI, Alexandre."Muntadas o la recerca que no para", *Serra d'Or*, November 1982 p. 43-54.

CHAMPESME, Marie Thérese. "Conversation avec Muntadas", *Sillage*, no. 22, Le Channel, Calais (France), October 1994.

CHRIST, Ronald. "Media and the Means: Muntadas", *Arscanada*, vol. XXXIX, no. 1, Toronto, November 1982.

CHRIST, Ronald; MUNTADAS. "Entrevista", *Sites 7*, New York, 1982.

CONOMOS, John. "Muntadas", *Art and Texte*, Sidney, January 1994.

DE NOOY, Wooter. "In The Circle", *From*, no. 2, Rotterdam, April 2000, p. 30-42.

DIMITIJEVIC, Nena. "Muntadas: Cheminement le long des stations du pouvoir", *Muntadas*, *Chimaera*, no. 8, Montbéliard/Belfort: CICV, 1992.

DRAGO, Elena del. "Muntadas, se il fine giustifica i mezzi", *Il Manifesto*, Italia, August 22, 2002.

DUGUET, Anne-Marie. "Notas a la Memoria de una Información Desconocida", in *Proyectos*. Madrid: Fundación Arte y Tecnología, 1998 [exh. cat.]. Reprinted in Anne-Marie DUGUET. *Dejouer l'image*. Nîmes: Jacqueline Chambon Éditions, 2002.

ERASO, Miren. "Antoni Muntadas. On Translation", *Zehar*, no. 34, Spring 1997.

FRANCBLIN, Catherine. "Y-a-t'il un individu dans la salle?", in *Muntadas, Between the Frames: The Forum*. Bordeaux: Musée d'Art Contemporain, 1994 [exh. cat.].

GALE, Peggy. "Muntadas' Eye", in *4ª Semaine Internationale de Vidéo*. Saint-Gervais; Geneva, October 1991 [exh. cat.].

GARCIA CANCLINI, Néstor. "Muntadas y las negociaciones sospechosas", in *Intersecciones*. Santa Fé de Bogotá: Biblioteca Luis Ángel Arango, 1999 [exh. cat.].

GAUVILLE, Hervé. "Muntadas, le monde congédié par l'écran", *Libération*, Paris, May 24, 1994.

GRUNDMANN, Heidi. "Algunas consideraciones sobre el sonido en las instalaciones de Muntadas", in *Muntadas. Trabajos recientes*. Valencia: IVAM Centre del Carme, 1992 [exh. cat.].

HEARTNEY, Eleonor. "Cultivating an engaged public art", *Art in America*, New York, October 1990.

HEARTNEY, Eleanor. "Reframing the eighties", *Art in America*, vol. 82, no. 11, November 1994.

Horrigan, Bill. "Masterpiece Theatre", in *Muntadas, Between the Frames: The Forum*. Columbus (Ohio); Cambridge (Massachussetts): Wexner Center for the Arts; List Visual Arts Center; MIT, 1994 [exh. cat.].

Huffman, Kathy. "Muntadas. Selected Video Works, 1974-1984", *Los Angeles Institute of Contemporary Art*, February 1985.

McGee, Micky. "Born-Again Broadcasting", *Afterimage*, Rochester, 1989.

Machado, Arlindo. "Muntadas entre el arte y los media", *Clarín*, Buenos Aires, August 17, 2002. Traduced from the portuguese "Muntadas entre a arte e a mídia".

Mantegna, Gianfranco. "The Neo Flaneur", in *Dissensi-Taormina Arte Catalogue*, Palermo: Sallerio Editore, 1991. Reprinted in *Journal of Contemporary Art*, New York, May 1992.

Marchan Fiz, Simón. "Una mirada nómada al paisaje de los medios", in *Proyectos*. Madrid : Fundación Arte y Tecnología,1998 [exh. cat.].

Marí, Bartomeu. "Hibridos", *Balcon*, no. 2, Madrid, 1988, p. 83-91.

Marí, Bartomeu. "Fragmentos", about *City Museum*, in *Images numériques. L'aventure du regard*. Rennes: Odile Blin et Jacques Sauvageot Éditeurs; École Régionale des Beaux Arts, 1996.

Martí Font, José María. "Cadaqués Canal Local. Una experiencia-piloto de comunicación", published in three parts in *Diario de Barcelona*, August, 13th, 14th and 15th. 1974. Reprinted in *Brumaria*, no. 1, 2002.

Mattelart, Armand. "Antoni Muntadas o como han evolucionado nuestros sueños de otra sociedad", in *Proyectos*. Madrid: Fundación Arte y Tecnología, 1998 [exh. cat.].

Melo, Alexandre. "Os poderes dos lugares", *Expresso*, Lisbon, May 16, 1992.

Melo, Alexandre. *A Proposito do Publico e do Privado*. Porto: Fundaçao Serralves, 1992 [exh. cat.].

Mercader, Antoni. "Híbridos: especulaciones y metáforas", in *Híbridos*. Madrid: Museo Nacional Centro de Arte Reina Sofía, 1988 [exh. cat.].

Morgan, Robert C. "On the activity of slowing down or the media becomes the media", in *Exposición*. Madrid: Galería Fernando Vijande, 1985 [exh. cat.]. Reprinted as "On the Activity of Slowing Down", in *Commentaries on the New Media Arts*. Pasadena: Umbrella Associates, 1992, p. 55-64.

Morgan, Robert C. "The icon without the image", *Art Criticism*, vol. 4, no. 2, New York, 1988. Reprinted as "Art into Ideas", in *Cambridge University Press*, Winter 1996.

Morse, Margaret. "Media-architectural installations", in *Muntadas. Trabajos recientes*. Valencia: IVAM Centre del Carme, 1992 [exh. cat.].

Papa, Sania. "Antoni Muntadas The C.E.E. Project (1989-1998)", *Arti*, Greece, 1998.

Parcerisas, Pilar. "Muntadas, contra la convenció", *Avui*, Barcelona, November 1985.

Peternáck, Miklós. "Four Footnotes for Muntadas", in *Antoni Muntadas. On Translation: The Monuments*. Budapest: Ludwig Museum, 1998, p. 25-29.

Phillips, Christopher. "Architectures of Information: The video work of Muntadas", in *On Translation. The Games*. Atlanta: The Atlanta College of Art, 1996 [exh. cat.].

Rofes, Octavi. "On the Audience: The Translation", in *On Translation. The Audience*. Rotterdam: Witte de Witte, 1999 [exh. cat.].

Roma, Valentín. *Slogans*. Girona: Sales municipals d'exposicions, 2000 [exh. cat.].

Rosen, Miriam. "L'homme-mémoire de la censure", *Libération*, Paris, December 31, 1995.

Ross, David. "An Endorsement", in *Barcelona-Paris-New York*. New York, 1985 [exh. cat.].

Searle, Adrian. "Antonio Muntadas – Ikon", in *Artscribe*, January – February issue, London, 1990.

Sichel, Berta. "Paysages Mediatiques", Muntadas, *Art Press*, no. 75, Paris, November 1983, and in *Treballs recents*. València: Sala Parpalló 1983.

Shikata, Yikiko. "Muntadas", *B.T.magazine*, Tokyo, June 1997, vol. 49, no. 742, p. 73-85.

Snodgrass, Susan. "Public Domain, Muntadas and The File Room", *The New Art Examiner*, October 1994.

Staniszewski, Mary Anne. "Catalogue essay", *Exhibition*. New York: Exit Art, 1987 [exh. cat.].

Staniszewski, Mary Anne. *Between the Frames: The Forum*. Bordeaux: capc Musée d'Art Contemporain, 1994 [exh. cat.].

Tarantino, Michael. *A Proposito do Publico e do Privado*. Porto: Fundaçao Serralves, 1992 [exh. cat.].

Torres, Alfredo. "Ni la utopia ni el pesimismo", *Bracha*, Montevideo, Uruguay, September 17, 1999.

Wallis, Brian. "Born-Again Architecture: Muntadas' *The Board Room*", in *Muntadas: The Board Room*. Toronto: The Power Plant, 1988 [exh. cat.].

EXHIBITION

Project Director
Manuel J. Borja-Villel

Curator
José Lebrero Stals

Coordinator
Marta García Haro
Teresa Grandas

Registrar
Aída Roger de la Peña

Architecture
Isabel Bachs

Restorers
Silvia Noguer
Xavier Rossell

ON TRANSLATION: MUSEUM

Concept and interpretation
Enric Franch
José Lebrero Stals
Valentín Roma

ON TRANSLATION: LA IMATGE

Project director and coordinator
Rosa Pera

Distribution
Olga Rodríguez Guevara
José Antonio Freire

ON TRANSLATION: THE WEB

Designer
Ricardo Iglesias

Coordinator
Sonia López

CATALOGUE

Edition
Mela Dávila
Valentín Roma

Coordination
Anna Jiménez Jorquera

Translation
Discobole
Paul David Martin

Editing
Cathy Douglas

Design
Ramon Prat, David Lorente

Technical Production
Oriol Rigat, Carmen Galán

Production
Font i Prat Ass. s.l.

Printing
Ingoprint, s.a.

Distribution
ACTAR Roca i Batlle, 2 08023 Barcelona
Tel. +34 93 418 77 59 Fax +34 93 418 67 07
info@actar-mail.com www.actar.es

Museu d'Art Contemporani de Barcelona
(MACBA). Plaça dels Àngels, 1
08001 Barcelona. Tel. +34 93 412 08 10
Fax +34 93 412 46 02. www.macba.es

ACKOWLEDGEMENTS

Judit Angel
Fernando Amat
Arlex
El Drapaire del Passatge
Pep Durán
Margaret Galbraith
Jon Gasca
Eva Ibáñez
Douglas Walla, Kent Gallery
Salvador Martínez Pérez de Hita
Montse Massagué
Gabrielle Maubrie
National Gallery of Canada,
 Ottawa
Moisés y Trini Pérez de Albéniz
Galería Moisés Pérez de Albéniz
All the entities and cultural
institutions that have taken part
in the project On Translation:
La imatge, and especially
Antoni Muntadas for his
generous collaboration and
support throughout the
development of this project.

This book has been published
on the occasion of the exhibition
Muntadas. On Translation:
Museum, organized by MACBA
and presented from November
29, 2002 to February 9, 2003.

The Museum am Ostwall in
Dortmund, Germany, will present
On Translation: Museum in 2003,
under the title On Translation:
Das Museum.

SEAT

Sponsor of MACBA